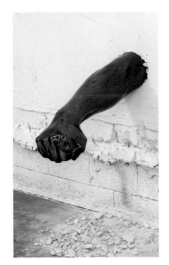

The Art of
not making

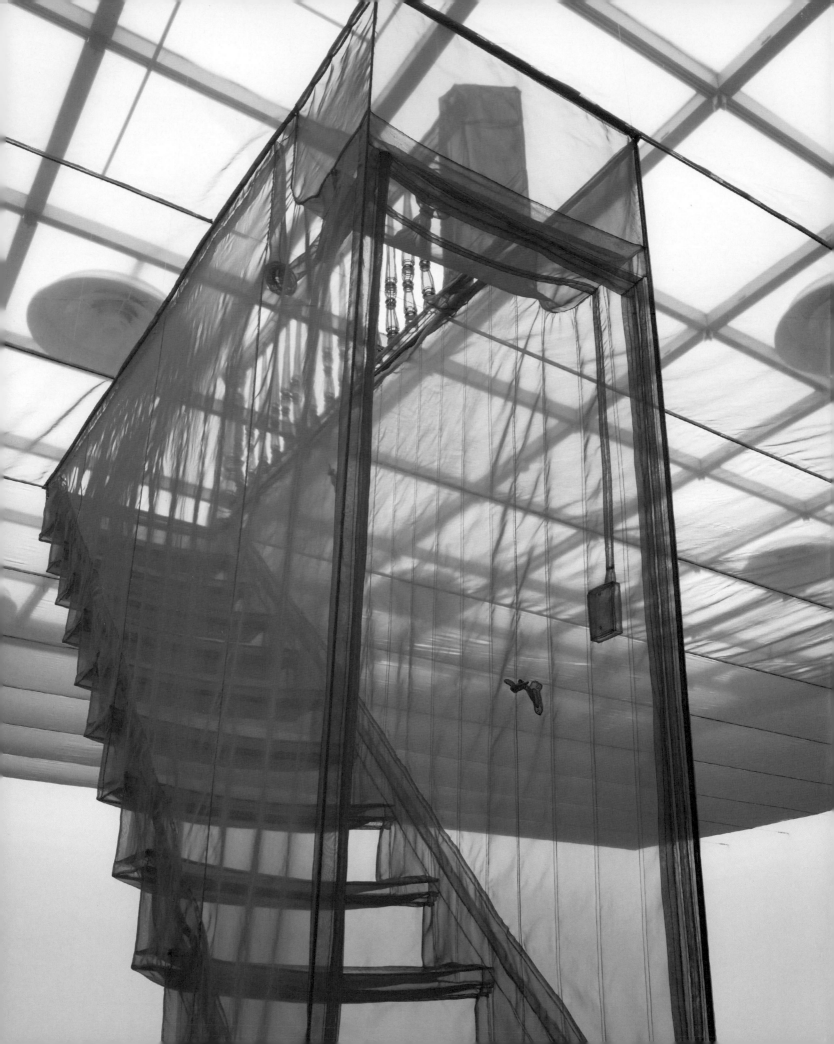

Michael Petry

The Art of not making

THE NEW ARTIST/ARTISAN RELATIONSHIP

Thames & Hudson

with 324 pictures, 318 in colour

This book is dedicated to my partner, Travis Barker.

PAGE 1 **Aaron Young**, UNDERDOG, 2009, polyester resin with fibreglass and chrome finish, 25.4 x 91.4 cm

PAGE 2 **Do-Ho Suh**, STAIRCASE-V, 2008, orange polyester and stainless-steel tubes, dimensions variable Suh (b. 1962, Korea) creates works that often refer back to buildings in which he has lived. Many are precise facsimiles – complete with walls, stairs, ceilings and doors, and details such as shelves, sinks, light switches, sockets and doorknobs – made entirely from transparent materials. Suh measures the details of the original dwellings and makes patterns, which he sends to seamstresses in Korea, who produce the pieces for him.

RIGHT **Takashi Murakami**, FLOWER MATANGO (B), 2001–6, mixed media, dimensions variable (installation view) Murakami (b. 1962, Japan) is one of the world's leading artists to have combined commercial and artistic success. He creates paintings, sculptures, wallpapers, video, as well as consumer fashion products. All of his works are made by a large staff of fabricators, each with their own specialist craft skills.

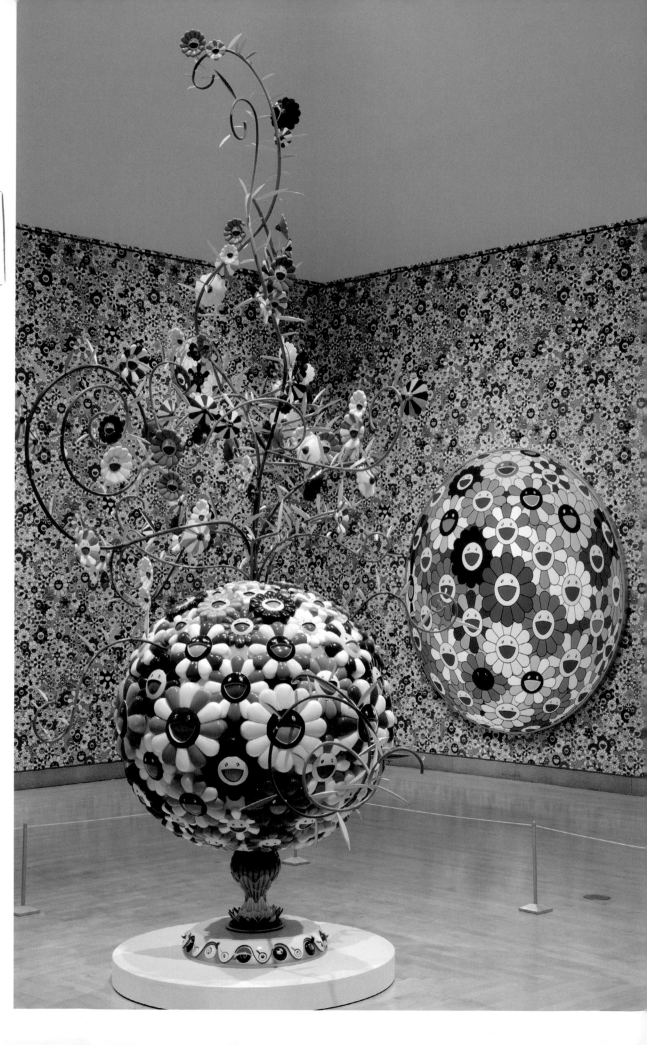

contents

When art meets craft

In recent years, there has been a return to a highly crafted aesthetic in art. The conceptualism that emerged in the mid-1960s – and the consequent 'deskilling' of art education and 'dematerialization' of practice – appears to have had its day. In its place has come a resurgent interest in the beautifully designed and produced object, manufactured from delicate or precious materials, and demonstrating extraordinary levels of skill and ingenuity. At the same time, as the visual arts have expanded from their traditional territories of painting, drawing, printing and sculpture to embrace new techniques and methods, and as art has become an increasingly prominent feature of our public spaces, artists are finding more opportunities to produce work on an ever larger and more spectacular scale and in a variety of mediums and settings.

With this growing level of creative and technical ambition, it is no wonder that so many artists turn to others to help them realize their art. The conventional view of the artist as someone who works alone and who personally creates each unique piece by hand as an expression of artistic 'genius' no longer applies. Instead, we increasingly see those who are named as 'the artist' being remote from the physical act of production, directing from the sidelines, while those with specialist expertise do the heavy lifting or fine detailing.

But when an artist does not make his or her own work, what does it mean for the nature of art, and for the status of the artist? What is the difference between an artist and an artisan? How can we distinguish art from craft? Do we even need to? What is the relationship between creativity and production? Where is the art and where is the artist? What, indeed, is the art work?

These and other questions about authorship, artistic originality, skill, craftsmanship, and the creative act run throughout this book. We will see a wide range of works and practices in which the person credited as the artist has relied on other people's technical knowhow, talent and industry – sometimes in part, sometimes entirely – to bring an idea to life. This may involve appropriating the work of another artist, or making use of an already existing object. It may also mean collaborating with an expert in another field or employing the services of a master technician. And we will see an equally wide range of motives for an artist to do so, from simply wishing to expand his or her repertoire of techniques to seeking to interrogate the social codes and values inherent in attitudes towards labour and creativity. Sometimes working with others is incidental to the end product; at other times, it is inherent to the artist's original concept and fundamental to the finished work.

The artist / artisan relationship

Artists have long used the talents of others, from studio assistants to workers in factories and foundries, to realize work they have not been able, or have not wished, to make themselves. For many, there was a genuine practical imperative for doing so. It takes years, sometimes decades, to learn all of the technical skills required to make the range of objects we class as art, be it glassblowing, lost-wax method, wood carving, ceramic slip casting, and so on. Unless a visual artist dedicates his or her career to working exclusively in one of these specific mediums, it is unlikely that they will take the time to acquire all of the skills needed themselves. Instead, historically they have asked specialist craftspeople and makers to contribute their experience, knowledge and helping hands to the process. Does that make the object that results from this collaboration an original work of art, or a piece of craft? Is it an art work because it was conceived by an artist? Or a piece of craft because it was brought into being by a craftsperson?

It is worth noting that such questions rarely arise in other fields of cultural activity. In film, for instance, there is no doubt where the authorship of a movie lies. The director may not have personally done the lighting, cinematography, sound, music, or editing, let alone the acting, but he or she still gets credited as the person who 'made' the film. People generally understand the collaborative process of making a movie, and the roles of those engaged in its production; and they understand that in saying that a film is 'made' by this or that named person, it does not discount the work of the many others involved. Nor do they deny the

'Another aspect of the "Readymade" is its lack of uniqueness … the replica of the "Readymade" delivering the same message. In fact, nearly every one of the "Readymades" existing today is not an original in the conventional sense.'

Marcel Duchamp

director the right to claim creative ownership of the film.

And yet, in contemporary art these issues persist. The perceived dichotomy between a work of art and a work of craft remains; the values that ascribe a hierarchy between the functional craft object and the sacred art work still hold true; and the artistic 'authenticity' of an object made by one person but credited to another continues to be hotly debated. This is as much the case in museums, schools, and art galleries, and among curators, students, artists, and makers, as it is among the general public.

The debate has its roots in the Renaissance. Artists as a distinct class came into being in Europe in the sixteenth century, and a distinction between artist and craftsman soon developed. As practitioners of one of the 'liberal' arts, artists were ranked alongside men of intellect and enquiry, such as philosophers, scientists, writers, and mathematicians. Craftsmen, in contrast, were relegated to the world of manual labour. (This was not, however, the case in the East: to this day in Japan calligraphers and potters are seen as equals to painters and sculptors.)

Much of the debate revolved around the principle of usage. If an object could be used – a glass, a jewel or a ceramic plate, say – then it belonged to the lesser world of craft. In contrast, a work of art simply existed to be itself, whether or not it had a message, concept, or style to convey. In the end, so the theory went, art is not concerned with the mundane realities of everyday life, but elevated to a higher plane.

The emergence of state-sponsored academies in the seventeenth and eighteenth centuries formalized this distinction and assured 'fine' art its superior status as an academic discipline. And in the nineteenth century, the Aesthetic Movement, with its slogan 'Art for Art's sake', took this idea to its extreme, claiming that art was a thing without a use or function and that it should have no social, moral or didactic purpose whatsoever. Emphasizing aesthetic and sensual values over all others, the Aesthetes asserted that art needed only to be beautiful.

Gender politics also played a part: while the fine arts were deemed to be a noble and intellectual pursuit, and as such the province of men, applied arts were made by women and thus relegated to a lower status. This distinction persisted into the twentieth century. Men made monumental sculpture; women cast pots; men painted vast heroic canvases; women did macramé.

The English historian and philosopher R. G. Collingwood, writing in the interwar years, continued to construct the debate in similar terms. His *The Principles of Art* (1938) stated that in the crafts there is a distinction between planning and execution, and that the craftsman 'knows what he wants to make before he makes it', while the true artist might just arrive upon a work via exploration, and finds expression of his emotions through the making. However, it must be said that for all this debate among thinkers, artists generally ignored such questions and got on with making things, either

with their own hands or by using those of craftsmen. Often, they did so to challenge the existing hierarchies.

Duchamp's challenge

One of the earliest to confront these issues in his work was Marcel Duchamp (1887–1968), and his explorations of the nature of the art object, artistic authorship and creative genius have inspired a century of practitioners ever since. His celebrated *Fountain* of 1917, a mass-produced porcelain urinal, was one of the first works by Duchamp to be made from an already existing object that he re-presented as art.

At the time, he was living in New York and was a board member of the Society of Independent Artists. Having bought the urinal from the J. L. Mott Iron Works on Fifth Avenue, he took it back to his studio, reorientated it by ninety degrees, and wrote on it 'R. Mutt 1917'. He then sent the piece under that name to the Society's 1917 exhibition, which, its organizers had proclaimed, would exhibit all work submitted. In the end, after much debate by the board about whether the object was art or not, it was not accepted for the exhibition. Duchamp and the American collector Walter Arensberg, who had been with Duchamp when he had bought and signed the urinal, resigned from the board in protest. However, the Dadaist journal *The Blind Man*, with which Duchamp was involved, reproduced a photograph of the work in its second (and final) issue. The anonymous editorial that accompanied the photograph made a statement that

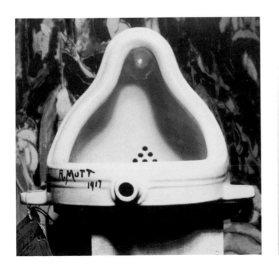

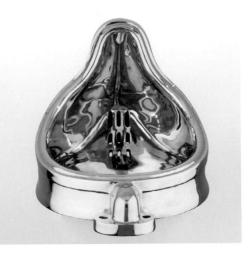

FAR LEFT **Marcel Duchamp**, FOUNTAIN, 1917, porcelain, 36 x 48 x 61 cm

LEFT **Sherrie Levine**, FOUNTAIN (AFTER MARCEL DUCHAMP), 1991, bronze, 36.8 x 35.6 x 66 cm, edition of 6

With readymades and altered readymades such as *Fountain* and *Air de Paris* (OVERLEAF), Duchamp challenged the idea of originality by taking the work of others and presenting it as his art. Levine appropriated Duchamp's conceptual stance by quoting his work and creating her own *Fountain*. She added another layer of complexity by having the porcelain urinal cast in bronze, utilizing the skills of yet more hands that are not her own.

would influence the work of artists to the present day: 'Whether Mr Mutt made the fountain with his own hands or not has no importance. He CHOSE it. He took an article of life, placed it so that its useful significance disappeared under the new title and point of view – created a new thought for that object.' This is the first articulation of what became known as 'nominalism': the concept that art becomes art when an artist *names* it as such.

Two years later, Duchamp made *Air de Paris* as a gift for Arensberg. Before leaving Paris to return to the United States, he asked a pharmacist to empty a glass bottle containing a 'physiological serum', and told him to 'let it fill with air and then seal it up again'. Duchamp's simple act in creating this 'altered readymade' has entered the canon of art history not only as an object by an artist that was manufactured by someone else with a greater technical skill – in this case, the glassblower who made the original bottle – but also as an art work that was completed by yet another person, the pharmacist.

Despite considerable controversy at the time, Duchamp's readymades are now widely accepted as works of art, not

Marcel Duchamp, AIR DE PARIS, 1919, glass, 14.5 x 8.5 cm

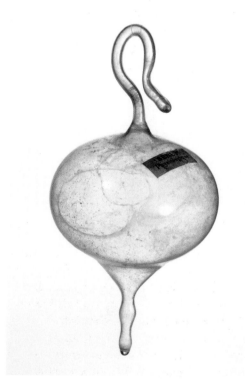

as craft, and there is no doubt about their status as such. Duchamp had demonstrated a whole new way of thinking about and making art. He knew that artists had used assistants for centuries, and also knew that his programme was just a development in that practice. Whether he could have physically made the work is not the point. He had the *idea* of sending a wealthy man something that he could not buy: the Parisian air. This idea, not the product of the glassblower's skill, was the work of art. The cultural capital of the world was something Arensberg's money could not capture, but Duchamp's imagination could and did. With both *Air de Paris* and *Fountain*, Duchamp was shifting the focus of art from physical craft to intellectual interpretation. The work of art, though consisting of an object manufactured by craftsmen, had been *created* by an artist.

Having drawn a distinction between the *work* of art from the *labour* of manufacture in this way, Duchamp continued to employ strategies that removed the hand of the artist from the production of the physical object. Among these was the use of chance and random acts to generate works that lacked any control or composition on the part of the artist. He also authorized others to manufacture copies of the readymades, including *Fountain*, which now exists only as a number of replicas produced in the 1950s and 1960s. An edition of eight was manufactured in 1964 from glazed earthenware painted to resemble the original porcelain, with a signature reproduced in black paint.

The end of the artist?
Duchamp's readymades are sometimes described as 'anti-art works'. Indeed, it is thought that he even invented the term 'anti-art'. But while he was adamant that he wished to de-deify the artist, he was not against art as such. What he opposed was officially accepted museum art, the aura that surrounded it, and traditional notions of beauty and good taste. In this way, he was very much in tune with his fellow Dadaists in Europe and America, who sought to destroy official culture with their anarchic, anti-bourgeois, iconoclastic activities. They

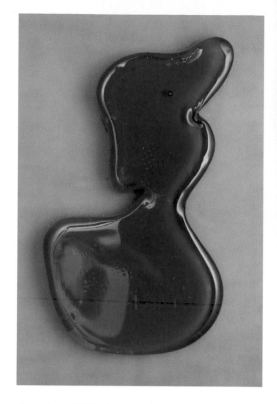

Jean Arp, COLLAGE NO. 2 (GLASS OBJECT), 1964, blue glass form on an opaque glass sheet, 50 x 34.7 x 3 cm, edition 2 of 3

too used Duchamp's term 'anti-art', and spoke about the 'end of art' and of 'destroying art'. But by that they meant art as previously known. According to them, past art belonged to a corrupt materialistic society that had produced the First World War then ravaging Europe. What was required was to destroy the old order and start afresh.

One of the leading figures of the Dada movement in France and Germany was Jean Arp (1886–1966). He is perhaps best known for his biomorphic shapes made from metal and painted wood reliefs. But like Duchamp, he challenged existing notions of art and experimented with spontaneous and irrational methods of artistic creation. He, too, embraced chance as a way of relinquishing control and to depersonalize the creative process. Some time around 1915, he started to produce his 'Chance Collages', which involved tearing up pieces of paper and scattering them onto a flat sheet, pasting each scrap wherever it happened to fall. These arrangements were made 'automatically, without will', according to Arp. 'Like nature, [they] were ordered "according to the laws of chance".'

One of Arp's most important supporters was the American collector Peggy Guggenheim, whose first purchase of a work of art was Arp's brass sculpture *Tête et coquille* (Head and Shell), which she bought in 1937 at Duchamp's suggestion. Guggenheim displayed what eventually became a substantial collection in her villa located on the Grand Canal in Venice, where Arp won the prestigious Grand Prize for Sculpture at the Venice Biennial in 1954. This award and Arp's acquaintance with Guggenheim led the French artist to collaborate with the city's master glassmaker Egidio Costantini (1912–2007). Together the two men created a series of small curved or rounded glass sculptures (*opposite*). Not only did these pieces echo the forms of Arp's earlier biomorphic works, but they also allowed him to have minimal control over the finished object. First, he was employing a craftsman to make it on his behalf; and second, by being led by the flow of molten glass as it cooled, he was once again allowing the rules of chance to determine the work's shape.

Costantini was one of the earliest examples of a modern fabricator: a specialist who is employed by an artist to produce a work or to provide technical skills. He collaborated with many of the

leading artists of the day, including Alexander Calder, Georges Braque, Pablo Picasso, Fernand Léger, Max Ernst, Marc Chagall, Oskar Kokoschka, Lucio Fontana, and others. Before his own glassmaking career, Costantini had been an agent for several Murano glass factories in Venice, which allowed him to learn the intricacies of the trade. He wanted to elevate the craft of glassblowing to the same level as sculpture or painting, and in 1955 he opened the Fucina degli Angeli (The Forge of Angels). After initial success, the Fucina was forced to shut in 1958, but reopened in 1961 thanks to financial help from Peggy Guggenheim. By the 1990s, Constantini was considered the 'master of the masters', a craftsman who could teach anyone how to transform their artistic vision into glass. He quickly earned the trust of the artists with whom he worked, and had considerable freedom to follow his own creative ideas, based on his deep knowledge and sensitivity for glass.

Even so, the works that came out of the Fucina were clearly credited to the artist in the collaboration, not to Costantini. The blue glass form shown on the opposite page is always identified as a 'Jean Arp'; the bronze circular panel with Murano glass bubbles overleaf, which was also produced at the Fucina, is always described as being by Lucio Fontana (1899–1968) – Costantini's involvement is rarely acknowledged. However collaborative the process may have been, and however hands off the artist elected to be, it remained the artist who chose whether to declare the finished object a work of art, and the one who took the credit as its creator. And therein lies the paradox behind Duchamp's and Arp's strategies. Rather than relegating or de-deifying artists, as they claimed to be doing by removing their hand from the process of production, they were in fact elevating them. For without the artist's initial idea or concept, an object is just a mere object; without the artist's intervention, it cannot become art. *Fountain* became

Joseph Kosuth, ANY TWO METER SQUARE SHEET OF GLASS TO LEAN AGAINST ANY WALL, 1965, glass, 200 x 200 cm, metal plaque, 5.8 x 20 cm

a work because Duchamp 'chose' it and signed it with an author's name. What is more, the later copies had to be *authorized* by him. In other words, he remained in control of the work. Despite appearances to the contrary, therefore, his readymades and Arp's 'chance' works secured and enhanced the authority of the artist, rather than diminishing it, as it was suggested.

The legacy of Duchamp
Duchamp's work influenced not only his contemporaries, but also subsequent generations of artists. The Surrealists of the 1920s and 1930s incorporated found objects into their works of art, as did postwar artists such as Robert Rauschenberg and Jasper Johns in the US and the New Realists in France, including Arman, Jean Tinguely and César. Similarly, Conceptual Art in the mid-1960s adopted many of Duchamp's ideas and strategies, and pushed them to their limit. Joseph Kosuth (b. 1945), in particular, was inspired by Duchamp's challenge to existing notions of art. As he explained in 1969, 'The "value" of particular artists after Duchamp can be weighed according to how much they questioned the nature of art.'

Kosuth's art and writings ask those very questions. Like Duchamp, he often uses readymade objects. In a series of early pieces, he took industrially made panes of glass and had them placed around a gallery space. In his essay 'Art after Philosophy' (1969), he argued that art was the continuation of philosophy, which he saw as having come to an end. To him, Duchamp's most important assertion was that art could be an idea. This 'change from "appearance" to "conception" ...[was] the beginning of "conceptual art".' One of his most famous works is *One and Three Chairs*. The piece features a chair, a photograph of that chair, and the dictionary definition of the word 'chair'. As Kosuth explained in 1970, 'I used common, functional objects – such as a chair – and to the left of the object would be a full-scale photograph of it and to the right of the object would be a photostat of a definition of the object from a dictionary. Everything you saw when

you looked at the object had to be the same as that you saw in the photograph, so each time the work was exhibited, the new installation necessitated a new photograph.… It meant that you could have an art work which was that idea of an art work, and its formal components weren't important. The expression was in the idea, not the form – the forms were only a device in the service of the idea.'

Like Duchamp, Kosuth sought to remove the hand of the artist and rejected any sense of his composing the work: 'Since I saw the nature of art to be questioning the nature of art, I felt the form the work took shouldn't end the questioning process, but begin it.… So the photographs used were always clean, cool, factual, almost scientific – as uncomposed as I could manage, and always taken by someone else, in order

to make clear that they were art in their use (in relation), not through the aesthetic choice, composition or craftmanship.' However, here we see a paradox similar to that in Duchamp's 'de-deification' of the artist: to avoid making any aesthetic choice apparent in the work, Kosuth must make just such an aesthetic decision by choosing to have another person take the photographs and create an 'uncomposed', scientific look. However objective these works may seem, they are the result of a subjective artistic decision that they should appear that way.

Influenced by both Duchamp and the early conceptualists, American artist Sherrie Levine (b. 1947) makes authorship and originality the subjects of her work. She practices a form of appropriation art, taking elements of the work of other artists – sometimes reconfiguring them, sometimes simply re-presenting them in a different context. A frequent technique is to re-photograph art works by other artists, always men. Levine often quotes entire works, for example photographing the photographs of Walker Evans. She also commissions fabricators to produce sculptural pieces that quote the works of other artists, such as her pool table *Fortune (After Man Ray)*, which refers to a painting by the Surrealist. She has also had many works manufactured for her that directly reference Duchamp, including her own versions of *Fountain*. Challenging ideas of the author, authorship and authority, and drawing attention to the connections between power, gender and creativity, consumerism and commodity value, and the social sources and uses of art, Levine plays with the theme of 'almost same'.

Though taking a very different form from Levine's work, the 'Compressions' of French artist César (César Baldaccini, 1921–98) explore many of the same issues. Beginning in 1960, César hired a crushing machine operator to compress found materials and detritus, including scrap cars, discarded metal and other junk, to produce startling sculptures. Like the work of appropriation artists and others who use readymade or found objects, César's practice questioned the

values of consumerist and throwaway society. Later in life, he produced a number of works with Egidio Costantini from glass Coca-Cola bottles that appear to have been squeezed into compact shapes as if they were plastic. An antidote to pop art's celebration of the power of consumer brands, César's 'crushed' bottles also challenge the very idea of the Duchampian readymade, which here has been screwed up like rubbish ready to be thrown away.

The resurrection of the author?

Like many of those in this book, Levine and other appropriation artists have been heavily influenced by the writings of French theorist Roland Barthes. In 1967, Barthes declared 'the death of the author' in a seminal essay that argued an author's intentions or biographical context should form no part of the reading of a text. According to Barthes, 'To give a text an Author', and assign a single, corresponding interpretation to it, 'is to impose a limit on that text.' Rather, each piece of writing contains multiple layers and meanings, drawn from 'innumerable centers of culture', not from one, individual experience. The meaning of a work depends on the impressions of the reader, rather than the 'passions' or 'tastes' of the writer; 'a text's unity lies not in its origins', or its creator, 'but in its destination', or its audience. Every work is 'eternally

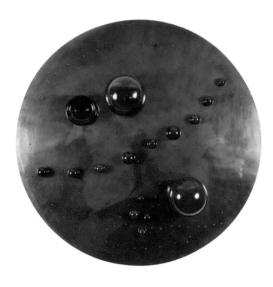

ABOVE **Lucio Fontana**, PANNELLO, 1965, 15 Murano glass bubbles and a glass bowl on copper panel with holes, 124.5 cm diameter x 6 cm

ABOVE RIGHT **César**, COMPRESSION, 1992, glass bottles, 37 x 23 x 24 cm

OPPOSITE, TOP **Olaf Nicolai**, CELIO, 2004, aluminium, acrylic glass, 130 x 90 cm

OPPOSITE, BOTTOM LEFT **James Lee Byars**, IS, 1989, gilded marble, 60 x 60 x 60 cm

OPPOSITE, BOTTOM RIGHT **Subodh Gupta**, ET TU, DUCHAMP?, 2009, black bronze, 114 x 88 x 59 cm

written here and now' with each re-reading, because the 'origin' of meaning lies in 'language itself' and its impressions on the reader. It is the reader who 'writes' the text; and by extension, the viewer who generates the art work. Barthes's use of the concept 'scriptor', rather than 'writer', to identify the person who actually lays down the words echoes 'fabricator'. Both terms indicate that the meaning of a work is not determined by the mere maker.

Barthes's essay removed both authority and authorship from artists and writers, declaring, 'A text is not a line of words releasing a single "theological" meaning (the "message" of the Author-God), but a multi-dimensional space in which a variety of writings, none of them original, blend and clash.' According to Barthes, no author or artist creates anything new or unique. Instead, everything is a recycled regurgitation of that which preceded it.

This theory has had a huge impact on the visual arts, and its influence can be seen throughout this book. But different artists have responded in very different ways. On one hand, some take it to mean that it is impossible to assert authorship of a work. If all cultural products are simply a reworking of all that came before, then no one can claim to have produced an original work of art at all. Instead, proponents of this view favour the readymade or appropriated object as being more open, transparent and honest. By acknowledging the appropriation that occurs within the production of all art, these artists use the power of pre-existing imagery and signs to produce 'new' works whose

purpose is to reveal the very processes of generating meaning that lie within and beyond the art work.

On the other hand, some have taken the 'death of the author' as a liberation from the tasks of production, one that resurrects and preserves the authority of the artist. If the intentions or context of the actual maker are irrelevant to a work's meaning, then why get your hands dirty with the making? Anyone can produce the work for you; its *authorship* lies elsewhere. Jeff Koons, Damien Hirst and Takashi Murakami clearly fit into this category, with their hundreds of assistants producing the work of 'the artist' in factory-like conditions, and so do most of the artists in the book, including Olaf Nicolai, who employs others to make his works to precise instructions and measurements. (In the work shown above, Nicolai refers to Duchamp's *Fresh Widow*, thus adding an element of appropriation for good measure.) Unlike artists who make things, whose spaces are traditional studios filled with all manner of materials, many artists in these pages work from offices, rather like an architect or film director.

Closing the circle
In the end, like two opposing ends of a spectrum brought together to form a perfect circle, these contradictory positions come back to the same point: that art lies not in the making of an object, but in the naming of it as art. The perfect circle and sphere were favourite motifs of the American artist James Lee Byars (1932–97), whose work appears several times in this book. His

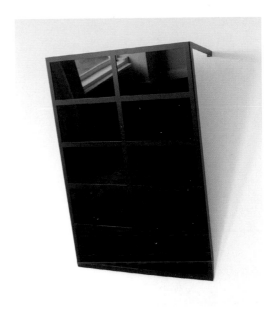

diverse practice, which incorporated sculpture, performance, installations and many other forms, not only reflects the current state of artistic production as one of flux, a place where many working methods are equally valid; it also contains similar contradictions to those we have identified here. He admired Duchamp, but acted as a shaman-like artist—priest, the antithesis of Duchamp's de-deified artist. He asserted the authenticity of his own artistic quest for perfection, while employing others to make his works for him, such as his gilded marble pieces (produced in a Giza workshop). And he sought out the eternal in his art, while declaring in 1978 that 'I cancel all my works at death', the opposite but also the corollary of Duchamp's nominalism.

Like many artists in this book, then, Byars returned to the example of Duchamp only to interrogate it in light of developments in theory and practice, such as conceptualism, appropriation art, and the death of the author. Subodh Gupta's sculptural version of Duchamp's *L.H.O.O.Q.* exemplifies this approach and points to the paradox in Duchamp's strategies. Made by a bronze foundry in London, it highlights the Frenchman's influence on artists who do not physically make their own work. But at the same time, it asserts the artist's right to claim authorship by pointing an accusing finger and asking 'Et tu, Duchamp?' It is a question that lies behind every work in this book.

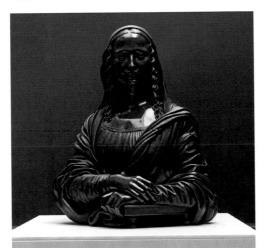

Ai Weiwei · Per Barclay · Jennifer Bartlett · Guðrún Benónýsdóttir · Barbara Bloom · Christine Borland · Daniel Buren · James Lee Byars · Chen Zhen · Tony Cragg · Richard Deacon & Bill Woodrow · Jan Fabre · Anya Gallaccio · Ryan Gander · Mona Hatoum · Roni Horn · Shirazeh Houshiary · Ann Veronica Janssens · François Morellet · Jean-Michel Othoniel · Jorge Pardo · Simon Periton · Michael Petry · Robert Rauschenberg · Tobias Rehberger · Maria Roosen · Silvano Rubino · Daniela Schönbächler · Shan Shan Sheng · Kiki Smith · Koen Vanmechelen · Not Vital · Pae White · Fred Wilson · Hermione Wiltshire · Cerith Wyn Evans

Glass

The use of glass to make decorative as well as practical objects has a long history going back to the ancient world. Glass was extensively developed in Egypt and further refined by the Romans, who spread the techniques of glassblowing in particular after its invention around 50 BC. The material's use in the visual arts dates back at least as far as the great stained glass windows of medieval European cathedrals, which remain influential on contemporary artists such as Gerhard Richter, Shirazeh Houshiary, and others who in recent years have produced window designs for churches.

From the nineteenth century, glass was used extensively in the decorative arts. Art Nouveau made great use of the material, producing coloured vases and similar pieces, often in cameo glass and using lustre techniques. In America, Louis Comfort Tiffany specialized in stained glass in panels and his famous lamps. From the start of the twentieth century, some glass artists began to consider themselves in effect sculptors working in glass, and as part of the fine arts.

With the emergence of Modernism, there was a broadening of artistic media, and glass became part of the curriculum at progressive art schools such as the Bauhaus in Germany. During the 1950s, studio ceramics and other craft media gained in popularity and importance in the United States. The 'studio glass movement' began in 1962 when Harvey Littleton, a ceramics professor, and Dominick Labino, a chemist and engineer, held workshops at the Toledo Museum of Art, during which they experimented with melting glass in a small furnace and creating blown glass art, thus being the first to make molten glass available to artists working in private studios. This approach to glassblowing grew into a worldwide movement, and today there are many art institutions around the world offering glassmaking resources. As artists began to see glass as a medium with which to experiment in the 1960s, the field expanded and makers of distinction developed their techniques to produce sculptural and two-dimensional works that further blurred the boundaries between art and craft.

Many of the great glass ateliers have worked with contemporary artists. One of the celebrated firms to do so is the Steuben Glass Works in Corning, New York, which was founded in 1903 and has produced art works for a range of artists, including Kiki Smith. 'I have worked with Max Erlacher at Steuben Glass', Smith explains. 'I give him drawings, which he engraves. Then the pieces come back to me and I line etch on top of his work. What he does is make an interpretation

of my drawings.' Generally, Smith tries to control the level of input from her collaborator. 'I like to make things that are neutral so that the hand of the glassblower is not in the work. I use geometric shapes like tear drops, so the pieces are not specific to the blowers. Sometimes the boundaries get blurred, as with Max at Steuben.' At other times, the collaboration is more of a two-way process: 'I am completely happy with suggestions,' she says. 'I made a vase at Steuben "out of ignorance." The engraving that came out of it was completely new. Ignorance facilitates you moving further.' And, similarly, working with Smith has had its impact on the glassmakers: 'It influences them, and adds things to their vocabulary, and sometimes they then want to use those new ideas in their own work.'

Based on Murano, an island near Venice, the Berengo Studio represents one of the more innovative efforts to encourage the use of glass in contemporary art. Glass from Murano (also known as Venetian glass) is the result of hundreds of years of refinement and invention, and Murano is still held as the birthplace of modern glass art. Since the 1980s, the studio's founder Adriano Berengo has invited dozens of international artists to use glass in their experiments. Berengo is striving to change people's perceptions of glass as a functional material, and of Murano glass as purely decorative, and to make it a vibrant medium for artistic expression. To date, almost one hundred and fifty international artists have come to the Berengo furnace to create glass sculptures, and the Studio now has works in numerous public and private collections throughout the world.

Perhaps the best-known name associated with international glass art is the American artist Dale Chihuly. A highly controversial figure, he is often regarded as a 'mere' craftsman by the art world, and yet from the beginning of his career, while blowing glass himself, he also commissioned others to create his large-scale installations, supervising the production like a film or theatre director. In 1976, Chihuly was involved in a car accident and lost the sight in one eye, and three years later he was injured in a surfing accident, meaning he could no longer make his work himself. Despite this fact, he has since created a huge number of sculptures, hiring others to do the work. Chihuly explained the change in a 2006 interview, saying 'Once I stepped back, I liked the view.' He claimed it allowed him to see the work from more perspectives and enabled him to anticipate problems faster. 'I am more choreographer than dancer, more supervisor than participant, more director than actor.'

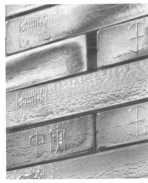

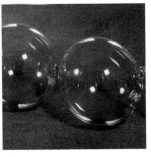

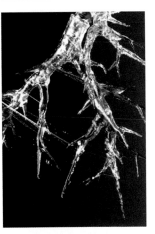

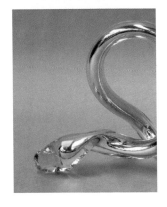

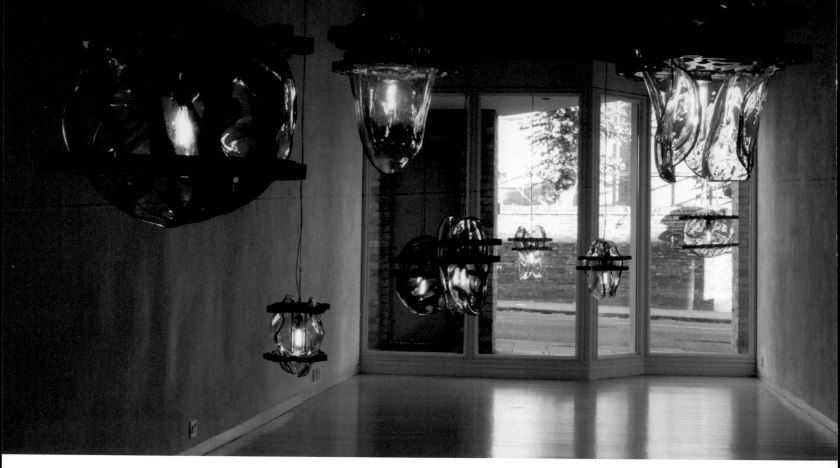

ABOVE AND OPPOSITE TOP **Jorge Pardo**, <u>UNTITLED</u>, 2005, glass, mdf, metal screws, light bulbs, dimensions variable

California-based Pardo (b. 1963, Cuba) presents furniture-like objects that investigate the nature of the art exhibition and look at how the manner and place in which an artefact is displayed changes our perception of it. His work ignores the conventional distinctions between design, architecture, and art. Instead, he combines all of these fields to create installations that question authorship and originality. He designs most of the objects himself, but also shows them alongside design classics to blur the boundary between his creations and those of others. His *Untitled Lamps* seen here resemble 1970s designs found in secondhand stores. They were conceived by the artist, but fabricated by specialist manufacturers on the Isle of Wight and Pardo's assistants in Los Angeles.

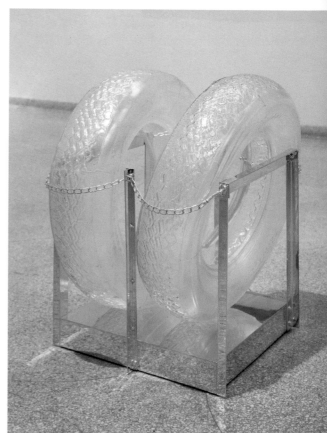

Robert Rauschenberg, <u>UNTITLED [GLASS TIRES]</u>, 1997, blown glass and silver-plated brass, 76.2 x 71.1 x 61 cm

With this late work, pop artist Rauschenberg (1925–2008, US) returned to a motif he had employed earlier in his career. *Automobile Tire Print* of 1953 was a 23-foot-long print made in collaboration with the composer John Cage using a car tyre and paint. Four years later, *Monogram* featured a stuffed ram with a tyre around its belly (a coded statement about his homosexuality). Rauschenberg had this glass version of the object fabricated at the Urban Glass company in Brooklyn, New York. It was produced under the supervision of sculptor Lawrence Voytek, who was Rauschenberg's director of art production for over twenty-five years.

BELOW **Ann Veronica Janssens**, <u>OBJECT</u>, 2008, uranium glass, 100 x 100 x 20 cm, edition of 7

Belgian artist Janssens (b. 1956, UK) uses light, colour, sound and objects to create works that heighten awareness of space, body and movement. In 2008, she employed Jan-Willem Van Zijst of Fenestra Ateliers in Belgium to produce glowing blocks of uranium glass. They were made by cooling melted glass on cold metal to create a unique rippled surface. The piece was produced with Brussels-based D&A Lab, which works with artists to explore the boundaries between art and design, aesthetics and functionality. The Lab mixes innovative methods and high-tech materials with traditional techniques to produce limited-edition objects.

'I don't think that art gets made with your hands.'

Jorge Pardo

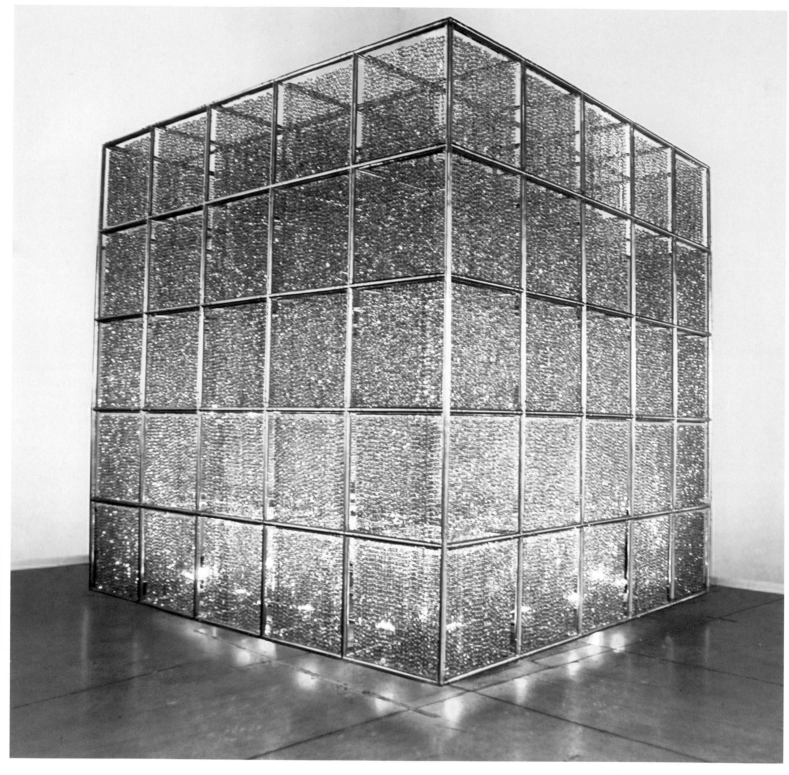

'In the end, it's not important whether an idea was the artist's or someone else's. The point is that you have created something new.'

Tobias Rehberger

ABOVE **Ai Weiwei**, <u>CUBE LIGHT</u>, 2008, glass crystals, lights and metal, 414 x 400 x 400 cm
China's most controversial artist, Ai (b. 1957, China) employs craftsmen to create playful works that reinterpret artefacts from Chinese culture. One of several chandelier pieces, *Cube Light* is made of 170,000 amber-coloured glass beads.

OPPOSITE **Tobias Rehberger**, <u>OUTSIDERIN</u>, 2002, light installation at the Museum of Contemporary Art, Karlsruhe
Rehberger's (b. 1966, Germany) installation comprised hand-blown glass made by the German company Glasmanufaktur Harzkristall. The lamps were connected to sensors outside and constantly changed in reaction to exterior light levels.

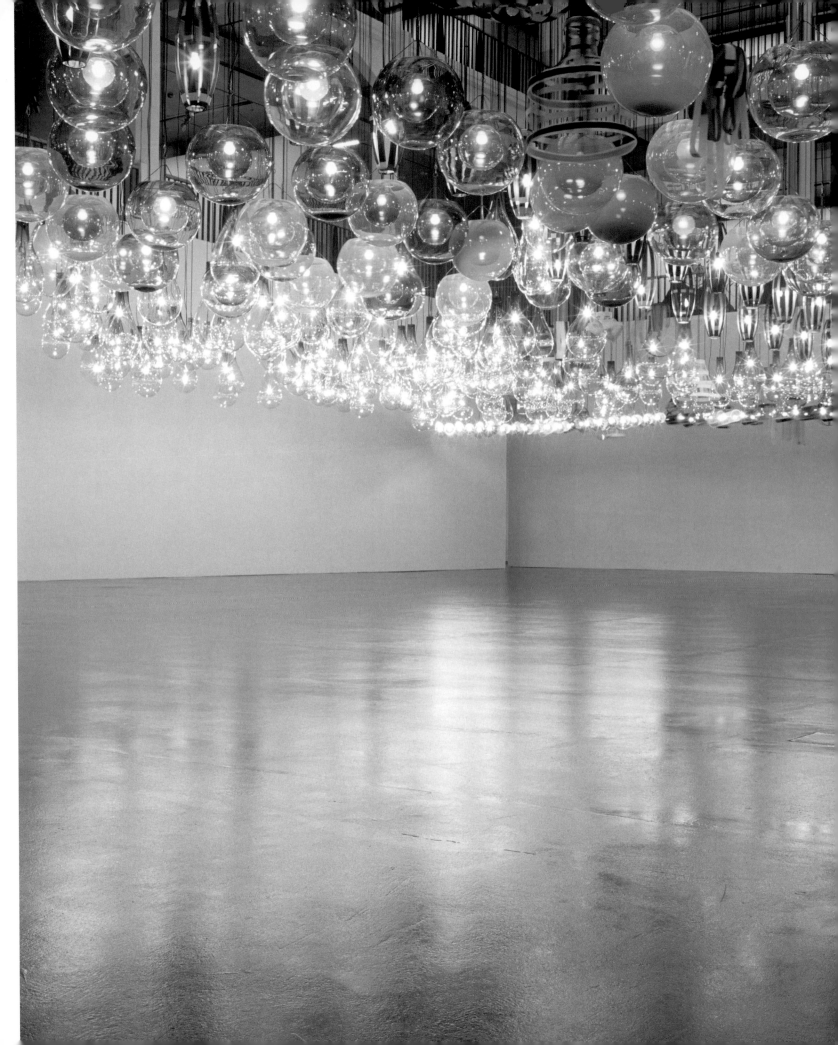

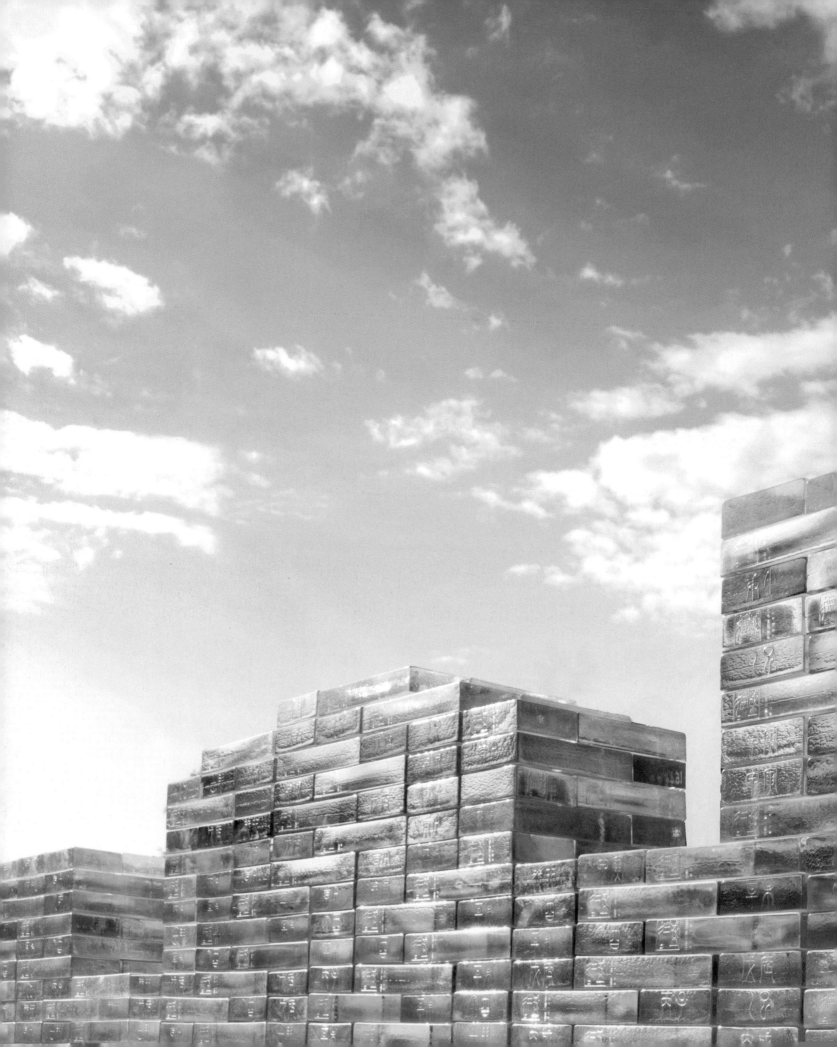

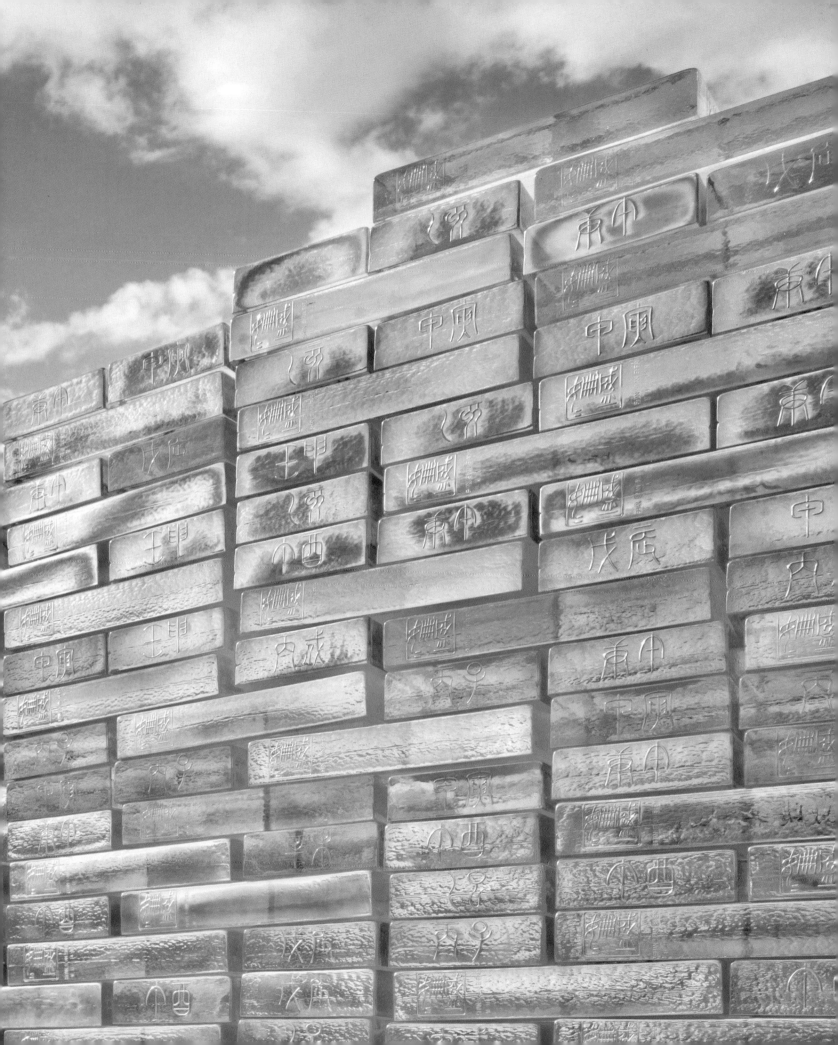

Shan Shan Sheng, <u>OPEN WALL</u>, 2009, Murano glass bricks, approx. 2000 x 200 x 80 cm

Shan Shan Sheng (b. 1957, China) was the first Chinese artist to be invited to work with the glass experts of Murano, an island near Venice renowned for a glass tradition that extends back over a thousand years. Constructed of 2,200 stacked glass bricks, corresponding to the number of years it took to build the Great Wall of China, *Open Wall* was displayed along the Grand Canal during the 2009 Venice Biennale. It acted as a threshold between water and sky, past and present, and Venice and China. Crafted from clear, iridescent or red/gold glass, each brick was engraved with a date signifying a historical moment during the Great Wall's construction, and its equivalent Chinese lunar year. The glass was made by the Berengo Studio, with whom Shan Shan Sheng has worked since 2000.

TOP LEFT **Pae White**, <u>SHIP TO SHORE</u>, 2003, blown glass bricks, dimensions variable

BOTTOM LEFT **Pae White**, <u>BLUE HAWAIIAN</u>, 2003, blown glass bricks, dimensions variable

White (b. 1963, US) works at the crossroads of art, design and architecture. She transforms common objects, giving them a quality that transcends their everyday function. She enjoys the surprises that can come from allowing others to produce the objects used in her work. 'I have fabricators in different parts of the world', she says. 'I am interested in the interpretation; I am interested in something coming from Lithuania that's not exactly what I thought it was going to be.'

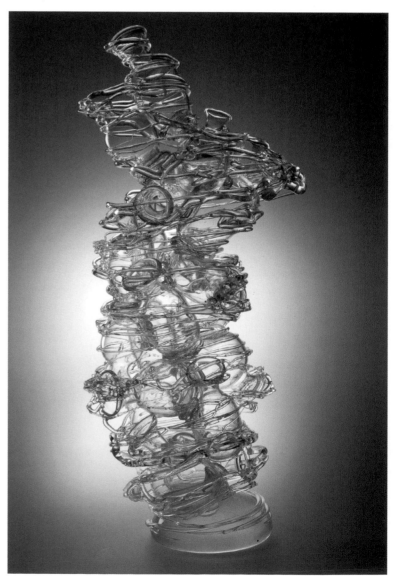

BELOW **Mona Hatoum**, <u>WEB</u>, 2006, crystal balls and metal wire, dimensions variable
Palestinian artist Hatoum (b. 1952, Lebanon) is attracted by the contrasting qualities of glass: it is transparent yet impermeable; fragile but potentially dangerous. Her impressive *Web*, a giant network of wire and glass balls, interacts with the architecture of its setting, changing size with each installation to fit the space. Here the work is pictured at Galleria Continua in San Gimignano, Italy, for which it was conceived. The crystal balls were hand blown to Hatoum's design by glassmakers from Colle di Val d'Elsa, a Tuscan town that has specialized in the production of lead-crystal glass since 1331.

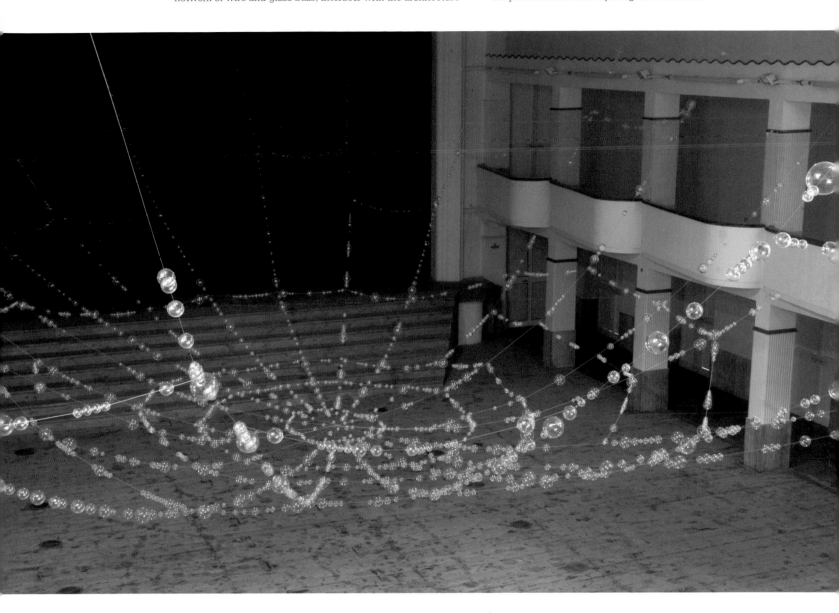

OPPOSITE RIGHT **Tony Cragg**, <u>VISIBLE MEN</u>, 2009, Murano glass, 67 x 16 cm
Cragg (b. 1949, UK) worked directly with the Berengo master glass craftsmen to realize this highly complex glass work. The piece was commissioned for the 'Glasstress' exhibition, organized by Murano glass producer Adriano Berengo at the Istituto Veneto di Scienze, Lettere ed Arti – Palazzo Cavalli-Franchetti as part of the 53rd Venice Biennale. The work mirrors the action of its making and complements Cragg's recent larger works in metal, stone and wood.

James Lee Byars, <u>THE ANGEL</u>, 1989,
125 glass globes, each 20 cm diameter
One of the twentieth century's most enigmatic
artists, Byars spent a lifetime searching for
perfection – or at least the *idea* of perfection.
He is best known for his performance art and
sculptures based on minimal, mathematical
and mystical forms and symbolic materials.
He had circles, cylinders and spheres fashioned
for him from the finest marble, gold, roses
and glass. His search for perfect beauty led
him to seek out highly skilled craftspeople
from around the world who could produce
his conceptual ideas to exacting standards.
No doubt realizing the impossibility of such
a quest, he nonetheless opened up a space
between the ideal and the real that created
considerable artistic tension. In this important
late work, the Japanese *kanji* character for
'angel' is constructed out of 125 Murano glass
spheres, each one hand blown using a single
breath of the maker. The anthropomorphic
and symmetrical shape of the work, with its
four limbs and spine, alludes to the Platonic
idea that sphericity is the essence of the
human soul.

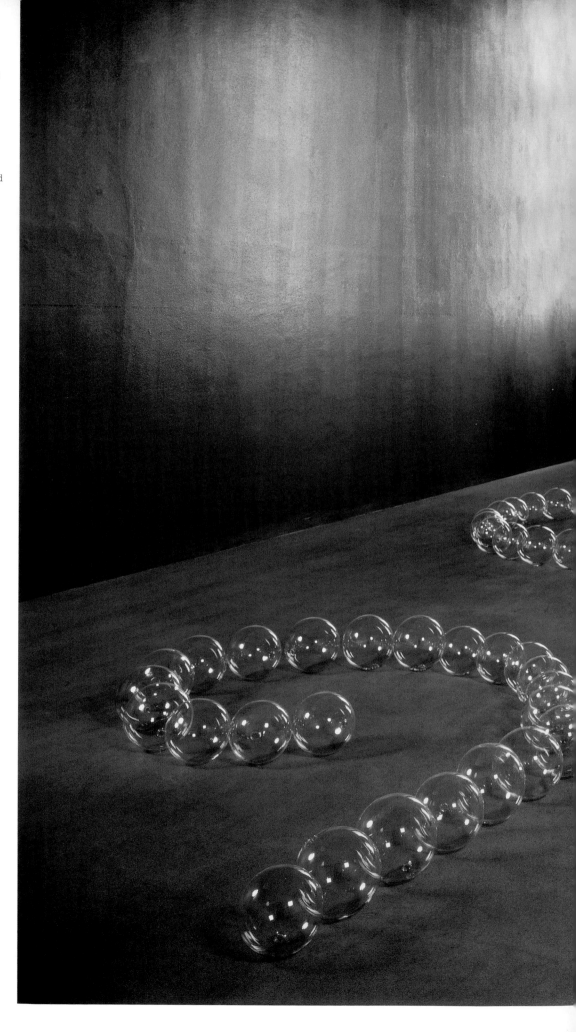

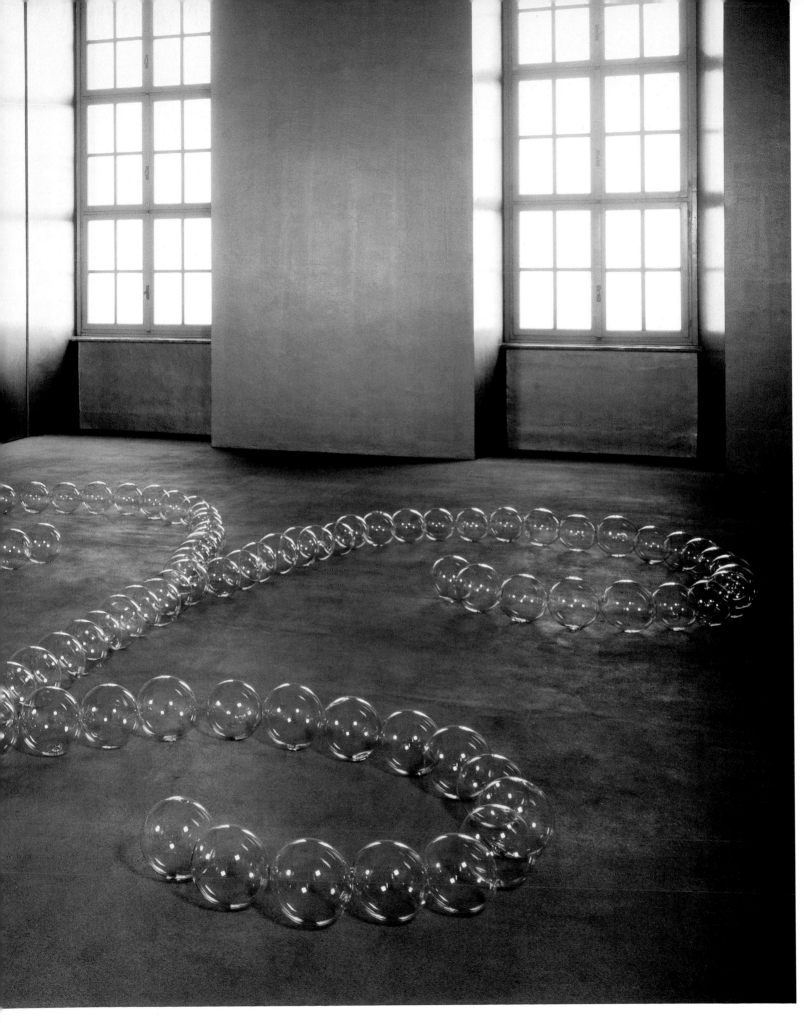

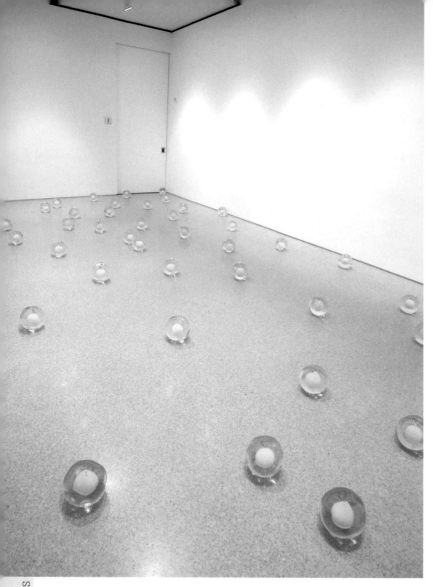

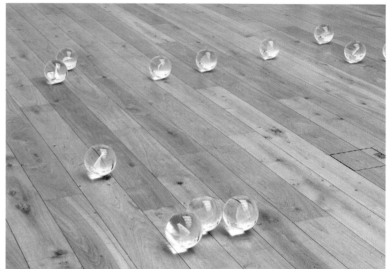

BELOW **Ryan Gander**, A SHEET OF PAPER ON WHICH I WAS ABOUT TO DRAW, AS IT SLIPPED FROM MY TABLE AND FELL TO THE FLOOR, 2008, 100 crystal balls, each 15 cm diameter, edition of 3

British artist Gander (b. 1976, UK) uses humour in his complex and often conceptual art. He works in a space between fact and fiction, deliberately blurring the lines to question the nature of authorship, originality and documentation. This piece, produced for a show at the South London Gallery in 2008, features crystal balls dispersed around the gallery floor. Each sphere is internally laser etched with a suspended image of a sheet of blank paper floating in it. The work was made at the Lee Laser factory in China. The piece ponders the possibility of making, and asks if the paper had not fallen, what might have been drawn or painted on it? Ripe with potential, the work alludes to the 'what if' of the creative process, the fugitive nature of thought and inspiration.

ABOVE **Not Vital**, 50 SNOWBALLS, 2001, Murano glass, variable sizes

Not Vital (b. 1948, Switzerland) lives a nomadic life between New York, Sent in his native Switzerland, Lucca in Italy and Agadez in Niger, each site having a distinct influence on his production. His art is characterized by a play of contrasts, opposites and ambiguities, and often mixes figurative elements with abstract forms, utmost sincerity with absurd humour. He juxtaposes materials with deep roots in art history, such as glass, bronze, marble, silver and gold, with organic matter including dung or animal carcasses. He frequently commissions craftsmen from his adopted habitats to produce his work, including silversmiths from Niger and woodcarvers from Switzerland. *50 Snowballs* was made by the master glassmaker Pino Signoretto at Vetreria Pino Signoretto, in Murano. Each snowball is unique and is formed of a clear glass outer layer protectively surrounding what appears to be a snowball (of white glass) inside, creating a paradoxically frozen image in glass of an object predestined to melt away.

RIGHT **Guðrún Benónýsdóttir**, LAVA DIAMOND, 2000, cast Icelandic lava, each unique, approx. 9 x 9 x 9 cm

Benónýsdóttir's (b. 1969, Iceland) *Lava Diamonds* function as a critique of kitsch tourist souvenirs (in Iceland, lava is often formed into cheap holiday mementos such as fish, seals and whales). She worked with Germain Ngoma in the casting workshop of the Visual Art Academy in Oslo (KHIO) to make ceramic shell forms, which were then cast by the renowned New Zealand-based fabricator David Reid.

'I don't make stuff, I alter it. I don't have the handmade element.... What I do as an artist is talk on the phone, and work with the craftsperson who produces what I want and make sure they do it right. There is no messy room; I work in my home.' Barbara Bloom

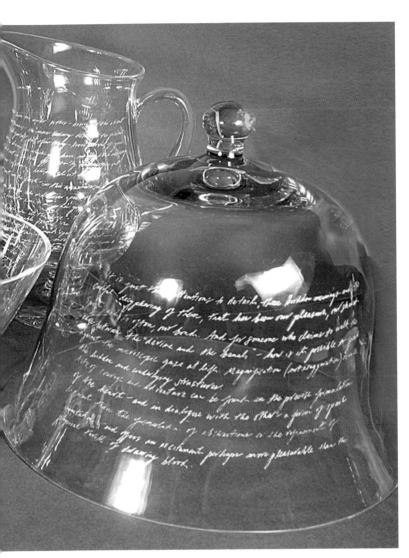

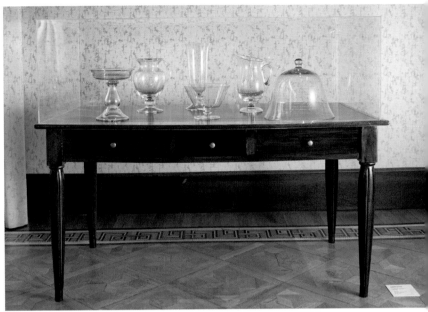

BELOW **Chen Zhen**, <u>CRYSTAL LANDSCAPE OF INNER BODY</u>, 2000, crystal, iron, glass, 95 x 70 x 190 cm (detail)
The work of Chen (1955–2000, China), who died from a rare blood disorder, addressed the fragility of the body and his own struggle with an incurable disease. For this work, he asked glassmakers to produce organs and a 'surgical bed'.

ABOVE AND TOP RIGHT **Barbara Bloom**, <u>FLAUBERT LETTERS II</u>, 1987–2008, six engraved glass objects, dimensions variable, edition of 3
Bloom (b. 1951, US), who often commissions or collects objects that date – or appear to date – from earlier periods of history, created this work for the 'Glasstress' exhibition organized by Adriano Berengo. Each object has been engraved with fragments of letters from Gustave Flaubert to his lover the poet Louise Colet, or ones written to Flaubert by Bloom herself.

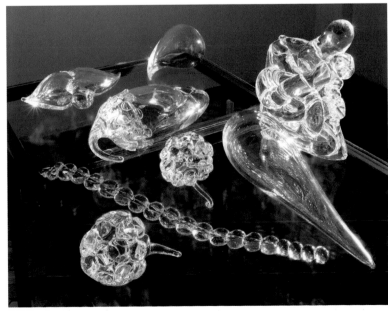

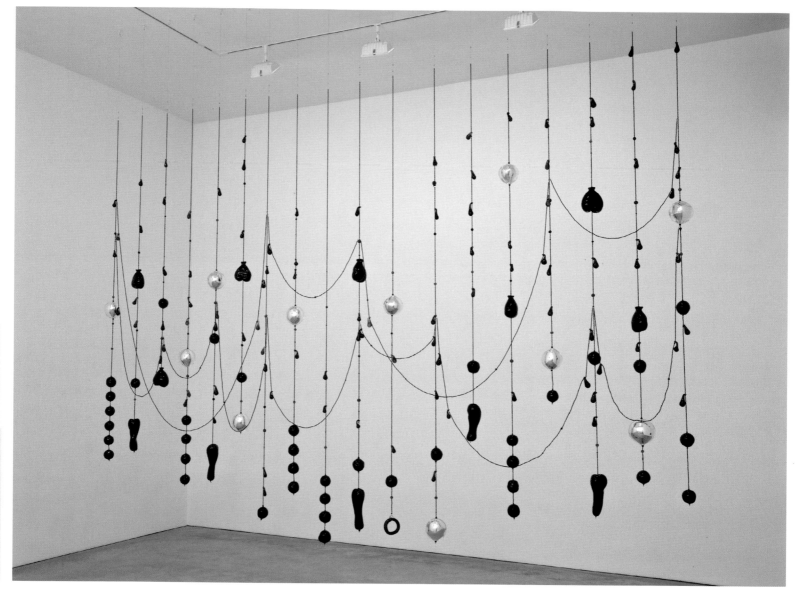

ABOVE **Jean-Michel Othoniel**, <u>BLACK HEARTS – RED TEARS</u>, 2007, black, red and mirrored glass, metal cable, 391.2 x 431.8 x 12.7 cm
Othoniel (b. 1964, France) is interested in the erotics of glass, which for him come from its state of permanent flux as a fluid in flow. He has created a large series of sculptures that are monumental but oddly intimate, and that resemble oversized bracelets or necklaces. He has often worked with Venetian glassblowers and the International Center for Research in Glass and Art (CITVA) in Marseilles, creating seductive forms that are situated between fine art, architecture and craft. His *Black Hearts – Red Tears* forms a sort of screen featuring what appear to be glass anal beads, sex toys and testicles. The work references the artist's same-sex identity in an abstract yet erotically charged way, while remaining an object that is also highly decorative. Works such as this directly address the gulf between the fine arts and crafts in the Western tradition.

OPPOSITE **Fred Wilson**, <u>IAGO'S MIRROR</u>, 2009, Murano glass, 203.2 x 123.8 x 26.7 cm, edition of 6 + 2 artist proofs + 1 final proof
Born to an African-American father and a Caribbean mother, Wilson (b. 1954, US) has long investigated race, culture and gender issues in his work. He normally uses objects made by others in his work, as well as designing pieces to be fabricated. 'I get everything that satisfies my soul, from bringing together objects that are in the world, manipulating them, working with spatial arrangements, and having things presented in the way I want to see them.' In 2003, he was selected to be the US representative at the 50th Venice Biennale. For the show, he had a series of pieces in black glass made by the Berengo Studio, including *Iago's Mirror*, not only a reference to the treacherous character in Shakespeare's *Othello*, but also a way of contrasting the traditions of Venetian opulence with the contemporary reality of African migrants selling fake luxury goods on the streets of the city.

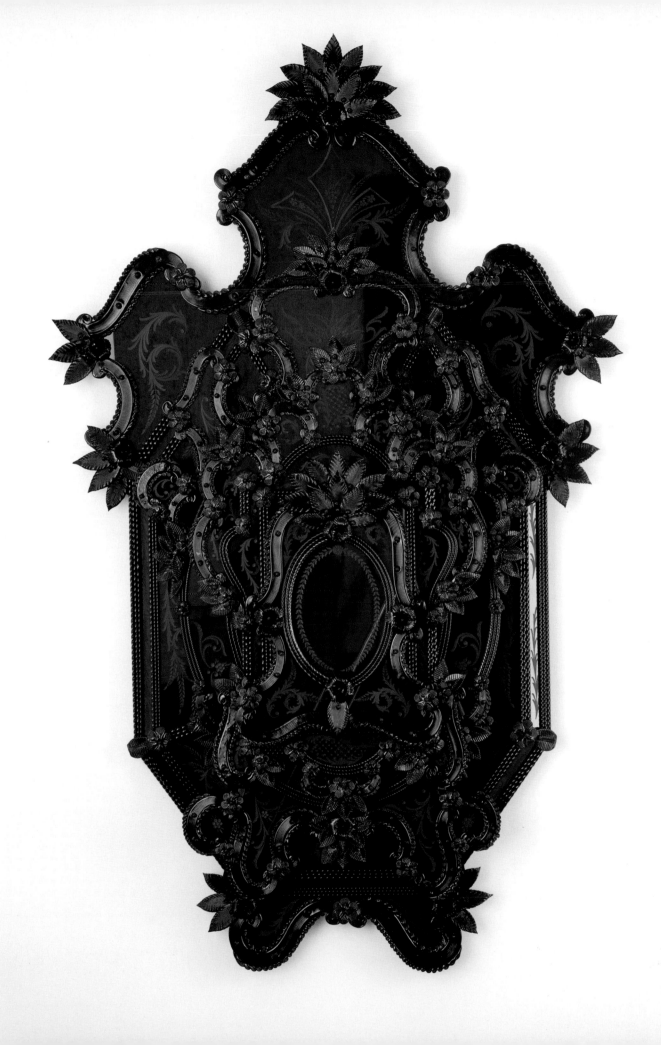

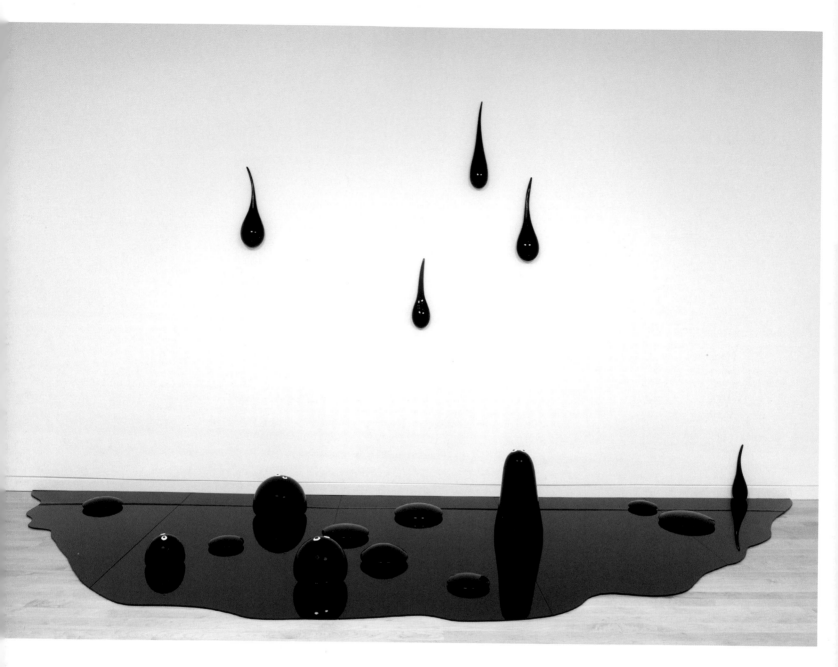

ABOVE **Fred Wilson**, DARK DAWN, 2005, blown glass and plate glass, installation dimensions variable

Wilson first worked with glass when he was invited to the Pilchuck Glass School in Seattle in 2001. There he collaborated with Dante Marioni, one of the best-known glassblowers in the US. He explains his motivation: 'I wanted to use materials that were extremely difficult to make art with, because they're so heavily laden with other issues – the notion of craft. Unfortunately, the art world grades objects in terms of whether they're high art.... I view it as a personal challenge to see what I can do with these materials. The glass was difficult because I knew nothing about its properties and had to work with a glassblower. Luckily, my idea worked well in glass and [Dante] enjoyed making those forms.' *Dark Dawn* is one of the later works blown by Marioni. Its droplike forms refer not only to tears of slavery, as Wilson has often done, but also to oil. The plate glass on the floor reinforces this idea by resembling the toxic liquid oozing around the wide-eyed black figures.

OPPOSITE **Kiki Smith**, TEARS, 1994, glass, 50 units, each approx. 11.4 to 36.8 cm in length, installation dimensions variable

Fellow American artist Smith (b. 1954, West Germany) began her career in the 1980s creating sculptural works that explored the body and mortality. In the 1990s, she evolved her practice to include floor pieces that continued to address body-related themes. She works in a wide variety of materials, including wax, bronze, ceramics and paper. But she has also produced many pieces with master glassmakers, including *Tears*, which was made with clear glass so that the viewer 'could see what was inside'. For Smith, each collaboration with a maker is an opportunity. 'Each stage affords you the possibility to have a different interaction. They might say "what about turning this sideways?" The work comes out of your intention, but it is definitely a collaboration.' However, Smith is careful to control the process. 'I always want them to keep a plainness to their work. You don't want to wonder if it is your work at the end.'

'When someone else makes your work, who they are goes into it as well. If they're connected to it, the fabricator can develop a wonderful relationship with the artist.... Each person brings a different talent and aspect to it. It can take you in another direction.' Fred Wilson

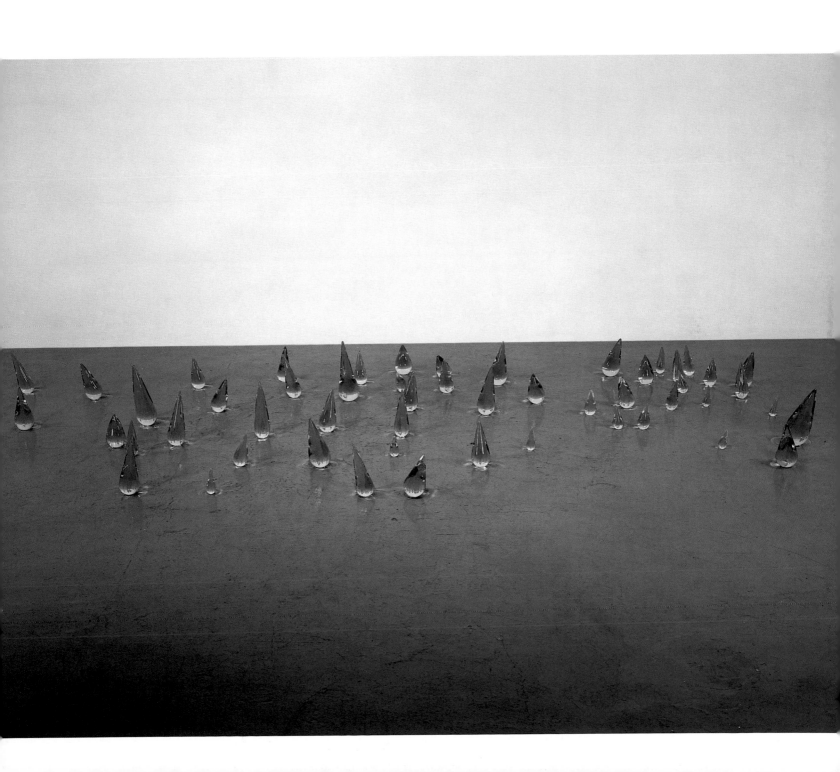

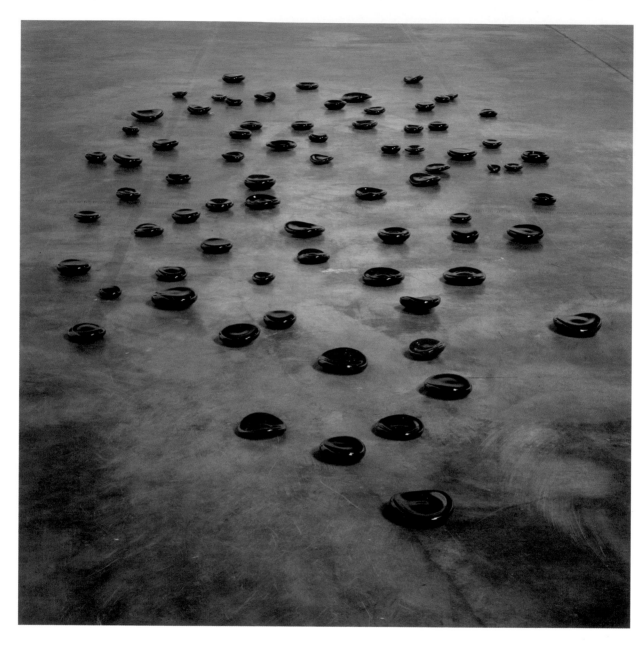

ABOVE **Kiki Smith**, RED SPILL, 1996, glass, 75 units, each
approx. 19.1 x 17.8 x 5.1 cm, installation dimensions variable
One of Smith's earliest attempts with glass was *Untitled*
of 1989–90, which involved her and her assistant moulding
hundreds of oversized spermatozoa and casting them in Schott
glass, used to make spectacles. 'It took a year and a half because
the pieces kept breaking. It was sort of a folly, but it was
something I really wanted to do, so we slogged through and
persevered.' Today, having produced many works in glass, she
does not yet consider herself a master: 'Glass is a real craft and
not something you can just pick up.' So when she needs help,
she enlists the support of skilled craftspeople, enabling her to
go on to create expansive floor pieces such as *Red Spill* and *Shed*.

OPPOSITE **Kiki Smith**, SHED, 1996, glass, 43 units, each approx.
26.7 x 9.5 x 10.2 cm, installation dimensions variable
Smith has collaborated many times with the masters of Steuben
Glass Works in upstate New York, including Max Erlacher,
who has worked as an engraver at the company since he came
to the US from Austria in 1957. 'Working with masters like Max
is the great pleasure of my life,' she says. 'I love working with
others who know more than I do. They make technical and
creative suggestions. Different generations see things
differently.' But getting others to understand her aesthetic
is sometimes a challenge. 'Kiki asked me to forget everything
I know about engraving,' Erlacher says. 'Ultimately we came up
with something that's never been done before – a new style.
At first I thought it looked primitive, but now I realize it's terrific.'

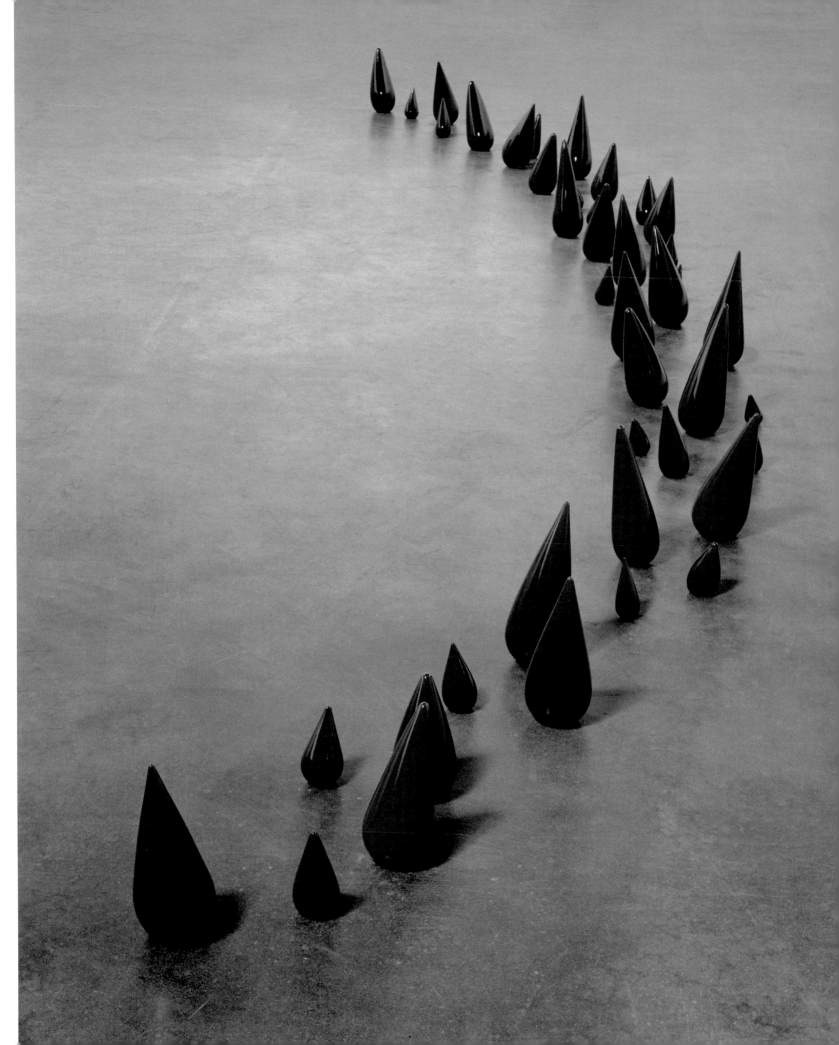

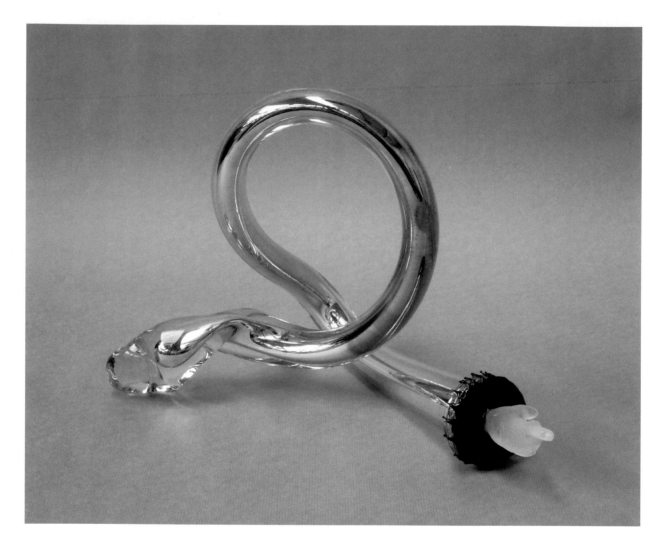

ABOVE **Bill Woodrow & Richard Deacon**, <u>BOUTEILLE DE SORCIÈRE 9</u>, 2008, glass, mirroring, sealing wax, 31 x 38 x 28 cm
Woodrow and Deacon (b. 1948 and 1949, UK) are each highly distinguished sculptors in their own right with distinct practices. But since 1993, they have come together to make a series of collaborative works called 'shared sculptures'. For their 2008 exhibition 'On the Rocks', they showed two bodies of works in glass made by craftspeople at the Centre International du Verre et Arts Plastiques (CIRVA) in Marseilles. The *Bouteilles de Sorcière* were a series of 'witches' bottles' in blown glass with silver interiors that were inspired by a small silvered bottle in Oxford's Pitt Rivers Museum that is said to hold a witch. These works were not only a collaboration between the artists, but also an interpretation of that collaboration by the glassmakers.

OPPOSITE **Michael Petry**, <u>THE TREASURE OF MEMORY</u>, 2000, glass, yachting rope, dimensions variable
Petry (b. 1960, US) has created several works with the aid of glassmakers, including *The Treasure of Memory*, which was part of his exhibition at Hå gamle prestegard in Norway. A necklace for buildings, it is based on a Roman glass necklace found in a Viking grave on the Hå site. Each giant 'bead' was blown by English glassblower Ian Hankey. Pictured here at the Glazen Huis Vlaams Centrum voor Hedendaagse Glaskunst in Belgium in 2008, the work looks different in each location as it responds to the shape of the site. To expand the collaborative process, the curator of each installation strings the work to their colour taste, following rules about the repetition of the three bead shapes and the distance between them.

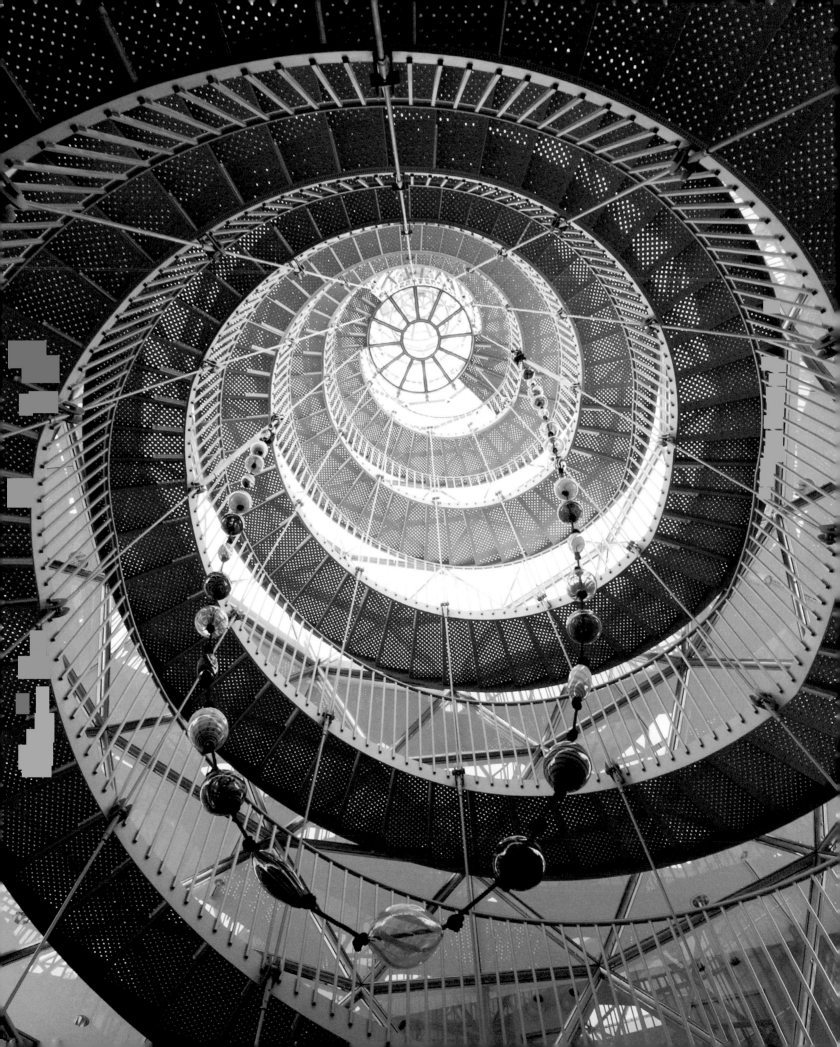

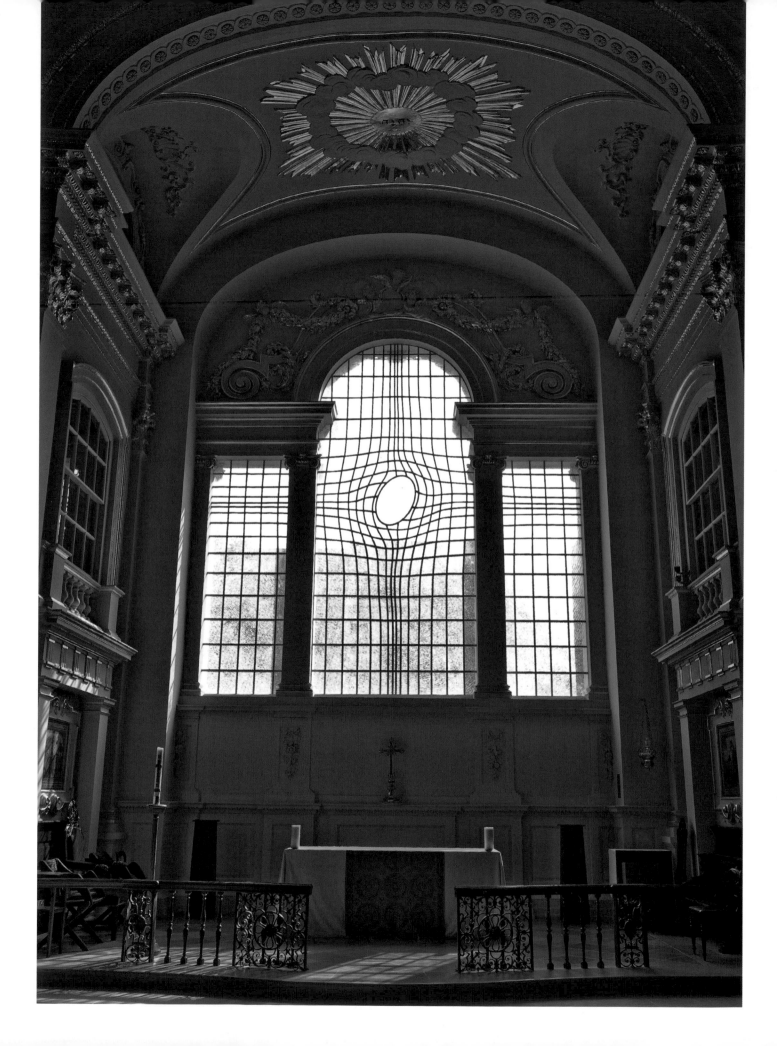

GLASS Shirazeh Houshiary

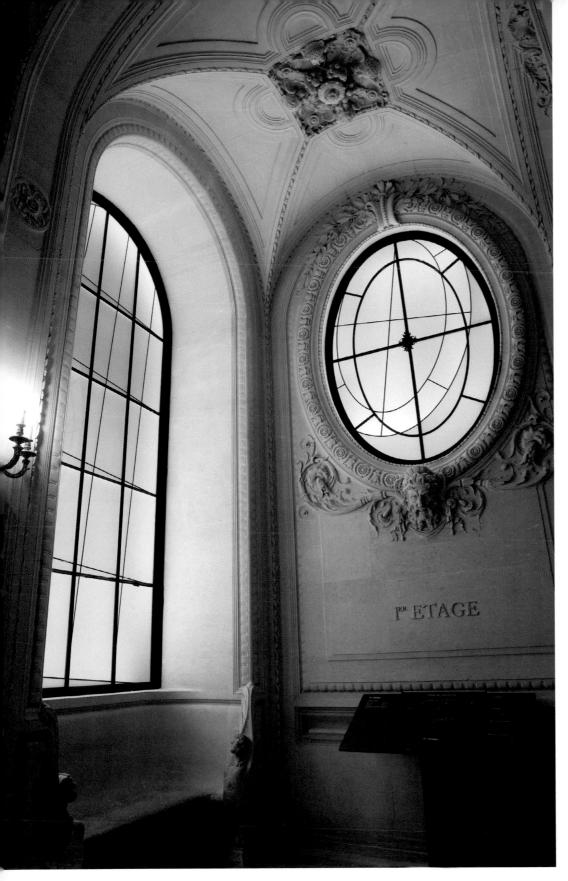

OPPOSITE **Shirazeh Houshiary**, <u>COMMISSION FOR ST MARTIN-IN-THE-FIELDS</u>, 2008, etched mouth-blown clear glass and shot opened stainless-steel frame

Houshiary (b. 1955, Iran) moved to London in 1976 and started her career as a sculptor and painter. She mixes aspects of Western modernist art with an Eastern sense of place and abstract imagery. In 2008 she was commissioned to make a new window for St Martin-in-the-Fields church in Trafalgar Square, London, to replace one that had been damaged by bombing in World War II. The church had been designed in 1726 by James Gibbs, whose vision was that it should contain only simple mouth-blown glass. Following Gibbs's vision, Houshiary and her architect husband Pip Horne (who collaborates on many of her sculptures) oversaw the fabrication of handmade clear-glass panels, which were etched on both sides with a feathery pattern based on her paintings. The seemingly abstract twist at the centre of the design creates an energy that evokes the physical agony of Christ on the cross.

LEFT **François Morellet**, <u>L'ESPRIT D'ESCALIER</u>, 2009, glass, lead

Morellet (b. 1926, France) started as an artist making paintings based on systems, methods and mathematics. He has long been interested in fabrication as a way of distancing of himself from the work and the viewer. For his permanent installation of seven glass windows in the Musée du Louvre in Paris, he redesigned the bay windows and oculi on the Lefuel Staircase in the museum's Richelieu wing. He took pleasure in 'fragmenting and destabilizing the panes of glass with their rather inelegant ironwork, and confronting them with their own image, created using an old and invaluable technique of the master glassworkers'. The visually elegant yet disruptive windows were manufactured to Morellet's designs by Les Ateliers Loire, a family firm established in Lèves, France, in 1946, using different types of glass and traditional leading techniques.

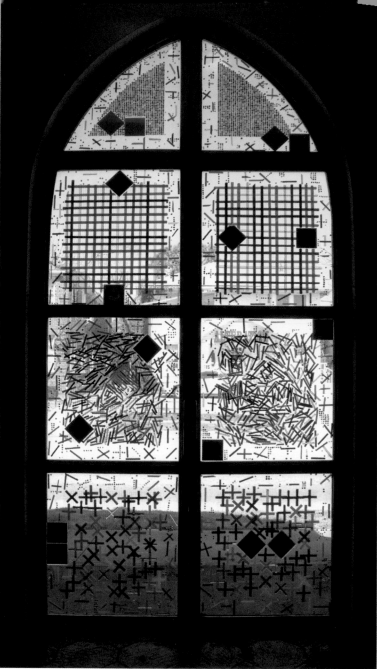

Jennifer Bartlett, <u>COMMISSION, ST STEPHENS EPISCOPAL CHURCH,</u>
<u>HOUSTON TX</u>, 1998, coloured glass, 244 x 168 cm

Bartlett (b. 1941, US) is best known for her distinctive dot paintings on gridded
steel plates and canvas works, many of which depict houses and architectural
structures. She has made a series of works in glass, often with Kenneth von Roenn
of Architectural Glass Art in Louisville, Kentucky, the most important being
a permanent installation commissioned by St Stephen's Episcopal Church in
Houston for their *columbarium*, a public place for the storage and presentation
of funeral urns. Bartlett's window panels, which can be seen from the street as
well as from the interior of the church, are a combination of laminated, fused,
silk-screened and hand-painted glass reminiscent of her monumental Homan-Ji
windows for the Ronald Reagan National Airport in Washington, DC.

Daniel Buren, <u>TRANSPARENCE VÉNITIENNE AVEC REFLETS</u>, 1972–2009, mirrored glass, 611 x 270 cm, work in situ

Influential French conceptual artist Buren (b. 1938, France) is known for site-specific interventions that use minimalist stripes of white and colour to integrate the visual surface and architectural space. Buren has used these stripes, uniformly 8.7 cm wide, in a variety of materials and sites all over the world, including shops, stairways, trains, theatres, bridges, galleries, museums and historic buildings. For him, the stripes are a 'visual tool' whose function is to reveal, through their placement, the characteristics of the site in which it is displayed. He has used glass in his work on many occasions, employing a range of glassmakers to realize his vision. In recent years, mirrors have increasingly intrigued Buren as another material with unique properties to explore. He is most interested in how they enhance the viewer's ability 'to see better, to see more or, better still, to see what, without them, would not be visible at all'. For this temporary site-specific work created for the 'Glasstress' exhibition in Venice, he placed custom-made reflective stripes in the windows of the sixteenth-century Palazzo Cavalli-Franchetti, transforming viewers' perception of the palace.

BELOW **Koen Vanmechelen**, <u>THE ACCIDENT</u>, 2005, Murano glass,
Mechelse Bresse stuffed, iron, rope, wood, 60 x 35 x 45 cm

RIGHT **Koen Vanmechelen**, <u>THE CATHEDRAL</u>, 2007, Inox, clear glass,
globe: the cosmopolitan chicken ten different generations, medusa totem:
clear Murano glass, 120 x 120 x 270 cm

Vanmechelen (b. 1965, Belgium) is fascinated by fowl, and mixes birds'
carcasses with blown-glass representations of their body parts. His work
is based on his scientific endeavour to create a new breed of chicken by cross
breeding all the world's known types (the Cosmopolitan Chicken Project).
Vanmechelen has worked with Venetian glass masters at the Berengo Studio
in Murano to realize works like those shown here.

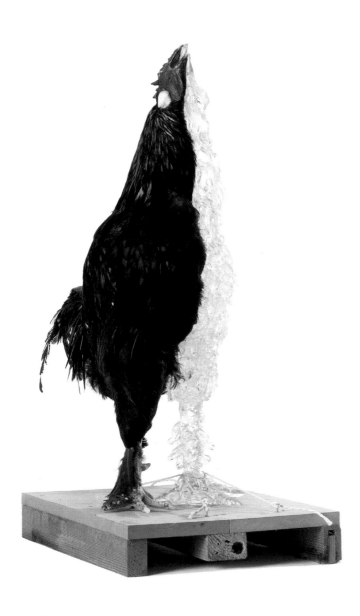

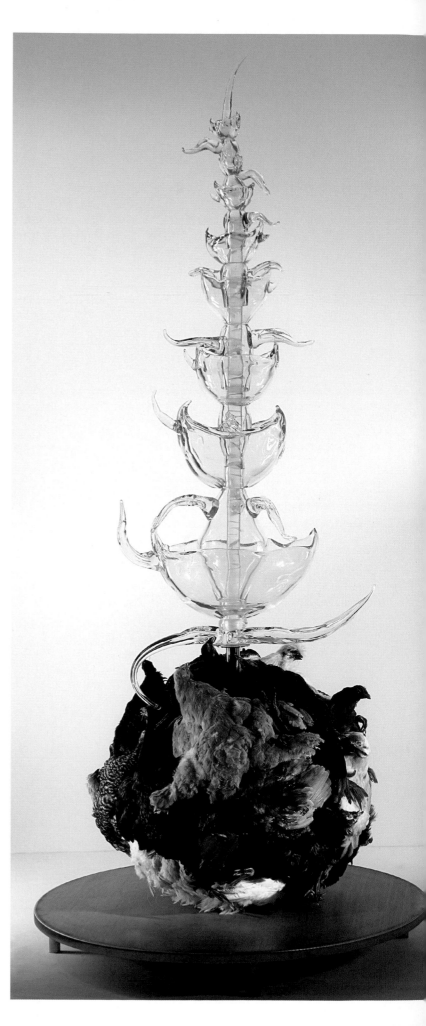

OPPOSITE **Christine Borland**, <u>BULLET PROOF BREATH</u>, 2001, glass,
spider's silk, steel, 34 x 22 x 22 cm

Scottish artist Borland's (b. 1965, UK) *Bullet Proof Breath* is a lamp-worked
glass representation of the branching bronchia of a human lung, partially
wrapped in spider silk extracted from a golden orb weaver spider. The silk has
a greater tensile strength than any other material and is being developed by
DuPont (with whom Borland worked) for use in bullet-proof vests. It was made
for her by the London-based Korean glassmaker and artist Jin Won Han.

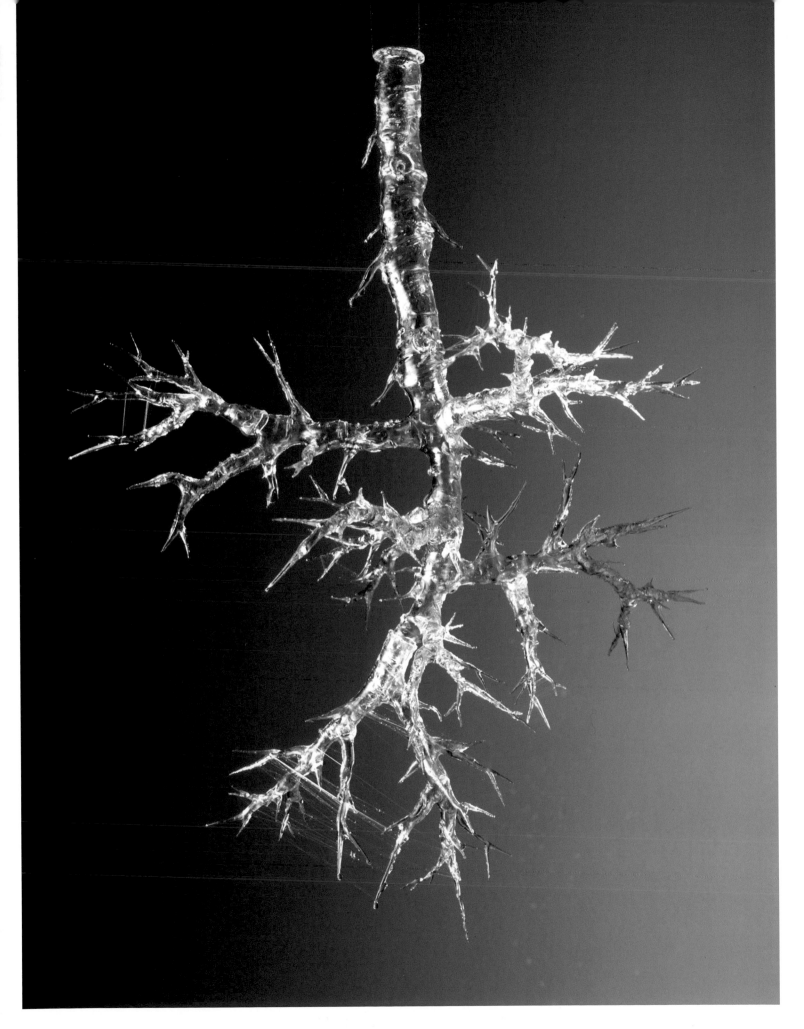

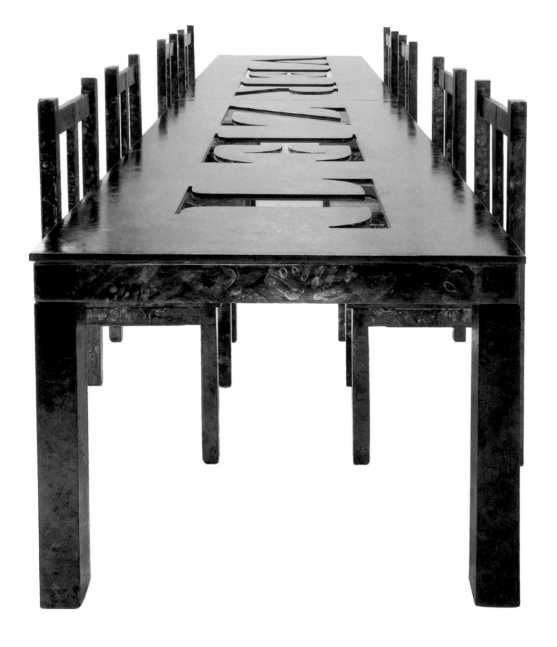

Jan Fabre, <u>TABLE FOR THE KNIGHTS OF DESPAIR (RESISTANCE)</u>, 2006, fused glass with blue glass enamelled surface, 400 x 100 x 74 cm, edition of 7

Fabre (b. 1958, Belgium) was commissioned to produce this glass table piece by D&A Lab in Brussels, based on a Perspex prototype he had made in 1987 with glass artist Jan-Willem Van Zijst of Fenestra Ateliers. The table has the Flemish word *verzet* (resistance) written onto its surface (cut out by water jet), while the accompanying eight chairs have holes in their seats in the shape of eagle's claws. Fabre then covered the pieces with a blue enamel featuring his handprints and those of young children, in a finish that resembles his trademark use of blue Bic ballpoint ink to colour sculptures and architectural spaces. Fabre again worked with Van Zijst to realize the finished work. 'It was a very interesting working process', says Fabre. 'To make this piece of art we did a lot of research on such things as how glass is best glued together, how it reacts with ink, and so on. We worked with a glass specialist from Holland, who fired every piece of glass separately. That meant it didn't look in the least "factory made" and you can really sense the craft: a result that had to be visible to me.' The table was then produced in a limited edition by D&A Lab.

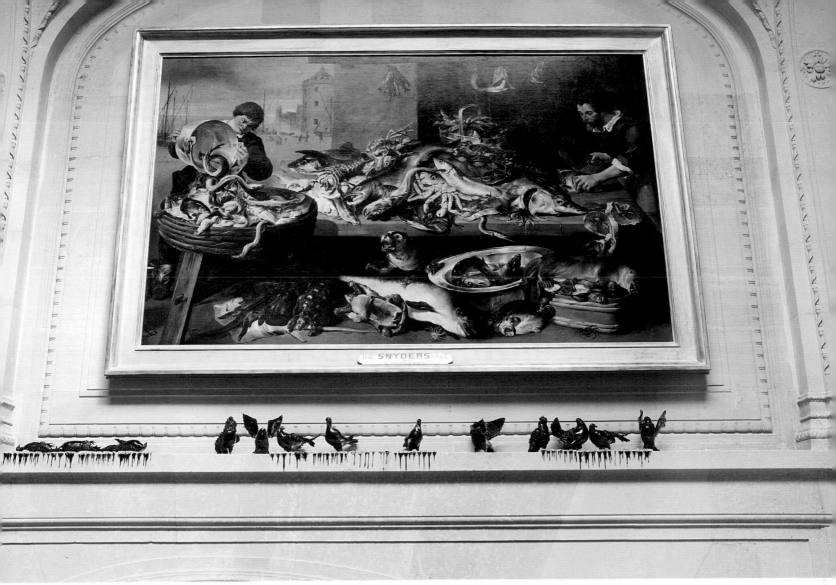

Jan Fabre, <u>SHITTING DOVES OF PEACE AND FLYING RATS</u>, 2008,
Murano glass, Bic ink, 25 x 25 x 260 cm

When Fabre was given the honour of being the first living artist to be invited
to have a solo show at the Louvre in 2008, he knew there was just one place
to go for help with producing the exhibition's most striking work. He asked
the Berengo Studio (with whom he has worked since the late 1980s) to make
the small glass doves from Murano glass. He then covered the pieces in ink
with an assistant, before installing them on the Lefuel Staircase in the museum's
Richelieu Wing, beneath paintings by the Flemish seventeenth-century artist
Frans Snyders.

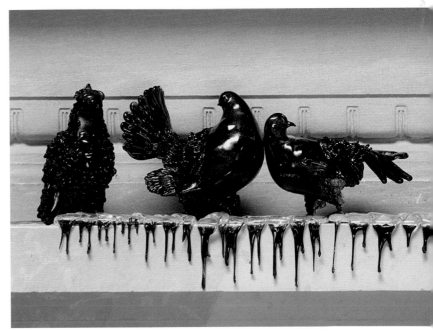

BELOW **Simon Periton**, <u>BARBITURATE</u>, 1998, coloured glass
(white, black or lilac), 69.5 x 9 x 4.7 cm, edition of 100,
Periton (b. 1964, UK) was commissioned to create *Barbiturate*
by the Multiple Store in London. Periton has said: 'I had in my
head an idea for a beautiful sculpture – a length of barbed wire
made out of fine bone china or porcelain. At first I thought this
could be cast, fired and decorated afterwards. But somehow all
this seemed a bit frivolous. It might appear nostalgic or romantic.
Glass comes as a rod that can be heated, twisted and wound
like wire. Here was an immediacy I liked. Glass is the epitome
of fragility. Barbed wire is practical, utilitarian. It is designed for
use rather than beauty. Made in glass, its practical use is denied.
It becomes house trained. The hazards associated with its use
turn upon its owner, who must now take care of it.'

Daniela Schönbächler, <u>BLUE MOON</u>,
2007, ink between glass, 30 x 30 x 16.5 cm
Daniela Schönbächler (b. 1968, Switzerland)
studied architecture before finding a way to
incorporate its structural qualities into her art
work. Her keen interest in 3D media evolved
into a more sculptural form of expression, where
glass became the unifying element. This new
direction led to technical studies of glass and
its properties in Germany, Switzerland and Italy.
She now lives in Venice and works on Murano,
giving her access to the island's master
craftspeople and the technical abilities to use
glass innovatively. Her work comprises various
forms of painting in and on glass, including ink
on glass canvases. As reflective, transparent
surfaces, they incorporate their surroundings,
and are therefore constantly transforming
and adapting. The work is static and yet in
a state of flux. For works such as *Blue Moon*,
Schönbächler paints on several panes of glass,
which the Murano glassmakers bond into single
free-standing cube-like forms that are then
sanded and polished.

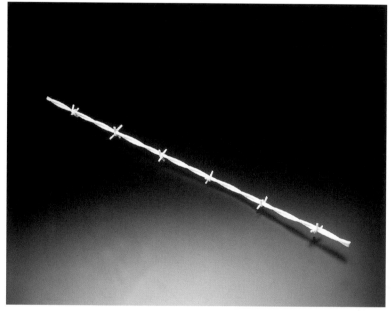

THIS PAGE **Silvano Rubino**, <u>ADDIZIONE SOTTRATTIVA</u>, 2009, steel, fretworked industrial glass, 400 x 100 x 80 cm, edition of 3

Rubino (b. 1952, Italy) is an artist who works in many media, including painting, video and photography. He has also worked with Murano glassmakers for several years, including the Berengo Studio and the Anfora Glass Furnace. He plays with the inherent ambiguity of glass, sometimes concentrating on its shape, at other times on its deceptive effects. For *Addizione sottrattiva* (Subtractive Addition), he employed Murano masters and a computer-operated machine milling factory to make a plate-glass table with outline shapes of plates and cutlery to form voids where the dishes should be. Large and rectangular, the table provides an obstacle to the viewer's passage, while at the same time denying the possibility of its natural use.

OPPOSITE BOTTOM **Roni Horn**, <u>UNTITLED (YES) 2</u>, 2001, solid cast glass, 122.2 x 73.7 x 43.2 cm

Horn (b. 1955, US) makes sculptural works that explore difference and similarity, reflection and doubling. Works like *Pink Tons* of 2008 (see p. 182) and the two-piece *Untitled (Yes)* feature huge slabs of glass that look like liquid, their highly polished tops gleaming in contrast to the rough untreated sides. Like many of the artists in this chapter, Horn transforms our perceptions about the nature of glass with these works, turning this traditionally fragile medium into a block of strength. She began using Schott optical glass when still a student. 'I love the clarity, as well as the fragility of the material' she says.

THIS PAGE **Per Barclay**, <u>UNTITLED</u>, 2003, mixed materials, dimensions variable Barclay (b. 1955, Norway) uses a variety of media in his art, including oil, water, glass and chainsaws. In each of these works, he oversees others to realize his concepts. His large site-specific installations are usually made by Salgipa, a firm of fabricators in Turin, with whom he has worked for more than twenty years. His untitled work at the Museo Reina Sofía in Madrid in 2003 was installed by six men from the factory. 'The main reason I live in Italy is that here you still find wonderful craftsmen and artisans that can practise the old tradition of their handicraft. The people who made my Reina Sofía installation mostly work with architects, designers and artists, including Michelangelo Pistoletto, Gilberto Zorio and Mario Merz. The installation was the biggest most complicated I have ever made. It relates to the crystal palace it was housed in, which was itself a technical wonder when it was built. I wanted to make something that reflected that in our time. There is a small lake outside the building and I wanted to respond to it by moving water about the space. On one hand, the work is calculating, cold with immaculate huge glass and steel tanks; but on the other, it also organic and fluid with water being moved from one basin to another through a thousand metres of transparent tubes. It was highly complex, yet perfect, really perfect – exactly as I wanted it.'

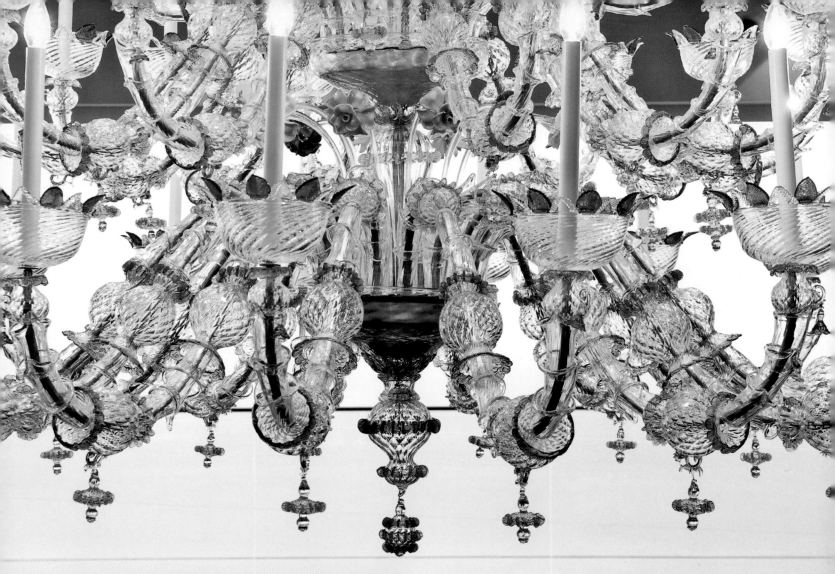

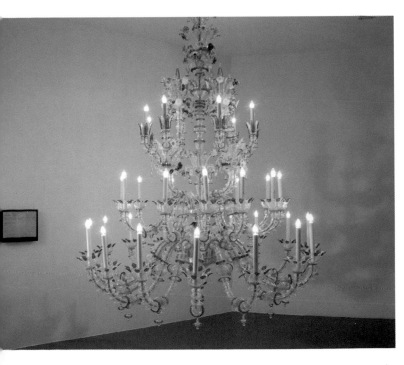

THIS PAGE **Cerith Wyn Evans**, 'ASTRO-PHOTOGRAPHY ...
THE TRADITIONAL MEASURE OF PHOTOGRAPHIC SPEED IN
ASTRONOMY ...' BY SIEGFRIED MARX (1987), 2006, chandelier,
flat-screen monitor, Morse code unit and computer, dimensions variable,
chandelier 260 x 220 cm

Wyn Evans (b. 1958, UK) has made a series of sculptures featuring chandeliers
controlled by computer systems that blink on and off to present various literary,
philosophical and theoretical texts in Morse Code. These works investigate
the nature of language and perception. He has used readymade chandeliers,
and has commissioned others from Murano glass manufacturers such
as Barovier & Toso and Venini. For this work, he commissioned the chandelier
from an Italian family of makers. Siegfried Marx's text relates the story of how
astrophotography developed, and with it the unfortunate discovery that dust gave
rise to microscopic inconsistencies in the photographic emulsion, causing stars
and galaxies to be misnamed and improperly recorded. Wyn Evans's work employs
the craft skills of the chandelier makers and the literary skills of the many authors
whose texts he deploys.

RIGHT **Hermione Wiltshire**, MY TOUCH, 1993, cibachrome photographs, glass, silicon glue and aluminium, 200 x 100 x 40 cm (detail) Wiltshire (b. 1963, UK) worked with glassmaker Simon Moore to create this work, in which her fingerprints were turned into huge glass pieces. Moore has said that, 'To have an idea that my own skills could not achieve has always been unacceptable. To have an idea that stretched and extended my skills was all the better.'

BELOW **Maria Roosen**, ISABELLE, CHARLOTTE, MARLENE, JULIETTE, GEORGINA, CECILIA, 2009, glass, dimensions variable
Maria Roosen (b. 1957, Holland) uses many materials in her work, but in her glass pieces she makes sensual and sexual imagery, using the glossy quality of the material as a means of visual seduction. Silvered breasts, erect penises, and sperm are all part of her vocabulary in glass, as are her voluptuous milk pitchers, consistent with her exploration of fertility, growth and temporality. She works with a variety of glass makers, including Glasstudio De Oude Horn in the Netherlands, Pino Signoretto in Murano, and the Ajeto Studio in the Czech Republic. She believes her ideas mature by working with these various craftspeople.

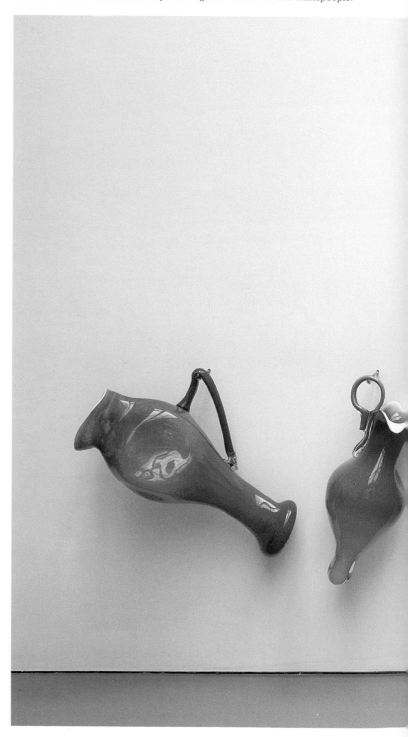

ABOVE **Anya Gallaccio**, SOLID AND MIRACULOUS IN THE FACE OF ADVERSITY, 2005, cast lead crystal, 20 x 33 x 18.5 cm, approx. weight 23 kg
Anya Gallaccio (b. 1963, UK) creates site-specific installations, often using organic materials as her medium. Past projects have included arranging a ton of oranges on a floor, placing a thirty-two-ton block of ice in a boiler room, and painting a wall with chocolate. The nature of these materials results in natural processes of transformation and decay, often with unpredictable results. Gallaccio has stated, 'I see my works as being a performance and a collaboration.... There is an unpredictability in the materials and collaborations I get involved in. Making a piece of work becomes about chance – not just imposing will on something, but acknowledging its inherent qualities.' For this work, she had a real durian fruit cast in a kiln by the London-based glass artist Angela Thwaites. The act draws attention to the normally fragile and temporal nature of the fruit by preserving its form in a durable material for perpetuity.

FOLLOWING PAGES **Maria Roosen**, ROSARY, 2008, glass, climbing rope, dimensions variable

'I let things grow. I sow the seed and then turn to other people to help grow the crop. I manage and guide the process – you could actually say I'm the artist with the green thumb.' Maria Roosen

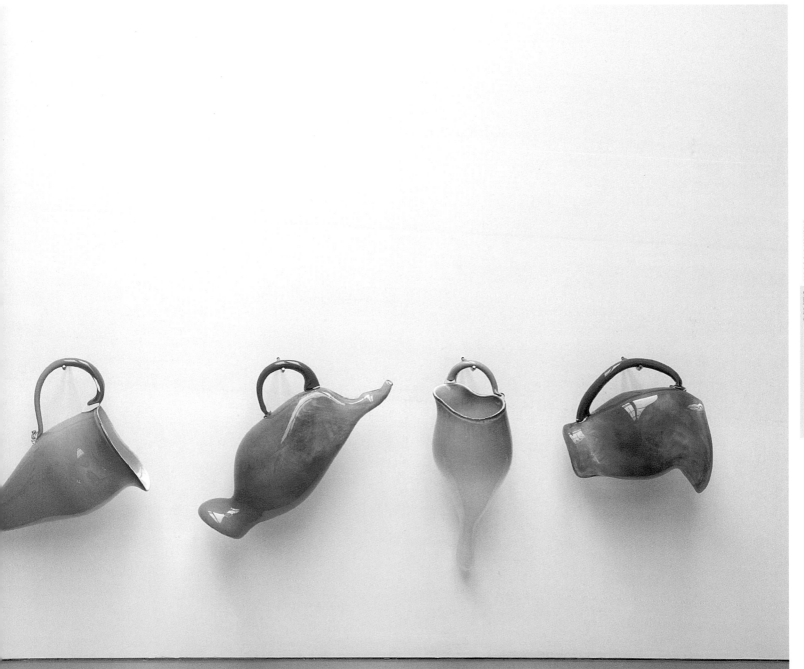

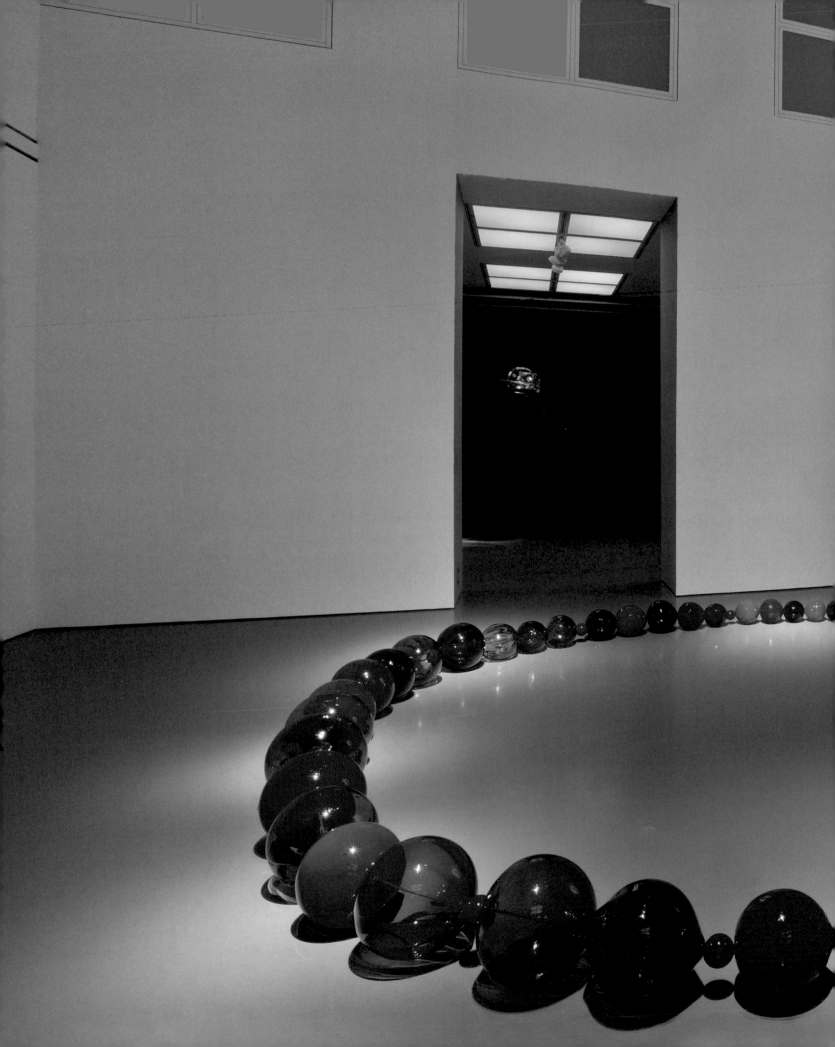

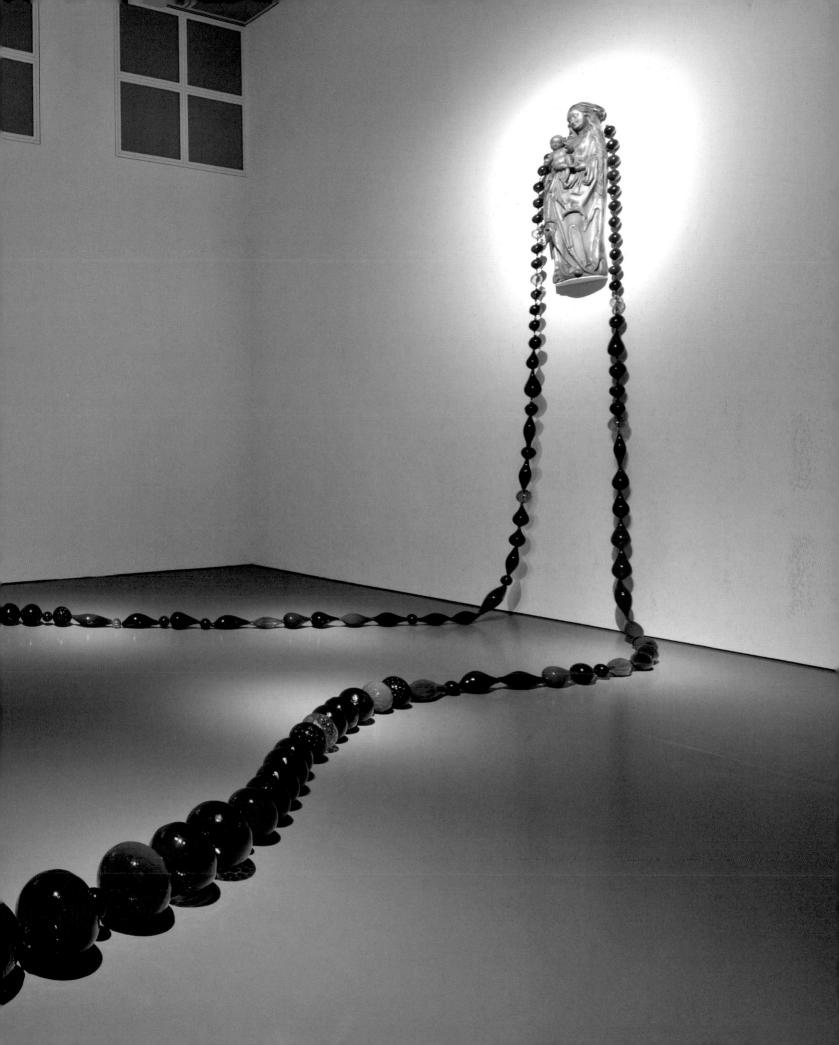

Fiona Banner · James Lee Byars · Saint Clair Cemin · William Cobbing · Cornford & Cross · Keith Coventry · Dorothy Cross · Richard Deacon · Marcel Duchamp · Angus Fairhurst · Matias Faldbakken · Ryan Gander · Liam Gillick · Subodh Gupta · Mona Hatoum · Joseph Havel · Hana Hillerova · Carsten Höller · Roni Horn · Gary Hume · David Ivie · Anika Jamieson-Cook · Rob Kesseler · Michael Landy · Sherrie Levine · Micah Lexier · Liliane Lijn · Kris Martin · Dhruva Mistry · Joel Morrison · Paul Morrison · Marc Newson · Cornelia Parker · Michael Petry · Ugo Rondinone · Simon Starling · Gavin Turk · Not Vital · Richard Wilson · Robert Wilson · Bill Woodrow · Aaron Young

Metal

Like the production of glass and ceramics, the smelting of metal ores into objects is one of the oldest known craft processes. Primitive metal-working took place in south Asia between 7000 and 3300 BC, around the time the Bronze Age is said to have started in Egypt, Mesopotamia and other regions of the ancient Near East. Early Harappan people in the Indus Valley also made copper, bronze, lead and tin in this period, as did early Chinese cultures. It took another five hundred years for the more durable iron to appear. As that metal became common for tools, machinery and weapons, the softer bronze was used for artistic and decorative purposes. The scarcer metals of gold and silver were reserved for precious artifacts, such as jewelry, religious or royal objects. Silver was more valued than gold in ancient Egypt as it was rarer, but both metals have long been seen as inherently valuable and used as coinage. King Pheidon of Argos is said to have produced the first standardized silver coins in about 700 BC, and Croesus did the same with gold around 550 BC.

By this time, metalworkers around the globe had become highly skilled in a range of techniques. As time progressed, metal objects became more common and more complex. The need to extract greater amounts of metal ore grew, and metalworkers became key members of society. The fate of entire civilizations were affected by the availability of metals and metalsmiths.

Metalworking falls into three main types of process: cutting, joining and forming. *Cutting*, as the name suggests, involves removing excess material to shape a piece of metal; this can be done with a hand tool or machine, or by using a burner or chemical erosion. *Joining* includes welding, brazing or soldering pieces of metal together; it requires very high temperatures. *Forming* modifies the metal without removing any material; it is done with heat and pressure, or with mechanical force, or both. Casting is the best-known of the forming processes, and has been used in the production of sculpture for millennia. Once the lost-wax method of bronze casting was discovered in China around 2000 BC, it allowed more sophisticated objects to be produced. However, it was a complicated, multi-stage process that required large workshops manned by many specialists. As artists of distinction emerged, their involvement in the process diminished and they were often responsible only for the production of the original, which was then used as a master for the production of multiple metal versions.

The commemorative medal is another object long produced by Western artists, including Hans Holbein the Younger and Albrecht Dürer, who even designed a medal to himself. Modern and contemporary artists have followed suit. The American sculptor David Smith designed a series of bronze *Medals for Dishonor* between 1938 and 1940, which were small, intimate works that contrasted with his better-known monumental sculpture. Similarly, the English sculptor Lynn Chadwick, known for his large figurative works, made a singular medal in 1984 called *Diamond*, an erotic image based on the female form. It was cast by the Pobjoy Mint for the British Art Medal Society. The Society has commissioned medals from many artists, all of which have been editioned by professional makers. In 2009, the British Museum exhibition 'Medals of Dishonour' showed satirical medals from the sixteenth century to the present, including new designs commissioned by the British Art Medal Trust from thirteen artists such as Jake and Dinos Chapman, Grayson Perry, Richard Hamilton, Mona Hatoum, Michael Landy, and Cornelia Parker.

Many twentieth-century artists also designed jewelry for manufacture by craftsmen. In 1903, the English artist and designer Charles Ricketts designed a ring for May Morris (daughter of artist and social campaigner William Morris), which was produced by Carlo Giuliano, a Neapolitan jeweller working in London. Later in the century, French artist Yves Tanguy had a pair of miniature painting earrings made for Peggy Guggenheim, and Georges Braque had some of his paintings turned into jewelry by well-known jeweller Baron Heger de Loewenfeld. In the 1940s and 1950s, Salvador Dalí designed several metal pieces based on his paintings and sculptures (for example, a 1949 ruby lips brooch modelled on his celebrated Mae West lips sofa). He made the designs on paper, and most of the pieces were produced in New York by the studio of Argentinean silversmith Carlos Alemany, under the supervision of the artist.

Once again, Duchamp provides an early example, not only for having used metal objects as readymades (such as *Bottle Dryer*, 1914), but also for having pieces cast for him. His *Bouche-Évier* (Sink Stopper) of 1964 was made in lead, and was said to have been produced because Duchamp needed to find a way to fill up his bath. It remained this utilitarian object for several years until 1967, when he authorized the International Collectors Society of New York to produce three editions of one hundred each in bronze, stainless steel and sterling silver. Today, artists use many types of metal in their work. Sometimes they make the pieces themselves, but usually, like Duchamp, they only oversee the making, casting or finishing processes. In this chapter, we will see examples from a variety of metalworking processes, often involving teams of master specialists.

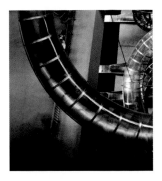

TOP **Ugo Rondinone**, <u>STILL.LIFE.</u>
<u>(A PIECE OF BREAD)</u>, 2008, bronze cast,
lead, paint, 63 x 85 x 66 cm, edition of 3
plus 1 artist's proof
BOTTOM **Ugo Rondinone**, <u>STILL.LIFE.</u>
<u>(FOUR SMALL POTATOES IN A LINE)</u>,
2009, bronze cast, lead, paint, four parts:
(1) 6.5 x 5 x 5 cm, (2) 8 x 6 x 4 cm,
(3) 7 x 5.5 x 5.5 cm, (4) 8.5 x 6 x 4 cm,
edition of 3 plus 1 artist's proof
Rondinone (b. 1964, Switzerland) works
in many media, from painting and drawing
to sculpture and installation. He makes
some of the works himself, while he
requires the craft or fabrication skills of
specialist makers to produce others, such
as his ongoing series *still.life*. The pieces
in this series are, on the one hand,
readymades in that they originate in
objects appropriated from real life; but
on another they also result from 'a process
of artful and painstaking fabrication'.
What appear to be rows of lowly potatoes,
walnuts, pieces of bread or tree trunks are
in fact highly detailed *trompe l'oeil*
fabrications made of lead-filled painted
bronze. Rondinone first selects the actual
real-life objects, and then has them cast,
whereupon they are returned to his studio
and are hand painted by his assistant
Anne Rose Schwab. The bread was cast
at Kunstbetriebe Münchenstein AG,
a production site outside Basel in
Switzerland. All the other works were
made at the Fonderia d'Arte in Naples.

'Artists appropriate images from the world and therefore shape how you experience the world; you look at a bin liner and you think of it as being a Gavin Turk.'

Gavin Turk

Gavin Turk, <u>PILE</u>, 2004, painted bronze, 163 x 110 x 70 cm
Turk (b. 1967, UK) also creates *trompe l'oeil* fabrications made of painted bronze. Pieces such as an empty polystyrene chip box, a homeless person in a sleeping bag, or a pile of rubbish bags all seem to be the extreme opposite of beautifully crafted deluxe objects, while existing as such. Although produced by professional bronze-casters, the bags are not without their technical difficulties. 'At one point, I wanted to make a bigger pile of maybe thirty bags, but this became impossible to fund. When they come back from the bronze foundry, they are often in two or more sections and so every little fold in the bag has to be treated and burnished. Then they are sprayed black, while the topknots are cast separately and added on later.'

Gavin Turk, <u>BRILLO</u>, 2000, painted bronze, 49.5 x 29.2 x 43.1 cm

As part of a sustained investigation into the nature of originality and artistic authenticity, Turk has used the work of other artists as this basis of his own art throughout his career. Typically, he further complicates the issue of authorship by having his works fabricated by others to the highest of standards. This bronze cast of an empty cardboard box, one of six such examples, is no exception. The title of the work is a direct reference to the Brillo boxes produced by Andy Warhol, the artist most frequently referenced by Turk. 'Whether I am using my own work or someone else's work is no different', he says. 'It is all a matter of interpretation in terms of ownership in art. For instance, if an artist makes a sculpture with felt, everyone will immediately think of Joseph Beuys's work, because he somehow has a kind of signature on felt. Artists just simply re-signature, re-authorise the visual experience until another artist does another signature on top.'

LEFT **Gavin Turk**, CHIPS TO GO, 2009, painted bronze,
15.5 x 21 x 15 cm
BELOW **Gavin Turk**, NOMAD (BLACK), 2009, painted bronze,
105 x 169 x 42 cm

ABOVE **Cornford & Cross**, <u>JERUSALEM</u>, 1999, bullet lead,
Caen stone, 293 x 63 x 63 cm

Matthew Cornford & David Cross (b. 1964, 1964, UK) jointly
make conceptual installations that critically engage with
particular spaces. *Jerusalem* was made for King Edward VI
School in Norwich. The artists collected spent bullets from
the firing range of the UK National Rifle Association and had
them melted down and cast into a life-sized image of a cadet
holding an SA80 assault rifle (modelled by Tom Crompton).
Cross then went to a stoneyard in Normandy to select a block
of stone for the plinth, which had 'Jerusalem' carved into it
by Norwich Cathedral's stonemason. Cornford & Cross destroyed
the work in 2002.

RIGHT **Cornford & Cross**, <u>WHERE IS THE WORK?</u>, 2004,
cast iron, 62 x 61 cm

The artists made this site-specific installation for an exhibition
at the South London Gallery. The duo reverse-engineered the
gallery's floor grille and had it replaced by an exact replica
made from cast iron. The production drawing for the grille
was made by Curventa Engineering, and the actual work was
fabricated at Whitton Castings, both in London. The grille is now
in the gallery's permanent collection. (Additional information on
both works can be found in the Interview section, pages 186–7.)

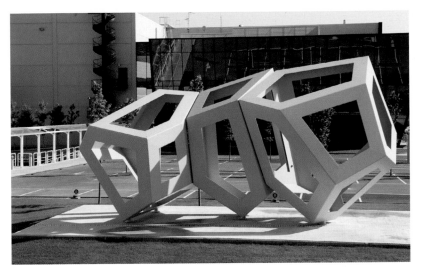

Richard Deacon, <u>NOSOTROS TRES (THE THREE OF US)</u>, 2008, painted mild steel, 480 x 880 x 370 cm

Deacon's imposing sculpture was commissioned by the Museo Würth La Rioja in Logroño, Spain, in 2008. Deacon first made a series of clay and paper models, the final paper one being refabricated in painted mild steel by the British firm Twin Engineering of Bletchley, Buckinghamshire. They first made a small steel model so that Deacon and their staff could 'tweak the geometry', and then scaled up the work to full size. As Deacon explains, 'Gary Chapman, Buddy Kim and Dave Walsh were the people involved in this project. After the model making, I did not physically manipulate it.'

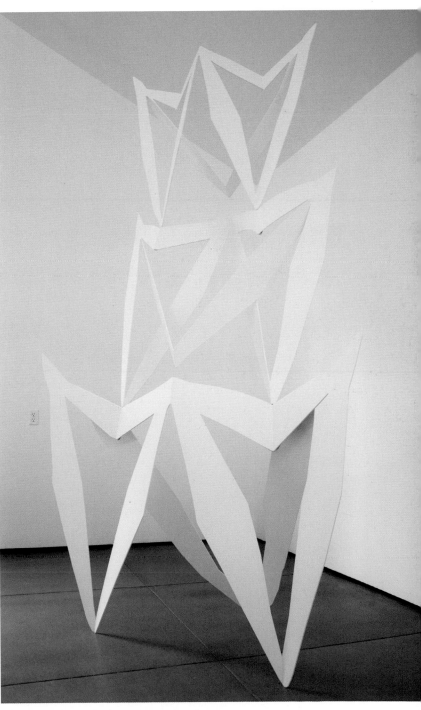

Hana Hillerova, <u>UNTITLED (UNFOLDING SPACE)</u>, 2009, powder-coated steel, 284.48 x 160 x 81.28 cm

Prague-born but Texas-based Hillerova (b. 1975, Czech Republic) is interested in the space between architecture, physics, biology and dynamic systems derived from complexity theory. Her works have an emergent, experimental quality, as she attempts to take theory from a wide variety of scientific disciplines and marry them with the visual arts, her *Untitled (Unfolding Space)* being a typical example. The steel sculpture was fabricated for her by Blumenthal Sheet Metal in Houston, which has produced work for a range of artists since the early 1990s.

FOLLOWING PAGE **Carsten Höller**, <u>TEST SITE</u>, 2006, stainless steel, polycarbonate, site-specific installation

Höller (b. 1961, Belgium) started out as a biologist, and he now incorporates his past work into his artistic practice, placing scientific observation and objectivity in dialogue with sensation and sensuality. His *Test Site* was part of the series of Unilever commissions for the Turbine Hall of Tate Modern in London. The five stainless-steel tubular slides with polycarbonate covers descending from different floors to ground level – the longest of which was 55 metres – were made specifically to explore the verticality of the imposing site. Visitors were allowed to ride the slides under supervision. The work was made by a German company with which Höller has worked for over ten years, and to German safety regulations.

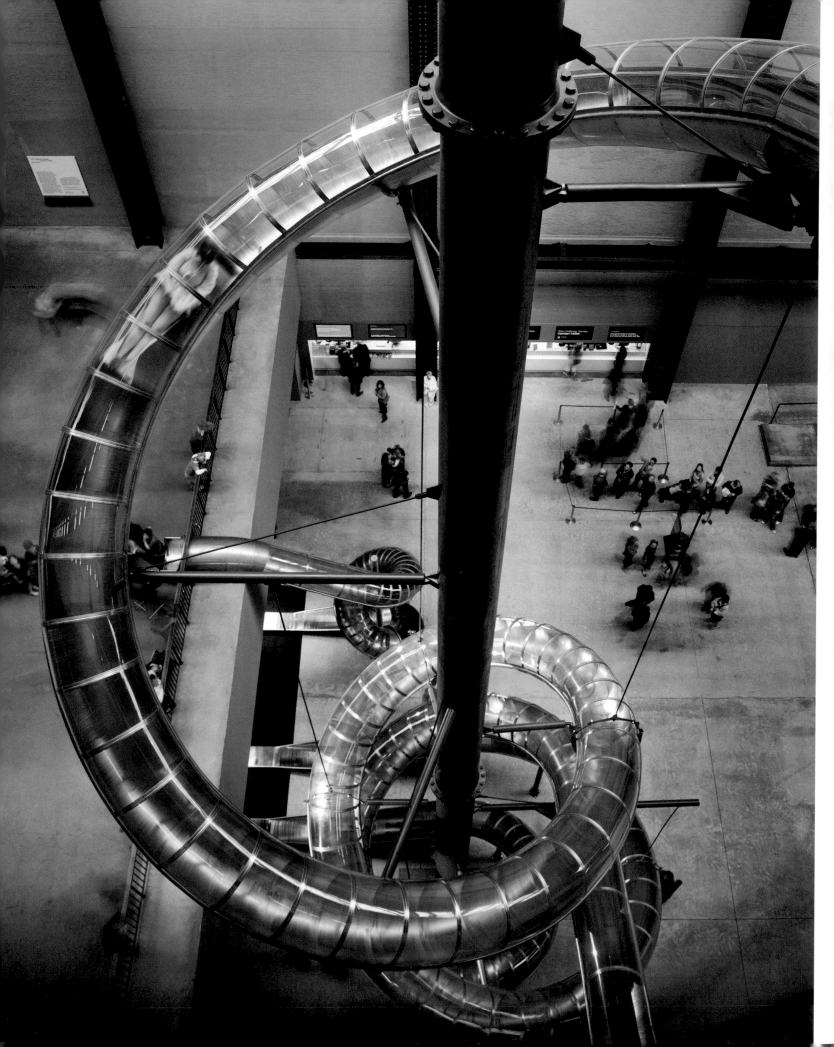

dimensions variable (installation view) Starling (b. 1967, UK) transforms the everyday into something unusual or disturbing. This installation at MASS MoCA in North Adams, Massachusetts, referenced not only the building's previous use as a shoe factory whose owners had imported Chinese workers to break a strike, but also the artist's own use of Chinese craftsmen to produce his works. Visitors saw almost life-size copies of stereoscopic photographs from 1875 (TOP), from the surface of which Starling had silver grains extracted. These were magnified one million times and made into three-dimensional models by computer rendering. A team of foundry workers in Nanjing, China, then created full-scale clay and plaster models, before forging the hand-polished stainless-steel sculptures at a fraction of what they would have cost in the West.

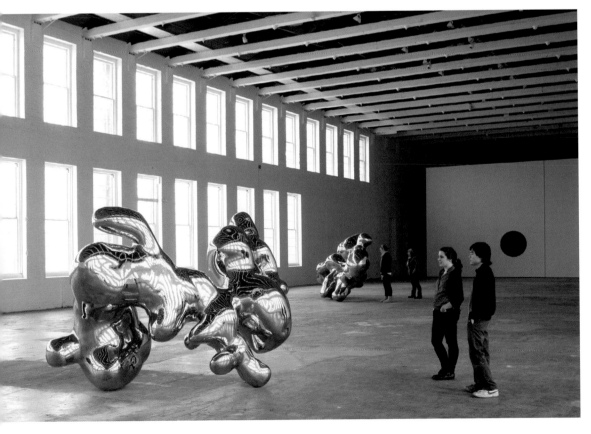

Gary Hume, <u>BACK OF SNOWMAN</u>, 2002, painted bronze, 302 x 210 x 110 cm
Known primarily as a painter, Hume (b. 1962, UK) has made a series of works
in three dimensions that recall the childhood imagery of his paintings, which
include rabbits, polar bears, owls and snowmen. Pieces such as *Back of Snowman*
were fabricated at the AB Fine Art Foundry in London using the lost-wax casting
method. The company has made a very large number of works in bronze, lead
and stainless steel for many international artists.

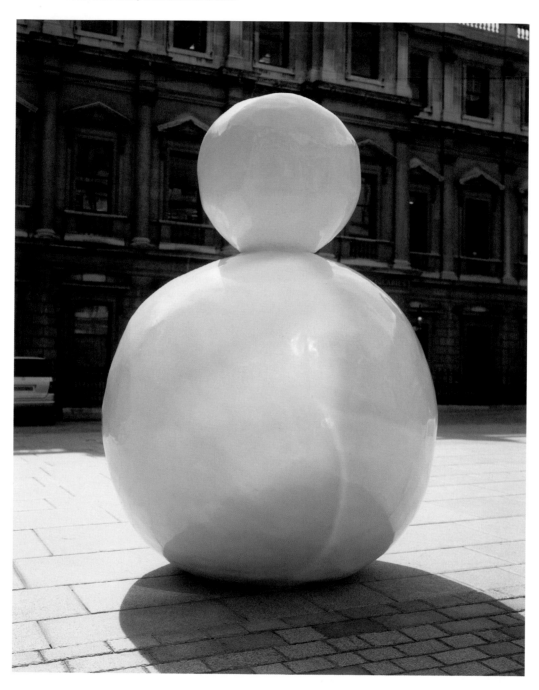

BELOW **Fiona Banner**, <u>COURIER FULL STOP</u> and <u>CENTURY FULL STOP</u>, 2002, bronze and paint, Courier: 150 x 150 x 150 cm; Century: 80 x 80 x 80 cm

Fiona Banner (b. 1966, UK) uses words and their construction into meaning as the basis for her practice. She creates texts, sculptures and wall pieces that feature letters, sentences and even punctuation. Full stops, commas and exclamation marks in a range of typefaces – such as Courier, Century and Slipstream – have all become three-dimensional sculptures in glass, neon, ceramic, concrete and bronze, the latter produced for her by the AB Fine Art Foundry.

RIGHT **Fiona Banner**, <u>SLIPSTREAM FULL STOP</u>, 2002, bronze and paint, 149 x 76.1 x 72.5 cm

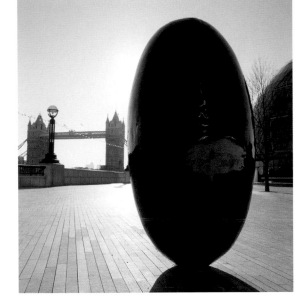

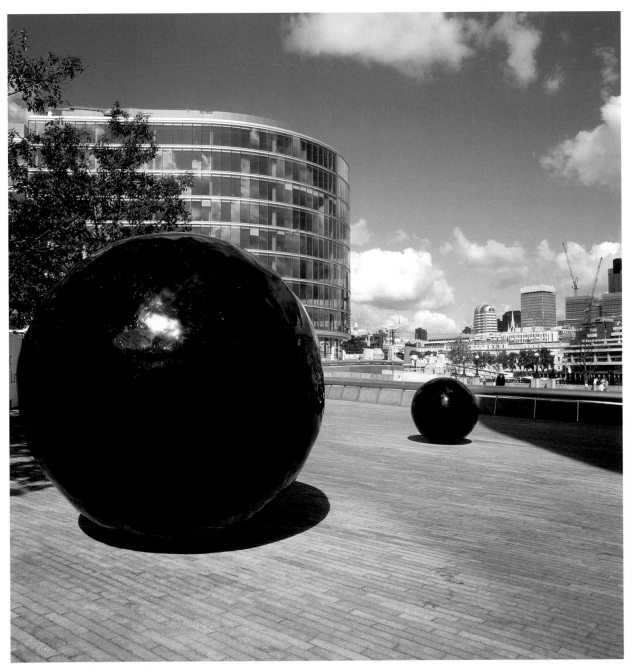

TOP RIGHT **Kris Martin**, MANDI XXI, 2009, information flapboard, black metal, 160 x 263.5 x 20 cm, edition of 5 plus 2 artist's proofs

Kris Martin (b. 1972, Belgium) uses the passage of time and the knowledge of the ever-present nature of death and decay as the starting-point for many of his works. In 2003, he was asked to make a work for the 3rd Berlin Biennale. He chose to present *Mandi III*, an empty train station or airport arrivals and departure board that flips at random but displays no characters or numbers, its ever-clicking plates promising information but never delivering. Time ticks away, and life passes to no measurable effect. Installed in the city's St Johannes-Evangelist Church, the work is an information board for our last journey, the one that leads us to our final destination. For *Mandi XXI*, Martin asked the Solari di Udine company in Italy, one of the world's leading manufacturers of public information display systems, to make him an all-black version that performed a similar dance of death. Martin has used the title 'Mandi' for several of his works reflecting on questions of life. The title is based on a colloquial Italian expression. A combination of the words *mano* (hand) and *dio* (God), it means 'in the hands of God' or 'goodbye'.

RIGHT **Matias Faldbakken**, 16:9, 2006, brushed aluminium, 2 parts, each 28.5 x 200 cm

Danish artist and novelist Matias Faldbakken (b. 1973, Denmark) is infatuated by the power of negation. He has said that 'the Eskimos have two hundred ways to say snow. I have three million ways to say no.' His sculptures and interventions are often seemingly throwaway and at odds with traditional gallery culture, as in his *ABSTRACTED CAR No2* for his show 'Extreme Siesta' at Kunsthalle St Gallen in 2009, where he spray-painted a car completely silver and parked it in front of the gallery, negating it, vandalizing it, and yet creating something new out of it. In *16:9*, Faldbakken had Signex, an Oslo sign company, make him two metal bands representing the negative space above and below a widescreen film image (16:9 ratio) when it is shown on a conventional television (4:3 ratio). These shiny bars were hung on the wall minus any intervening picture – thereby reversing the area where 'nothing is doing'. While referencing the leftover area at the top and bottom of the television screen or computer monitor, the work also plays with the legacy of Minimalism.

BELOW **Not Vital**, <u>GORE VIDAL</u>, 2007, two silver boxes,
3 x 3 x 10 cm, 19 x 19 x 25 cm

Not Vital has created a series of 'Portraits' that feature
combinations of silver boxes of various sizes to depict actual
people. Each small sculpture has the name of the depicted
stamped into it. The configuration of boxes evoke buildings
as well as bodies and have the possibility of both closure as
well as openness. American writer Gore Vidal appears alongside
artists Bruce Nauman and Constantin Brancusi, actress Audrey
Hepburn, designer Christian Dior, philosopher Michel de
Montaigne, and jazz legend Louis Armstrong. When originally
shown at the Sperone Westwater gallery in New York, the
birthdates of the subjects were written on the wall behind their
portraits. The dimensions of the boxes correspond with the dates.
Vital used traditional local silversmiths in Agadez, Niger, where
he owns a house, to fabricate the works.

BELOW **Saint Clair Cemin**, <u>PORTRAIT OF THE WORD 'WHY'</u>,
2008, stainless steel, 228.6 x 180 x 158.8 cm

Saint Clair Cemin (b. 1951, Brazil) uses many different materials
in his sculptures. Depending on the scale of the works, he either
fabricates them himself or has the work done by others. Since
2000 he has had a series of large outdoor and smaller indoor
cast-metal works fabricated for him in China at foundries with
experience of fabricating large-scale public sculptures. He uses
Chinese factories that employ nineteenth-century techniques.
They realize clay models from his designs (with as many as
fifteen people working on each piece), which Cemin then works
on further or approves for the next stage. A plaster positive is
cast and the clay model destroyed. The final plaster model is then
transported by truck for four hours from the model studio in
Beijing to the foundry in the Hebei province. The works take
several months to cast, with Cemin also overseeing all the finishing.

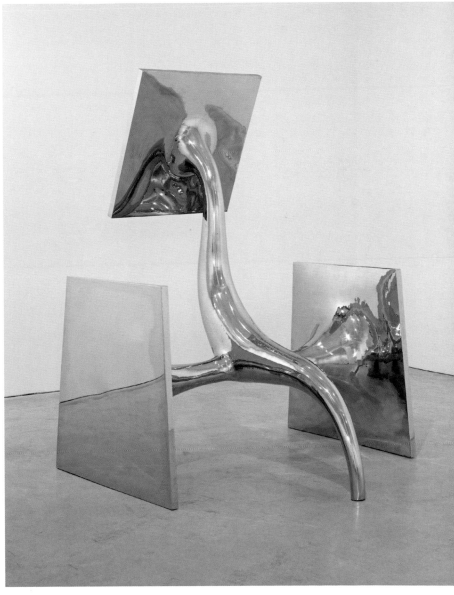

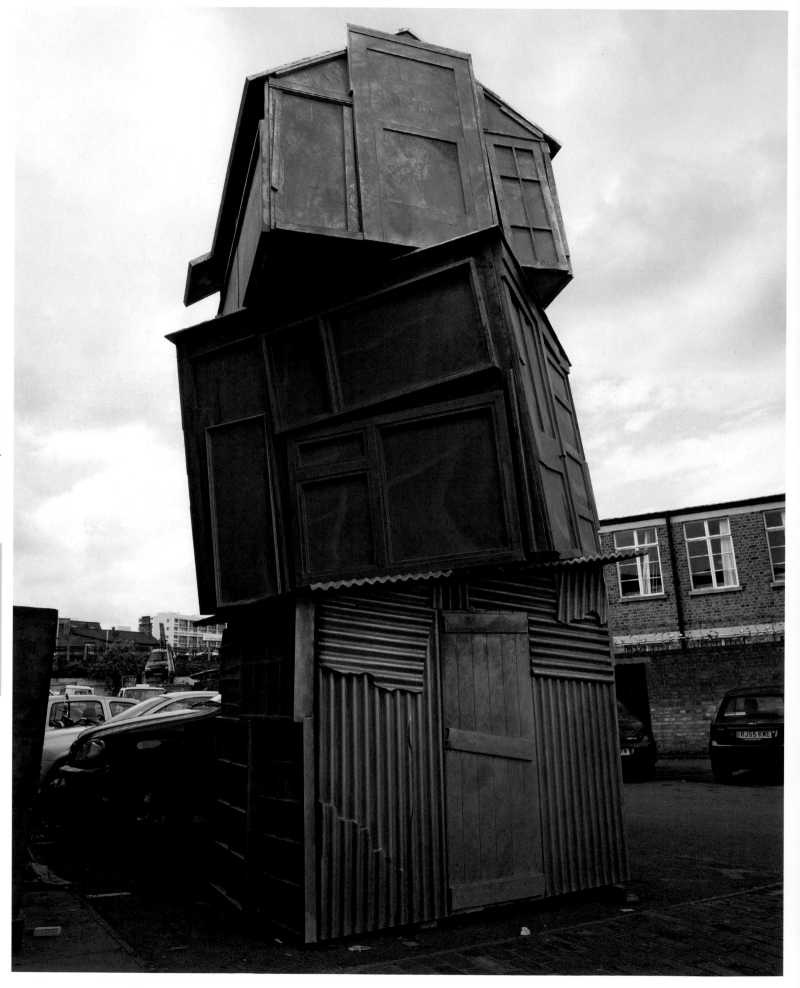

OPPOSITE **Richard Wilson**, STACK SHACK, 2006–10, cast aluminium, 6 metres high

Wilson (b. 1953, UK) is one of Britain's most inventive sculptors and installation artists. Drawing inspiration from the worlds of engineering and construction, he transforms architectural space and objects on a grand scale. Often his works feature movement or incorporate temporary structures. *Stack Shack* is his first permanent installation in London and was commissioned by the St James Group for the upmarket housing development Grosvenor Waterside in the city's Chelsea area. The ironic work has been placed in the central square of the new development, a site of urban regeneration. It is constructed from cast aluminium panels in the shape of three stacked sheds or improvised buildings that appear to have been dropped and abandoned. The work was fabricated for Wilson by MDM Props of London, which was founded as a theatrical prop and modelmaker in 1993 by ceramicist and sculptor Nigel Schofield. Since the end of the 1990s, the firm has produced art works for many well-known artists from Damien Hirst and Anish Kapoor to the Chapman Brothers and Anselm Kiefer. As a result, MDM has learned how to adapt to a range of aesthetic sensibilities, what Schofield terms the 'palette' of each artist. As he puts it, 'You just set out to give them what they want.' Despite the fact that Schofield and his team are the hands that make the art work, he never confuses his role with the artist's. 'It's their work that's being made', he says. 'It's not our work. It's theirs.' While some artists collaborate intensely with the fabricators and closely oversee the production process, others provide only the fragment of an idea or a quick sketch. Either way, Schofield says, 'they're the ones who have driven it on. You've just got your set of instructions to follow to make the piece.'

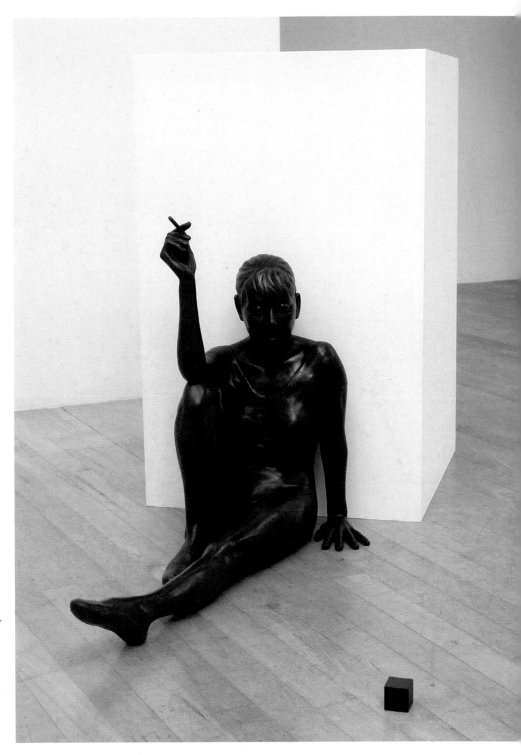

ABOVE **Ryan Gander**, I DON'T BLAME YOU, OR, WHEN WE MADE LOVE YOU USED TO CRY AND I LOVE YOU LIKE THE STARS ABOVE AND I'LL LOVE YOU 'TIL I DIE', 2008, bronze, wood, acrylic, figure approx. 60 cm tall; plinth 80 x 50 x 50 cm; cube 2 x 2 cm

Gander's piece features a young ballerina sitting on the floor (cast in bronze) posed to resemble a Degas model. The figure leans against an empty white plinth smoking a cigarette, 'her head is poised and her eyes look straight ahead focused on an ultramarine blue acrylic cube'. The work was realized for Gander in Wales by Nick Elphick, a sculptor who specializes in lifelike figure work. Gander befriended Elphick when they were studying sculpture together.

Keith Coventry, <u>YORKSHIRE ROAD E14 (PLANTED 1998,
DESTROYED 2000)</u>, 2009, bronze, 173 x 30.1 x 29.9 cm
Coventry (b. 1958, UK) produces paintings and sculptures that
question the legacies of Modernism within a British context.
He investigates the failure of attempts at social engineering
in the face of drug abuse, petty vandalism and bad food habits.
His *Kebab Machine 1* of 1998 is a life-size cast of a familiar staple
of late-night beer drinkers. The monumentalizing of this most
debased and derided foodstuff into a bronze sculpture highlights
its vast popularity, while questioning ignored governmental
health guidelines on the consumption of junk food. Similarly,
Coventry's series of destroyed saplings, again cast in bronze,
address the distance between city planners and those who have
to live in the urban environment. *Mare Street E8 (Planted 2005,
Destroyed 2005)* and similar works feature broken trees planted
by councils in London to improve the local area. They are bound
to a stake to keep them upright, as the real saplings are, with
a plaque at their base stating where the original tree was found,
when it was planted, and when it was destroyed by local
vandals. Coventry has stated 'youths resent this greening of their
urban environment'. Whether that is true or not, the sculptures
investigate the gap between the ideal and the reality of so much
social and environmental planning.

Paul Morrison, <u>PHYLUM</u>, 2006, industrial powder-coated marine aluminium and galvanized steel, 400 x 250 x 2 cm, base: 3 x 150 x 150 cm
Morrison (b. 1966, UK) is known for his black-and-white paintings of the natural world that have been distorted to unsettle the viewer and bring out a sense of danger or hidden threat. While he bases his work on actual plant material, he often enlarges small flowers or shrinks trees. He has also created a series of large, yet nearly two-dimensional metal sculptures that exaggerate those unsettling feelings.

LEFT **Dorothy Cross**, <u>FOXGLOVE</u>, 2009, cast bronze, 140 x 40 x 35 cm
Cross (b. 1956, Ireland) employs an Irish foundry to produce bronze sculptures of flowers. For *Foxglove*, she cut the plant into pieces before dipping them into warm wax so as not to shrivel them. She has said of their fabrication process that 'the difficulty is that because there is other material in the wax sometimes ash and vegetable matter can clog the channels. John at Dublin Art Foundry has devised a system of pouring the bronze at a very high temperature, which produces such delicate flowers.'

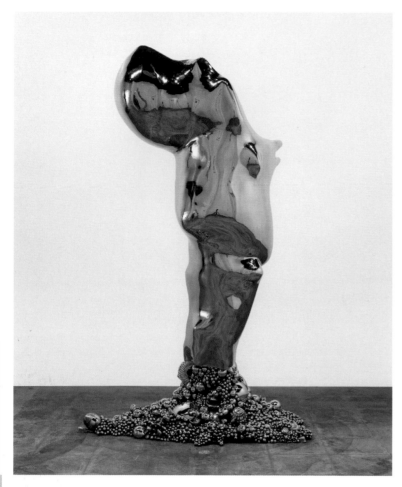

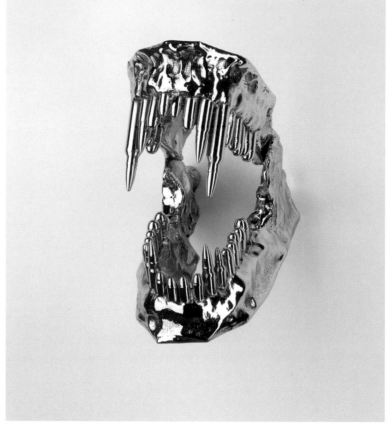

ABOVE **Joel Morrison**, <u>PISTOL</u>, 2008, stainless steel, 218.4 x 134.6 x 85.1 cm, edition of 3 plus 1 artist's proof

Morrison (b. 1976, US) starts out with found everyday objects such as plastic bottles, light bulbs, toilet plungers, fake fruit and other junky material acquired from 99-cent stores in his native California. He then tapes and wraps them (with foam) into new shapes that refer to other historical sculpture from Greek antiquities to Brancusi or Moore. He then uses the services of expert craftspeople to turn the piled objects into meticulous stainless-steel or fibreglass-coated art works. Sealed in these skins, everyday objects bulge out of their moulds, creating a landscape of unnatural peaks and unidentifiable protrusions that result in humorous, fluid, organic forms.

'I always have gotten other people to make things. I have an active mind, but I haven't always been so good at making things, so I'd get something made, or printed, by someone else. It was a response to the skills or lack of skills that I have.'

Micah Lexier

THIS PAGE **Micah Lexier**, <u>I AM THE COIN</u>, 2009, 20,000 custom-minted nickle-plated coins, 254 x 508 cm

Lexier (b. 1960, Canada) has long been attracted by the possibilities of collaboration. He was commissioned by the Bank of Montreal to make this new work for their Toronto Project Room. What appears to be a random grid of letters reveals itself to be a series of words and sentences uninterrupted by spaces or punctuation marks. These combine to tell a story that was written especially by Toronto writer Derek McCormack. The bottom half of the grid spells out the story, which can be read like a book, from left to right; the top half of the grid is a mirror image of the bottom. The story is all about coins, the work itself, and the people who produced it. In addition to McCormack, Lexier used master craftspeople at every stage of the complex project: from the initial graphic design to the production of the coins, the fixing of mounting pins on each one, the polishing, and finally the installation and proofreading. Lexier himself provided only the original idea, leaving others to realize the finished art work on his behalf.

123

Lexier has also produced a series of aluminium pieces cut with a water jet. This large work, which was commercially fabricated for the artist, presents the numbers from 1 to 9, where the surface area of each one has been equalized by removing parts from the bottom of the figure.

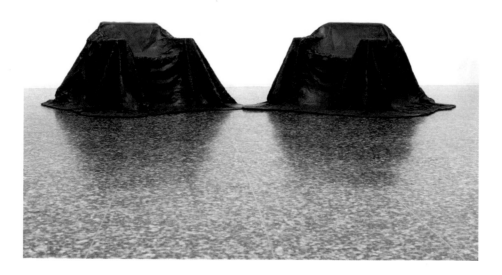

ABOVE **Robert Wilson**, <u>STALIN CHAIRS</u>, 1973, lead, 84 x 152 x 152 cm

Wilson (b. 1941, US) is well known as a director of live theatre and video art, as well as a maker of sculpture and installations. Many of his sculptural pieces start out as props for performances, but they are never mere decoration. He strives to instill aspects of his characters in the sculptures. He has had dozens of chairs fabricated for his performances in a variety of materials from bronze to oak. Wilson always names the pieces after historical figures. 'In a sense, they are more like poetic visions of personalities of our time, the way the Greeks made sculptures of the gods of their times.'

OPPOSITE, TOP LEFT AND BOTTOM **Mona Hatoum**, <u>PRAYER MAT</u>, 1995, nickel-plated brass pins, brass compass, canvas, glue, 67 x 112 x 1.5 cm

At once beautiful and disturbing, threatening and seductive, *Prayer Mat* references the carpets placed on the ground by Islamic worshippers to face Mecca, which sometimes have an embedded compass, like Hatoum's. The carpet of thousands of pins also recalls beds of nails and minimalist sculpture. The work was made in her studio by assistants, who slowly pushed one pin at a time through the base fabric until the entire surface was covered, in a procedure not dissimilar to the tying of individual knots to make traditional carpets.

RIGHT **James Lee Byars**, <u>THE HALO</u>, 1985, brass ring, gold polished, 220 x 220 x 20 cm

The circle was one of the perfect shapes Byars constantly sought out in his art. This enormous brazen ring, designed to lean against the wall, is brass on the inside and gold on the outside. In Byars' work, gold is an omnipresent but ambivalent symbol; its connotation of idealized beauty aligns it with elusive perfection. This and other gold pieces were made for Byars by traditional metalsmiths in Giza, Egypt.

'I am the idol thief. I steal from the drama of Hindu life. And from the kitchen – these pots, they are like stolen gods, smuggled out of the country.' Subodh Gupta

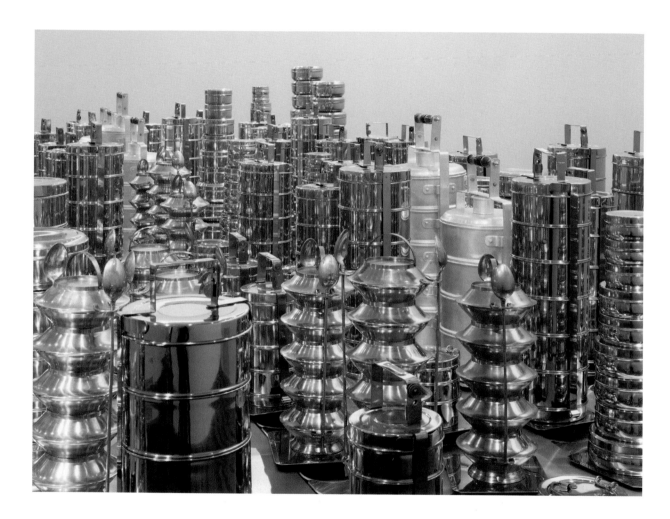

ABOVE **Subodh Gupta**, <u>FAITH MATTERS</u>, 2007–10, sushi belt, motor, steel, stainless-steel, aluminium and brass utensils, dimensions variable (detail)

Gupta (b. 1964, India) is best known for incorporating everyday Indian objects, such as steel tiffin boxes, thali pans, bicycles and milk pails, into complex yet stunning sculptures. These extraordinary structures made from ordinary items reflect on changes in India since Gupta's youth. 'All these things were part of the way I grew up. They are used in the rituals and ceremonies that were part of my childhood.' By appropriating everyday objects and turning them into art works, he is following in the tradition of artists such as Duchamp. In this way, Gupta succeeds in finding a language that references everyday life in India but is understood internationally.

OPPOSITE **Subodh Gupta**, <u>LINE OF CONTROL</u>, 2008, stainless-steel and steel structure, stainless-steel utensils, 1000 x 1000 x 1000 cm

Exhibited at Tate Britain in London in 2009, Gupta's monumental mushroom-cloud sculpture made from cooking utensils refers to the contested border territories of Kashmir between India and Pakistan. While the viewer may marvel at the artist's imagination and creativity, Gupta himself feels that the key component in his art is the transformation of everyday objects, and he confesses that he doesn't in fact create anything, 'I transform. My job as an artist is to think, to conceive the ideas. My art is made up for me by expert artisans all over the world: the thali works were made in America.'

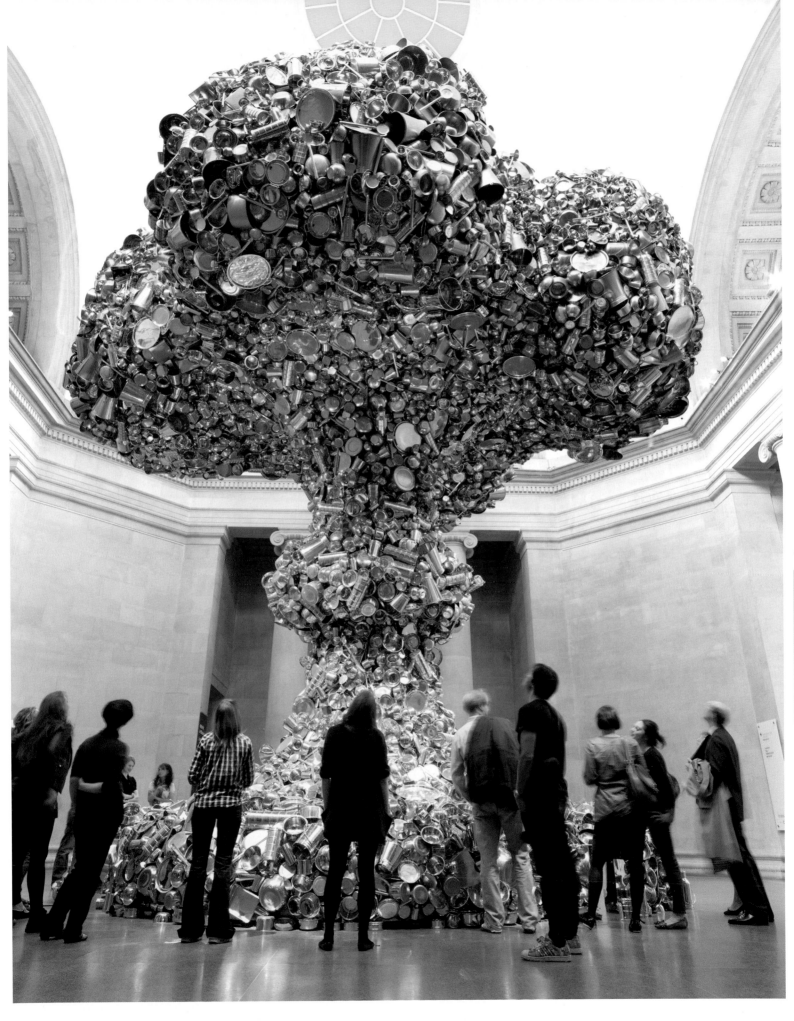

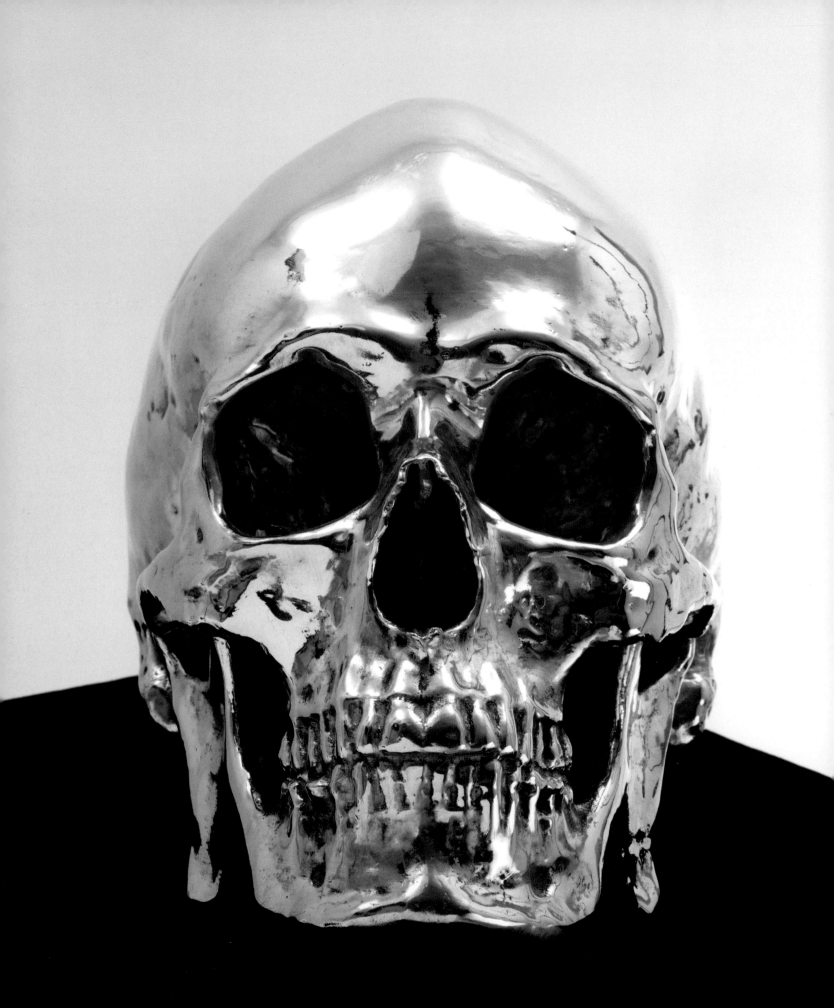

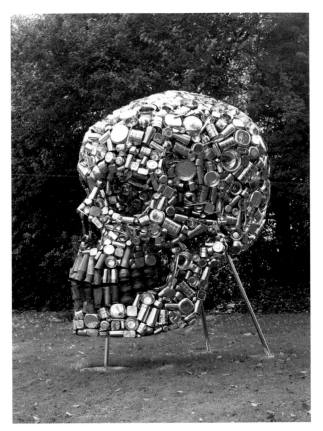

LEFT **Subodh Gupta**, MIND SHUT DOWN, 2008, stainless steel, old utensils, 240 x 150 x 205 cm
Weighing more than a ton and towering over the viewer, Gupta's various giant skulls made from cooking pots and buckets have been exhibited in European cities such as Venice, Moscow and Paris – one even crossed the Atlantic to find a temporary home in Chicago – changing with each new cultural context. The use of the tiffin is much more than the practicality it symbolizes; it is about the love that goes into food preparation and the central role it plays in the Indian household. Speaking about borrowing from this most sacred of places in an Indian home (Indian kitchens usually house the family idols and cannot be entered with shoes on), Gupta says: 'My work is about where I come from. Hindu kitchens are as important as prayer rooms. The mediums I pick already have their own historical and cultural significance. I put them together to create new meanings.' As with other works by Gupta, the skull was fabricated by workers to his design.

RIGHT **Sherrie Levine**, STEER SKULL, UNHORNED, 2002, bronze, 31 8 x 45.7 x 49.5 cm, edition of 12
Levine's recontextualization of other artists' work questions the authenticity and autonomy of the art object and its status as a commodity. She challenged Duchamp's concept of the readymade by having found objects such as an animal's skull cast in bronze. By using painstakingly polished and gilded metal, Levine turns these everyday objects into 'high art'. Commentators often state that these pieces refer to the work of modernist sculptors such as Brancusi or Arp. However, this was unintentional for Levine, an unexpected result of her use of others to produce the objects. 'When I got the first one back, I was totally amazed at the reference to Brancusi and Arp. I wasn't expecting that at all, but once I actually saw it, the similarity was unmistakable.'

OPPOSITE **Kris Martin**, STILL ALIVE, 2005, silver-plated bronze, dimensions of the artist's skull, edition of 5 plus 1 artist's proof
Martin's *Still Alive* features a human skull that is exactly the same size as the artist's own head. Like a historic still-life memento mori, it reminds the viewer of the fragility and temporary nature of life. The work was made for Martin by Art Casting in Belgium.

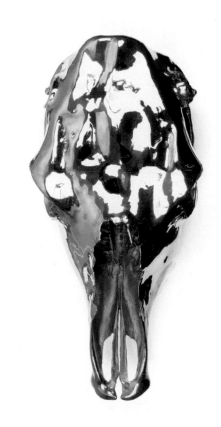

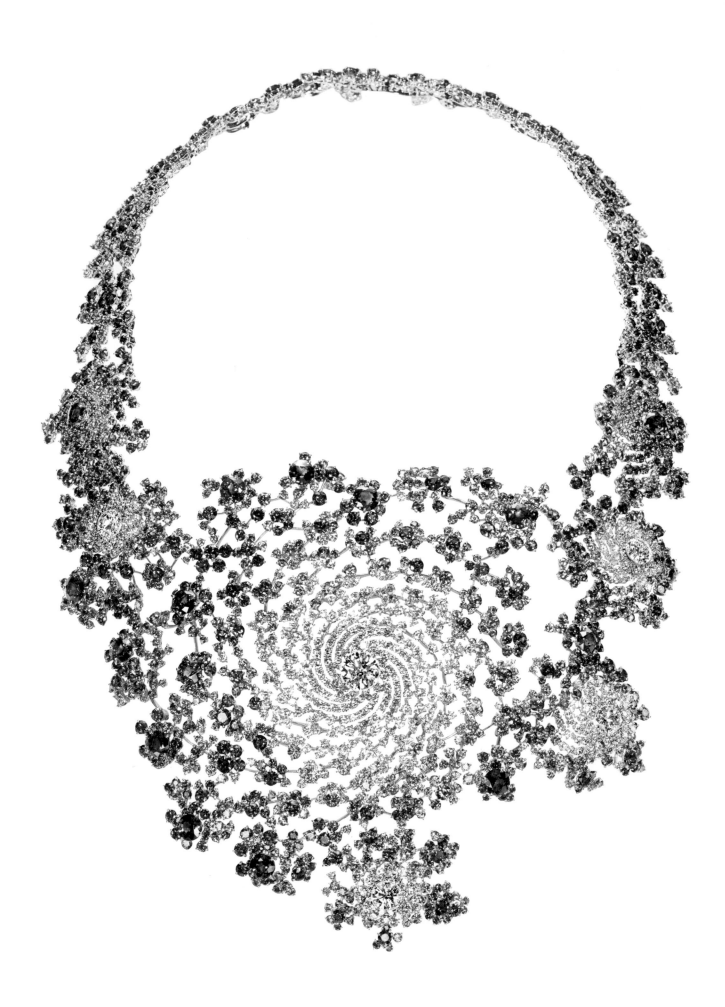

OPPOSITE **Marc Newson**, <u>JULIA NECKLACE</u>, 2009, diamond, sapphire, dimensions variable
Newson (b. 1963, Australia) is an industrial designer by training who has straddled the fine art /
craft / design divide to such an extent that he is the first designer to be represented by the
Gagosian Gallery, one of the world's top contemporary art spaces. He has worked in a variety
of media, including marble, metal, and wood. His *Julia Necklace* for Boucheron jewellers in Paris
is based on the mathematics of fractals, first explored by French mathematician Gaston Julia in
the early twentieth century. The white-gold necklace took craftsmen 1,500 hours to make, and used
2,000 sapphires and diamonds (including five round diamonds from 0.75 to 2.50 carats). It was made
using rapid-prototyping, and all the stones are secured in three-pronged settings, giving the visual
effect of the stones floating.

ABOVE **Anika Jamieson-Cook**, <u>ARGOS</u>, 2009, gold,
3.8 x 1.3 cm on 38.1 cm chain
Jamieson-Cook (b. 1983, UK) has created a series of jewelry
pieces by having them manufactured at low-cost chain
stores. For this particular one, she went to the Peckham
branch of Argos, a popular high-street store, and asked
for their custom jewelry service to make a name necklace
using the name of the retailer itself and the typeface used
for its logo. The work was part of an exhibition 'Shop Shop',
which looked at the relationship between art and commercial
products, and which was itself presented in a disused shop.

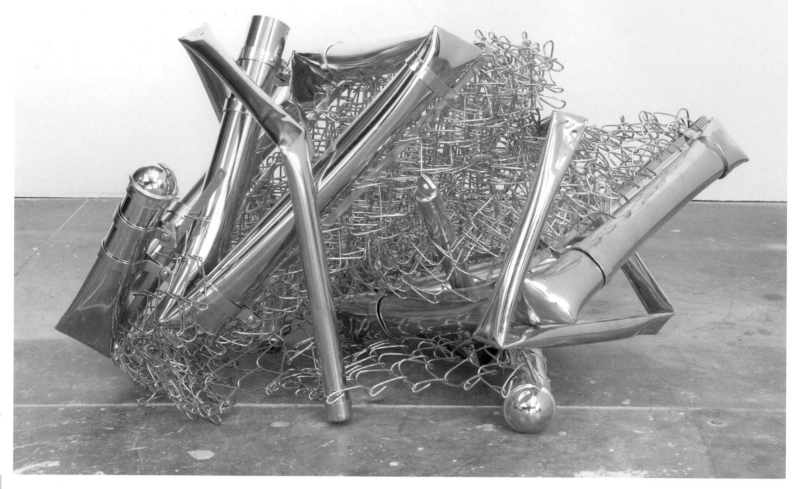

'I have collaborated with professionals and craftspersons many times. It is the nature of my practice to contact people in order to fill the skills I lack. I usually just focus on what I'm good at, although I'm still figuring out what that is.'

Aaron Young

RIGHT **Saint Clair Cemin**, THINKER (PENSADOR), 2008, hammered copper, 104 x 114.3 x 95.3 cm
Saint Clair Cemin has had two versions of this sculpture made for him by his fabricators in China,
one in stainless steel in 2006 and this later one in copper.

OPPOSITE ABOVE **Aaron Young**, <u>TUMBLEWEED (CRUSHED FENCE)</u>, 2009,
24-carat gold-plated steel fence, 66 x 92 x 84 cm
Collaboration is at the heart of Young's (b. 1972, US) work. He has hired people
who are stereotyped as rebels (for example, skateboarders, motorcyclists)
to take part in his action-based performances, and professional glassmakers
and goldsmiths to fabricate other works for him. In a number of pieces,
he has crushed or smashed up fences and crowd barriers and then
had them professionally gold-plated.

BELOW **Roni Horn**, <u>PAIRED GOLD MATS, FOR ROSS AND FELIX</u>, 1994–5, two
pure gold mats, 152.4 x 124.5 x 0.002 cm
Horn's interest in the double and difference has often had a subtle erotic pull to it,
as in the photographs of herself as a child and later as her more androgynous self.
This piece sees two sheets of beaten pure gold, hammered to a thousandth of an
inch, nestled together in an intimate coupling. The title refers to artist Felix
Gonzales-Torres and his lover Ross Laycock, who both died from AIDS-related
illnesses. As Horn describes it, 'One mat is placed on top of another. From
between them, firelight glows. It peeps and seeps out from the edges. The light
is the gold reflecting off itself. Here is the metaphor for intimacy. Here is the
eroticism, the splendour and mythology of gold.'

OPPOSITE **William Cobbing**, CLAPPER TONGUE, 2009, bronze, rope, electrical strike hammer, 50 x 39 x 28 cm

Cobbing (b. 1974, UK) made several site-specific works for a residency at Berwick Gymnasium in the north-east of England. The area has long been a site of invasion, and has many ruined Elizabethan forts and World War II concrete bunkers. *Clapper Tongue* is a 45-kg bronze life-cast portrait bust in the form of a bell. Its title not only refers to the parts of bells, known as the crown, ears and eyes, and tongue, but also hints at the obsolescence of the disused bell tower in the town, where a bell was formerly used to warn of impending attack. Cobbing has his bronze work cast at foundries in the UK and Italy.

William Cobbing, GRADIVA PROJECT, 2007, cast iron, 67 x 48 x 1.4 cm

Cobbing's *Gradiva Project* featured a cast-iron manhole cover bearing the image of Gradiva (meaning 'beautiful step'). It refers to the character of a gothic novella in which an archaeologist falls in love with the image of a woman from ancient Pompeii. At the time, Cobbing was artist-in-residence at the Freud Museum in London. Sigmund Freud was fascinated by the story of Gradiva, whom he interpreted as a symbol of healing, and he used it as the basis for his comparison of archaeology with psychoanalysis – that is, the excavation of repressed desires through analysis. He even displayed a bas-relief plaster cast of the young woman in his study. Cobbing transferred the image onto a manhole cover the exact size of those found in Italy, which was temporarily installed in place of existing covers in Rome and Pompeii. The sturdy cover was made to be walked on and is now permanently sited in the garden of the Freud Museum.

LEFT **Joseph Havel**, <u>VOID SUMMARY</u>, 2009, bronze, 188 x 61 x 56 cm
Havel (b. 1954, US) creates text pieces from shirt material sewn and wound around wire, which are then dipped in wax and cast by the Ken King foundry in Houston, Texas. The company specializes in thin and delicate castings made from the 'direct burn-out' process. A ceramic mould is formed around the original art work, which is made out of a combustible material such as wood, paper or fabric. The art work is then burned away, leaving a void to be filled by molten bronze.

OPPOSITE **Liam Gillick**, <u>ÖVNINGSKÖRNING (DRIVING PRACTICE PARTS 1–30)</u>, 2004, powder-coated aluminium, thirty elements, each approx. 243.8 x 30.5 x 1.3 cm
Liam Gillick (b. 1964, UK) designs highly sophisticated objects that appear to be sculptures or architectural features, but are intended to be sites where complex discussion on topics such as modernism and capitalism (and their failure) can take place. *Övningskörning (Driving Practice Parts 1–30)* was the first part of his ongoing fictional work-in-progress and related works entitled *Construcción de Uno*, about a group of ex-workers of a Volvo manufacturing plant in Brazil who return to the site after it has closed down and improvise new production methods using redundant factory signage. The project began in 2000, when Gillick was part of a competition to redesign the town square of Kalmar, Sweden, the town where in the 1960s Volvo had instituted its socialistic approach to car manufacturing. While the factory was already closed when Gillick first visited Kalmar, it became the starting point for his investigation into what might have happened after the experiment was concluded. The piece shown here, which was displayed at the Milwaukee Art Museum, is made up of thirty powder-coated aluminium elements, representing the first thirty lines of this story. It consists of that number because the galleria in which it was installed had thirty arches. Like most of Gillick's work, it was produced by an outside firm of fabricators.

an experimental factory
recent closure of the plant
primary activity produce objects
methods of production to alleviate
the most destructive aspects of life
on the production line
subsequent take over and closure
all the remaining work
could we send if we stop

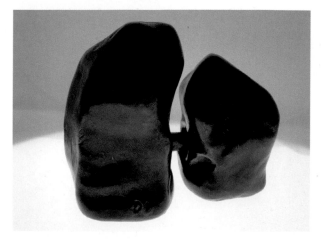
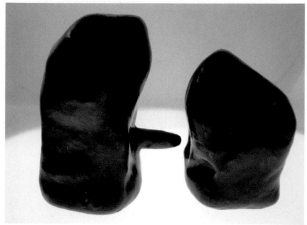

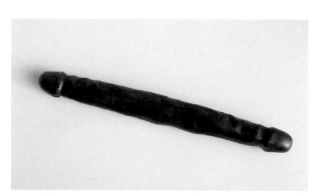

ABOVE **David Ivie**, <u>COPULATING ROCKS</u>, 2009, bronze and lead, 13 x 6.5 x 10 cm

Ivie's (b. 1962, US) *Copulating Rocks* are from a whimsical series of works with dark undertones. These small, hand-sized bronzes address topics such as murder, smoking and eroticism. Part of their appeal is being able to handle them and help them perform their title. Better known as a painter, Ivie has his sculptural objects cast by Damon Rawnsley at the Crucible Foundry, London, and finished by Sam Dalton and Yunus Ascott.

CENTRE LEFT **Michael Petry**, <u>THOR</u>, 2001, bronze, 45.7 cm length, 15.2 cm girth, edition of 2

While curator at Oslo's KunstAkademit, Petry was challenged by his students to create a bronze work that would allow them to carry out the actual casting process. He presented them with a rubber double-headed sex toy bought from an adult store and asked them to cast and patina it to resemble the original.

BOTTOM LEFT **Angus Fairhurst**, <u>UNDONE</u>, 2004, bronze, 61 x 274 x 137 cm, edition of 3

Fairhurst (1966–2008, UK) made a series of comic works about the world of gorillas, including this giant bronze banana. His metal sculptures were made at Pangolin Editions, one of Britain's leading foundries specializing in lost-wax and sand casting.

OPPOSITE **Liliane Lijn**, <u>WHITE KOAN</u>, 1971, painted mild steel, neon tubes, electric motor, 610 cm high x 366 cm base diameter

One of the pioneers of kinetic art, Lijn (b. 1939, US) has long used the technical expertise of others to realize her art. Her first large-scale metal piece was *White Koan*, a revolving and illuminated conical structure made by a London steelworks. As the cone revolves, the neon ellipses expand and contract the spaces between them. At night, it dissolves into the shadows, leaving the rings floating in space. It is now at the University of Warwick.

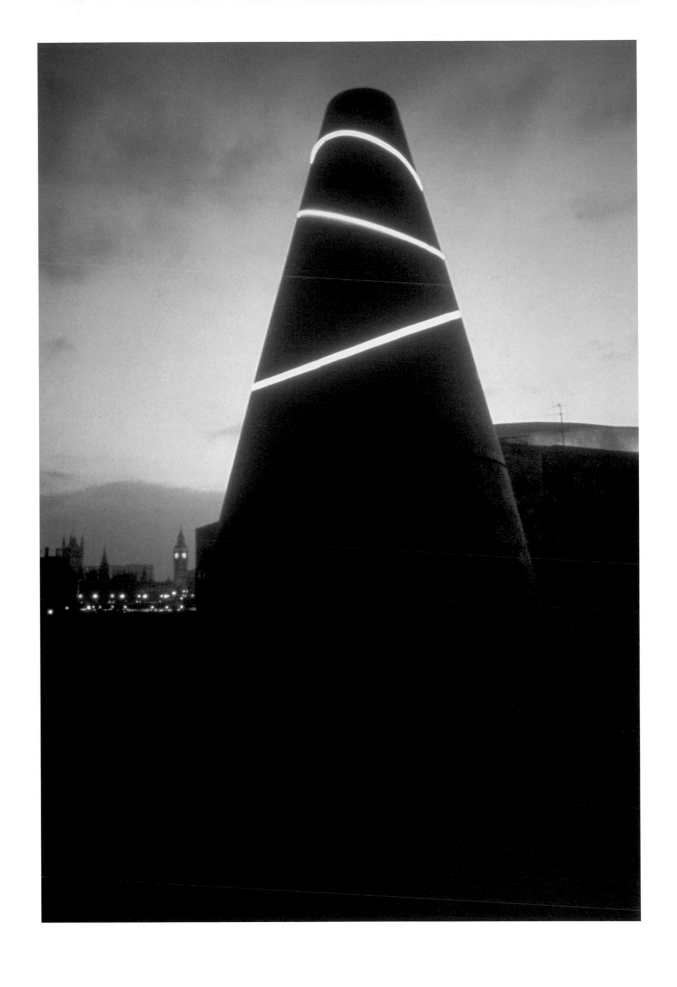

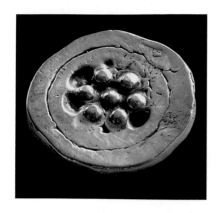

ABOVE **Marcel Duchamp**, <u>BOUCHE-ÉVIER</u>, 1964, lead, 7.5 cm diameter

RIGHT, FROM TOP **Dhruva Mistry**, <u>MAYA MEDALLION – THE DARK ONE</u>, 1988, cast bronze, 13.3 cm, edition of 56
Mistry (b. 1957, India) is one of many artists commissioned to design medals for the British Art Medal Society. He has produced two for the Society: this and the *Humanity Medal* below.

Rob Kesseler, <u>BOOK OF LEAVES</u>, 1991, cast bronze, 7 x 7.8 cm
Kesseler's (b. 1951, UK) bronze leaf was also commissioned by the British Art Medal Society and cast by the Nautilus Foundry in London.

Dhruva Mistry, <u>HUMANITY MEDAL</u>, 1994–7, cast bronze, 9.5 cm diameter

Cornelia Parker, <u>WE KNOW WHO YOU ARE. WE KNOW WHAT YOU HAVE DONE</u>, 2008, struck silver, 3.8 cm diameter, 0.4 cm thick
Parker (b. 1956, UK) designed this medal featuring the back of Tony Blair's head on both sides for the British Museum exhibition 'Medals of Dishonour' in 2009.

Presented to

DEAN ROWBOTHAM

for breaking his **ASBO**

on more than 20 occasions

WHAT HE DID:

Issued threats of violence

Was verbally abusive

Harassed residents of Hartlepool

Caused a nuisance while under the

influence of alcohol in public

Damaged property

Threw missiles

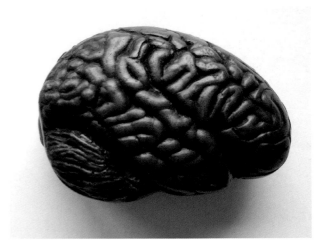

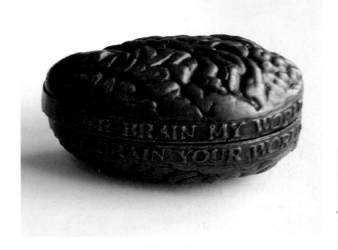

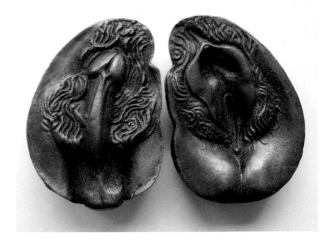

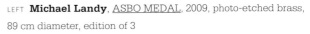

LEFT **Michael Landy**, <u>ASBO MEDAL</u>, 2009, photo-etched brass, 89 cm diameter, edition of 3

Landy's (b. 1963, UK) *ASBO Medal* was commissioned by the British Art Medal Trust for the 'Medals of Dishonour' show. It commemorated a notorious English hooligan breaking his anti-social behaviour order for the twentieth time and listed his many offences.

ABOVE **Bill Woodrow**, <u>OUR WORLD</u>, 1997, bronze, 5 x 3.5 cm, cast by Niagara Falls Casting for the British Art Medal Society

Barry X Ball · Louise Bourgeois · Scott Burton · José Damasceno · John Frankland · Gary Hume · Kris Martin · Marc Newson · Not Vital · Pae White

Stone

The use of stone as an artistic medium far precedes that of all other materials. As early as 2,500,000 BC, early humans made stone tools, while more crafted objects such as blades and axes date from the Paleolithic period (1,500,000–10,000 BC). The Venus of Tan-Tan, found in Morocco, is thought to be the oldest stone figurative object and dates from between 300,000 and 500,000 years ago; and the Venus of Berekhat Ram, a carved pebble found near the Golan Heights, may date to 230,000 BC. Paintings on stone produced around 70,000 years ago have been found in the Blombos Caves in South Africa, and carved stone cupules dating back to 70–40,000 BC have been discovered at the La Ferrassie Cave in France. Perhaps the most famous prehistoric stone object, the Venus of Willendorf from Austria, is between 23,000 and 26,000 years old. The Mesolithic period (up to 4000 BC) brought more realistic depictions, including the Fish God found at Lepenski Vir in Serbia, dating from 7,000 years ago. The Neolithic period (4000–2000 BC) saw permanent settlements, the evolution of organized religious groups, and the development of writing, art, and architecture. The emergence of huge stone buildings such as the Pyramids, with their stone sculpture and hieroglyphics, saw art production become formalized.

In the ancient and classical periods, stone works became highly prized. The Egyptians used stone to create vessels for use in the afterlife, body decoration, and votive objects. Minoan and Greek culture produced some of the finest stone carvings ever created, culminating in the works in the fifth century BC for the Parthenon. The Romans, too, created many marble sculptures. In the second century AD, Emperor Hadrian commissioned statues of his great love, the young man Antinous, that adorned temples across the Roman Empire.

The Christian era saw stone become an important element in churches across Europe. Stone sculpture was placed inside the buildings, as well as externally as objects of veneration and education. Further east, the monumental Buddhas of Bamyan from c. 600 were carved into cliffs in Afghanistan. On Easter Island in the Pacific Ocean, huge Moai standing stone sculptures were sited across the island from c. 1200.

The Renaissance witnessed a flourishing in the arts of stone carving, with Michelangelo's *David* and bound slaves among the finest examples. It was in this period that the area around Carrara, Italy, became to be linked in the greater imagination with marble production, as a source for the material and a centre for carving. It was common for established sculptors to have large studios where much of the manual labour was done by apprentices. The 'master' often only ever worked out the original design and finish of the sculptures, overseeing the creation of the form and final details. Gianlorenzo Bernini, who worked in Rome in the early seventeenth century, had his best-known marble statues completely carved by assistants (using only small models he had made). This included his *Apollo and Daphne* (1622–5), carved by Giuliano Finelli, who fell out with Bernini over his lack of credit in its production.

Until the twentieth century, stone was used almost exclusively to produce figurative sculpture. But in the modern period, artists including Constantin Brancusi, Barbara Hepworth, and Henry Moore used the material to produce abstract forms. In his early years, Moore directly carved marble himself, but later he used assistants to produce large plaster and stone maquettes for his bronzes. Arno Breker, the sculptor of choice for Nazi Germany, had hundreds of assistants to help him create the many neoclassical figures representing physical prowess and Aryan might that Hitler's regime commissioned from him.

Towards the end of the twentieth century, fewer artists worked with stone, which had become an expensive material and perceived to be old fashioned. By the 1960s, carving was no longer routinely taught in art schools. The introduction of new media and ways of making work (video art, performance art, conceptual practice) saw stone more or less banished from contemporary practice. It was also linked with patriarchal traditions (not least because of artists like Breker), at a time when women artists such as Eva Hesse were challenging the historical canon and materials linked to it, preferring instead to make sculptural work out of newer materials such as latex and wax. That is not to say that feminist artists like Louise Bourgeois did not tackle the medium. However, those who did often had their work fabricated for them by craftspeople.

With the financial boom of the late 1990s and 2000s, and the consequent rise in the market for contemporary art, stone returned. As the price of artists' works soared, so did their ambitions. Jeff Koons's self-portraits and depictions of his then wife Cicciolina in white marble might be seen as the starting-point for this revival. Marc Quinn's deconstruction of the classical ideal and the 'neo-neoclassicism' of Koons could not be further apart, yet their sculptures are both fabricated in Italy following a similar production process, using the skills of local craftsmen. The artists featured in the following pages do not normally (if ever) lay hammer to stone themselves. Nonetheless, this chapter looks at how they all make extraordinary art with minimal knowledge or experience of working with stone.

STONE Gary Hume / Scott Burton

OPPOSITE **Gary Hume**, <u>MILK FULL</u>, 2006, marble, lead, 246 x 185 cm

Hume is well known for his lush paintings that use large flat areas of paint, often built up to relief form. In 2006, he showed his *Cave Paintings* for the first time. These large and heavy marble tableaux were made from a variety of stone pieces cut out like stained glass and then locked together with lead tracery. Hume's drawings – scaled up to life-size cartoons – were used to imprint the final design on the stone. This image was then laboriously chiselled out, and thin lead rods were hammered into the grooves by teams of workers. The resultant images recall Renaissance marble table-top marquetry or *pietre dure* mosaic, as well as Hume's own flat painted surfaces.

THIS PAGE **Scott Burton**, <u>THREE-QUARTER CUBE BENCH (ENLARGED VERSION, GROUP OF FOUR BENCHES)</u>, 1985–9/2003, radiant red granite, four pieces each 76.2 x 76.2 x 76.2 cm

Burton's (1939–89, US) early works in the 1960s were drag performances that evolved into tableaux vivants for groups of people. His sculpture developed out of the furniture he used as props in these performances, but they always remain part furniture, undermining the idea that art is somehow separate from everyday life. In the early 1980s, he produced a number of monumental pieces from boulders of rock, such as these interlocking granite chairs. He wanted his works to function both as lasting public art and collectable private objects and had them fabricated by highly skilled stonemasons.

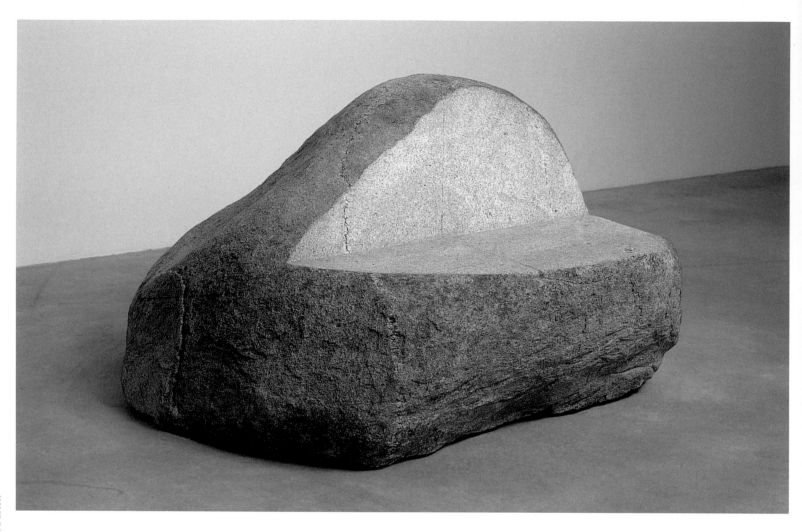

Scott Burton, <u>ROCK CHAIR V1</u>, 1981, sierra granite,
76.2 x 122 x 81 cm

BELOW **John Frankland**, <u>BOULDER (SHOREDITCH PARK)</u>
RIGHT **John Frankland**, <u>BOULDER (MABLEY GREEN)</u>, 2008,
granite, two pieces, each approx. 400 cm tall
Frankland (b. 1961, UK) is a sculptor whose large-scale internal
site-specific installations question the nature of both architecture
and sculpture. When he was commissioned to make a permanent
public piece for two parks in the London borough of Hackney,
he decided to place an enormous boulder of granite in each
one. The two boulders, each weighing around 100 tons
and approximately 4 metres tall, seem to have been simply
materialized in the space from nowhere. In fact, the whole
process of placing them there was a complex task involving
a large number of experts, including engineers, city planners,
risk assessors, dynamite technicians and a team of lorry drivers.
Frankland picked the already blasted rocks from the Carnsew
Quarry in Cornwall, and had them transported to London. The
two pieces are almost readymades, just very large ones. The
boulders are ideal for climbing on, and the public is encouraged
to do just that. Frankland discusses his practice on page 190.

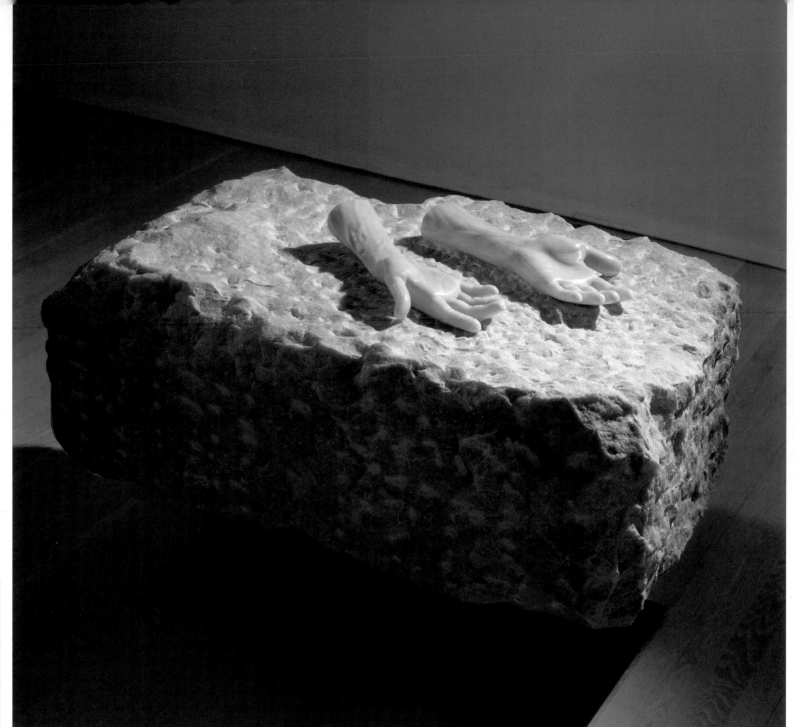

ABOVE **Louise Bourgeois**, <u>DÉCONTRACTÉE</u>,
1990, pink marble and steel, 72.3 x 91.4 x 58.4 cm
Bourgeois (1911–2010, France) was one of the
twentieth century's greatest sculptors. However,
she remained in relative obscurity until her later
years, and was only afforded the opportunity
to make a series of much larger works in her
eighties and nineties. The three 30-ft steel towers
that opened the Turbine Hall of Tate Modern
in 2000, and the giant spider *Maman* that stood
outside the gallery (made of steel and marble
and subsequently editioned as six bronzes),
were fabricated for her, as were the vast majority
of her late large-scale works. In her earlier works,
she did the stone carving, sewing, and casting,
but later she relied on a vast number of others
to realize the majority of her works. Bourgeois
was said to be the founder of a form of
autobiographical confessional work (which paved
the way for Kiki Smith, Tracey Emin and others)
and made a series of 'Cell' sculptures that
are highly claustrophobic and combine carved
marble and found objects to make prison-like
structures that viewers entered to experience
the work. The pieces depicted here are similar
to those often found inside her cells.

BELOW **Louise Bourgeois**, <u>UNTITLED (WITH GROWTH)</u>, 1989,
pink marble, 80 x 53.3 x 144.7 cm

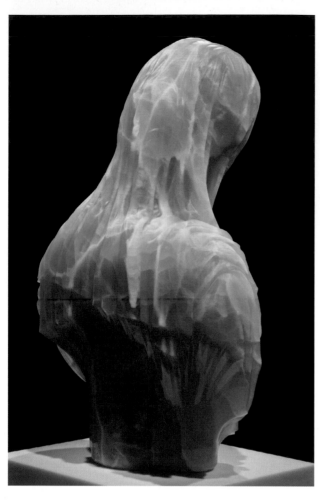

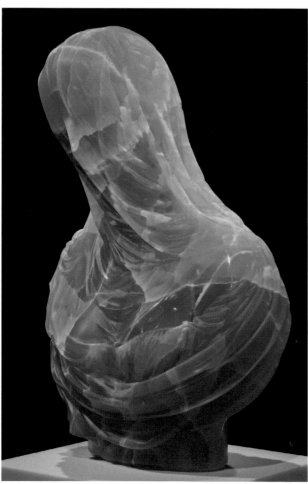

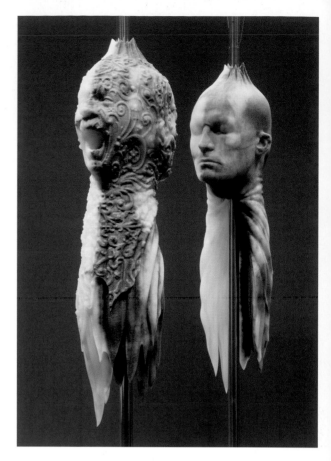

LEFT TOP AND BOTTOM **Barry X Ball**, <u>PURITY</u>, 2008–9, sculpture: golden honeycomb calcite, stainless steel, 61 x 41.9 x 28.6 cm; pedestal: Macedonian marble, stainless steel, wood, acrylic lacquer, steel, nylon, plastic, 114.3 x 35.6 x 30.5 cm

American sculptor Ball (b. 1955, US) combined contemporary and traditional techniques and specialist expertise to produce this modern take on a Baroque masterpiece. He began by using digital technology to scan *Purity* (*Veiled Woman*) by Antonio Corradini in the Ca'Rezzonico, Venice. A series of digital photos was taken and pieced together to form a virtual version of the appropriated sculpture and then digitally manipulated by the artist. The file was sent to an industrial stone-carving company, where two pieces of stone – one of calcite and one of onyx (see p. 100) – were shaped on computer-controlled milling machines. Next came days of meticulous machine carving, with multiple passes by progressively finer diamond tools. Months of hand carving and polishing followed, before the stone was finally masked, sandblasted, and oil-impregnated. The translucency of the two materials – not traditionally used in sculpture – creates the illusion of the sculpture emanating light, at once conveying the warmth of flesh and the diaphanous qualities of a veil.

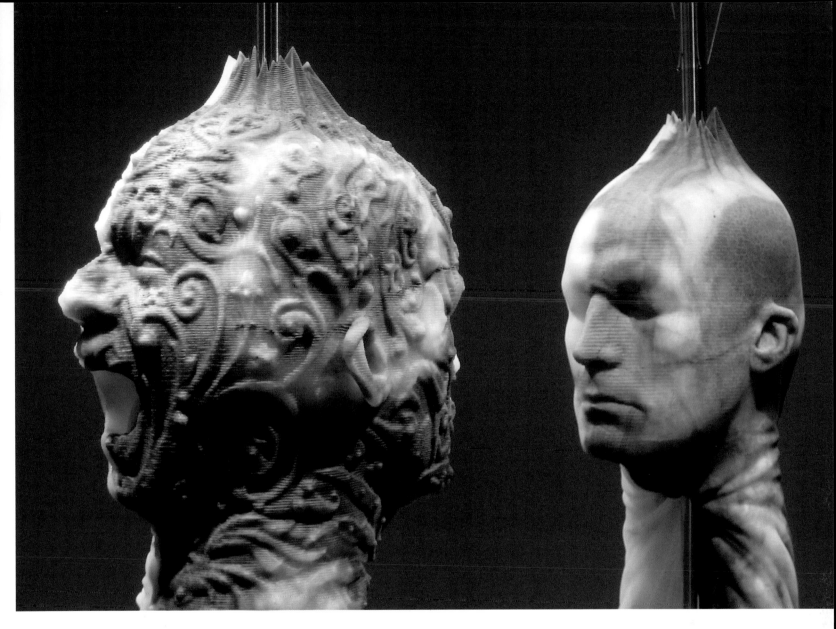

Barry X Ball, <u>DUAL-DUAL PORTRAIT (MATTHEW BARNEY / BARRY X BALL)</u>, 2000–7, Mexican onyx, stainless steel, 24-carat gold, various other metals; head/shaft assembly: each 139.7 x 13.3 x 20.3 cm; stone figures: each 55.9 x 13.3 x 20.3 cm

This macabre portrait of Ball's fellow American artist Matthew Barney skewered with 24-carat gold-plated poles was one of the first produced by the stone-carving company that Ball employed to manufacture his *Purity* sculptures. The process took almost three and a half years to complete and began with the artist taking a plaster life cast of Barney's face. Working from the cast, he made a plaster positive, which he sculpted by hand. A completed positive was then scanned using a laser to create a virtual model. The virtual model was stretched, shrunk and decorated before being sent to the computer-controlled milling machine. The treated onyx somehow does not seem like stone, but appears pliable and sagging like human skin. The viewer is baffled by the realistic likeness of the portrait, the natural striations in the stone, the overlaying of lace patterning and the minute bands of fluting across the pieces.

OPPOSITE **Barry X Ball**, <u>PURITY</u>, 2008–9, sculpture: Iranian onyx, stainless steel, 61 x 41.9 x 28.6 cm; pedestal: Macedonian marble, stainless steel, wood, acrylic lacquer, steel, nylon, plastic, 114.3 x 35.6 x 30.5 cm (detail)

ABOVE **Kris Martin** <u>MANDI VIII</u>, 2006, plaster, 220 x 150 x 100 cm, edition of 3 plus 1 artist's proof

Martin's *Mandi VIII* is a life-sized reproduction of the famous Laocoön sculptural group. The marble original (in the Vatican collection) depicts the priest from classical mythology Laocoön as he and his sons are killed by serpents sent by Poseidon for warning the Trojans that the horse with which they had been presented was a trap. Martin has had the serpents removed, and the figures seem to howl against a void, or perhaps against the void of death itself. The work speaks of modern, nameless or faceless fears that haunt contemporary society. It was produced for Martin by master craftsman Bernhard Gutmann and the Gipsformerei (Replica Workshop) of the Staatliche Museen zu Berlin.

José Damasceno, <u>DANCEFLOOR (STEP BY STEP)</u>, 2006, marble, dimensions variable

Damasceno (b. 1968, Brazil) is a sculptor who works with a wide variety of media, as well as collage and photography. For his exhibition 'Inframarket' at the Thomas Dane Gallery in London, he made a three-dimensional representation of a dancefloor using marble cut-outs of male and female dancers' steps. He said that he was fascinated at how musical London was and wanted to explore it metaphorically as well as physically. While most people would not naturally think of Britain as particularly rhythmic (as opposed to Brazil), the installation depicts a wonderful chaos of bodies in movement. The work was fabricated for Damasceno by the Chilean sculptor G-Z Arnold, who lives and works in Rio de Janeiro.

LEFT **Marc Newson**, <u>VORONOI SHELF</u> <u>(WHITE)</u>, 2006, Carrara marble, 180.1 x 279.9 x 39.9 cm, edition of 8
More art work than functional object, Newson's 'shelf' has been carved from one single piece of white Carrara marble. Newson has been at the forefront of designers who have actively worked to blur the boundaries between art and craft. Whether they are unique or highly limited editions such as this, his pieces are always produced to the highest craft standards. Newson has said of the marble pieces, 'Sometimes I start with the material, sometimes the idea. In this case the materials were the inspiration. I began by identifying materials that I had always been interested in but had never used. Often the context of materials strikes me more than the materials themselves. Context is new, not materials.'

OPPOSITE BOTTOM **Pae White**, <u>CORIAN® BED</u>, 2006, Solid Corian®, 800 pounds
weight, dimensions: Italian king size
White worked with graduates from Art Center College of Design in Pasadena,
California, to fabricate this large bed-frame sculpture carved out of Corian®,
a synthetic stone made by DuPont. The large heavy frame took on rococo aspects,
as the computerized router faithfully carved out flowers and the padded headboard
in great detail. The bed had a virginal quality to its creamy silkiness of surface
when shown, as *ghost*, with white bedding. White has said that she 'wanted
the "look" of something that might have been carved in the Black Forest,
but by an albino alien and I think we came pretty darn close.'

ABOVE **Not Vital**, <u>SLED (A)</u>, 2004, white marble, 100 x 100 x 25 cm
Not Vital has had a large number of marble works fabricated in Italy at
Pietrasanta, near Lucca. The town has long been associated with the production
of marble, and became important in the fifteenth century when Michelangelo
started to use the stone found there in his sculptures. The marble used for
David was quarried from Monte Altissimo, north-east of Pietrasanta. Not Vital's
use of traditional materials places him within a classical sculptural tradition,
but he translates these materials into unique forms. His marble sled is made
in the shape of two intersecting child-sized sleds, their crossed slats forming
a grid at the centre, and their perpendicular runners immobilizing the heavy
sculpture, which appears to be encased in ice.

Ghada Amer & Reza Farkhondeh · Pierre Bismuth · Peter Blake · Mara Castilho · Marc Camille Chaimowicz · Carlos Noronha Feio · Joseph Havel · Andy Holden · Gary Hume · Marya Kazoun · Grayson Perry · Maria Roosen · Rebecca Scott · Berend Strik · Do-Ho Suh · Fred Tomaselli · Patrick Traer · Gavin Turk · Kara Walker · Andrea Zittel

Textiles

Humans have used natural fibres to decorate themselves and their surroundings since prehistory. Animal furs may have formed the first wardrobes, but the production of textiles is probably older than pottery. Fabric is, of course, more fragile than stone sculpture or rock painting, and as such there are few early examples left. It is believed that the earliest textiles date to 6500 BC and were similar to felt. Simple fabrics were developed throughout the entire world around the same time, but in cultures with sophisticated forms of art (Egypt, Iran, China), highly decorated textiles were worn by rulers as a sign of their power. The Chinese produced expensive silks as early as 5000 BC.

The Silk Road, an ancient trading route from China to the Mediterranean, saw the finest fabrics traded and a dialogue begin between different cultures using fabric and colour as a universal language. Inks for dyeing were developed in China and Egypt around 2500 BC, although these were reserved for the ruling classes, who always had the best fabrics, the finest weaves, and the most expensive dyes. Tyrian Purple was worn by Greek nobility, and later by the Roman Senate, and later still by the Christian Church hierarchy and European kings. A pound of the dye required millions of molluscs and was more costly than gold. Similarly, in South America, Cochineal red (made from female beetles) was considered more important than the metal, which was more readily available. Blue Indian dyes represented the sky and good luck; and in the West, blue from the very rare and expensive mineral lapis lazuli, found in modern Afghanistan, was highly sought after during the Renaissance for depictions of the Virgin Mary.

Ornate textiles had great value not only because they were made from rare materials transported from afar, but also because they required an enormous amount of labour. Sometimes, this meant the handiwork of just one person over an extended period of time, but more often the production of fabrics involved the input of many pairs of hands. From its earliest days, then, textile manufacture was a collaborative process. The elites wore the finest clothes as an indication of their high status, but also of their ability to command a large retinue of workers. Gender politics also played a part, for these signs of patriarchal might were almost always produced by teams of women, establishing a division of labour that persists to this day.

Clothes were not the only form of labour-intensive textile used by the privileged to display their wealth. Rugs and wall hangings were also developed alongside bodywear. These highly crafted objects not only served a practical purpose, providing warmth in drafty castles, they were also highly decorative and soon became prized and portable art works. The Hestia tapestry woven in Egypt from wool and linen in the sixth century AD depicts the Greek goddess of the hearth and is one of the first known Byzantine textiles. Its beautiful naturalistic forms were perhaps a model for later medieval Christian narratives in fabric, such as the French *Apocalypse of Angers* tapestry (1373) or the *La Dame à la licorne* (The Lady and the Unicorn) tapestries woven in Flanders at the end of the 1400s from designs produced in Paris. Such works required the creative input of many highly skilled individuals, from the artist who created the image to the craftspeople – dyers, weavers, seamstresses – who executed his (and it usually was 'his') intentions. In the early sixteenth century, Raphael employed a team of dozens to produce a series of tapestries for the Sistine Chapel depicting his Gospel scenes.

Chinese, Indian and Afghan rugs decorated palaces and more modest homes until the twentieth century. While practical objects, they were also often the only source of art or design in the homes of the majority. By the end of the nineteenth century, William Morris had created a revival in tapestry, employing several artists of the day to design pieces for him. In the twentieth century, artists in Russia and Germany sought to bring art to the masses by using industrial processes, and functional objects such as clothes, rugs and wall coverings were one way of doing so.

Today, artists continue to design wall and floor textiles, and occasionally clothing, which are produced by workers in various parts of the world. Sometimes, the use of others goes beyond mere practicalities and is a central element of the artistic concept. Famously, the Italian artist Alighiero Boetti had his embroideries made in Afghanistan by traditional craftswomen, providing them with much-needed income as part of the conceptual nature of his work. Similarly, others in this chapter, including Do-Ho Suh, Gary Hume, Grayson Perry, Mara Castilho and Fred Tomaselli, employ teams of highly trained specialists, who have learned their trade over a lifetime, to make fabrics and tapestries meticulously by hand to order. Andy Holden, Patrick Traer and Maria Roosen, meanwhile, deliberately challenge the gender divisions inherent in textile production by working with female knitters or seamstresses to produce large, monumental or 'masculine' objects. Joseph Havel, on the other hand, uses mass-production clothing manufacturers to create delicate works that contrast a fragile appearance with bold titles such as *Lust* and *Desire*.

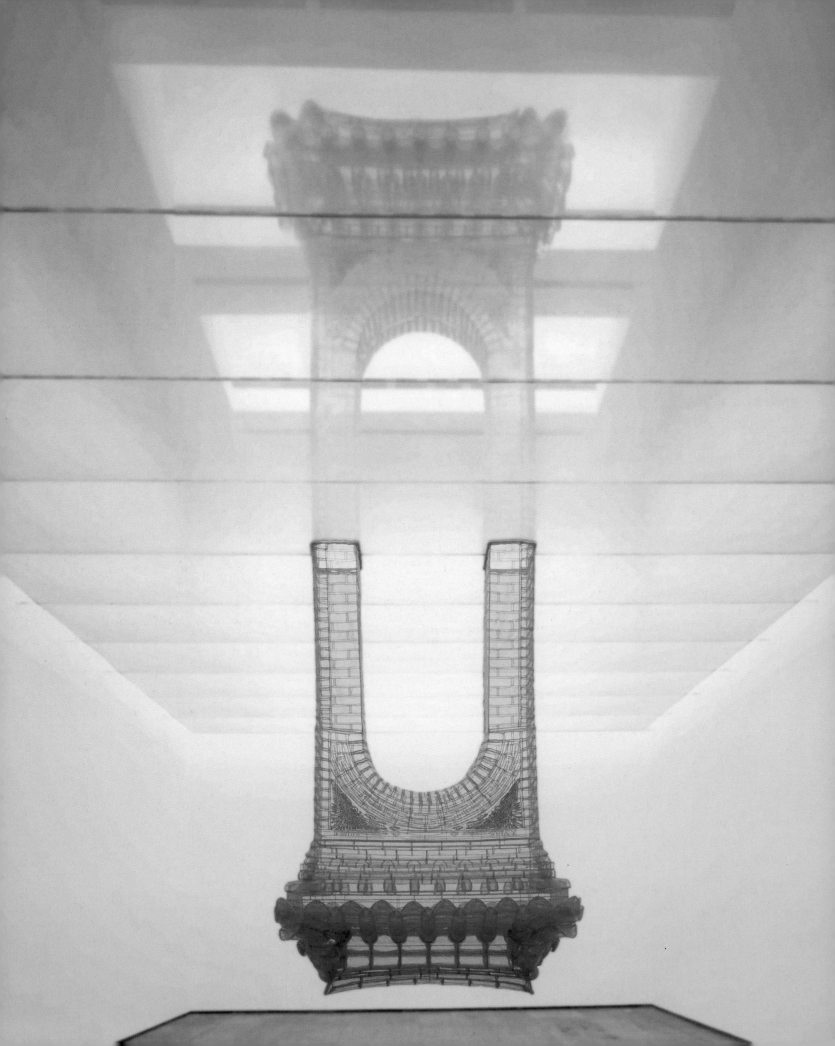

OPPOSITE **Do-Ho Suh**, <u>REFLECTION</u>, 2004, blue nylon and stainless-steel tube, dimensions variable, edition of 2

Reflection is a replica of the gate between the main house and the children's bedroom of Suh's parents' home in Korea, crafted entirely from sheer blue nylon and suspended upside down in the middle of the gallery. Suh has re-created all of the detailing of the original gate, from the dragon design to the brickwork. It seems to hang from a ceiling made from similar fabric stretched across the space. But above, a second gate stands right way up, a perfectly identical mirror image. The transparent walls allow the viewer to see the structure as if on a computer CAD system or in X-ray, undermining the solidity of space.

BELOW **Do-Ho Suh**, <u>THE PERFECT HOME II</u>, 2003, translucent nylon, 279.4 x 609.6 x 1310.6 cm

The translucency of Suh's works, such as this replica of his New York apartment, evokes the paper walls of traditional Korean homes and the thin fabrics of Korean costumes, but also signals the fact that they are not the real thing. 'In my world I don't create the space out of nothing', he says. 'Because it is about the memory, I wanted to use a material that renders this idea of nothingness.' As Suh's projects become ever more ambitious, he needs to draw on a wealth of expertise. As a result, he employs forty people, from sculptors to architects and product designers, in an operation that is more like a factory than a traditional artist's studio.

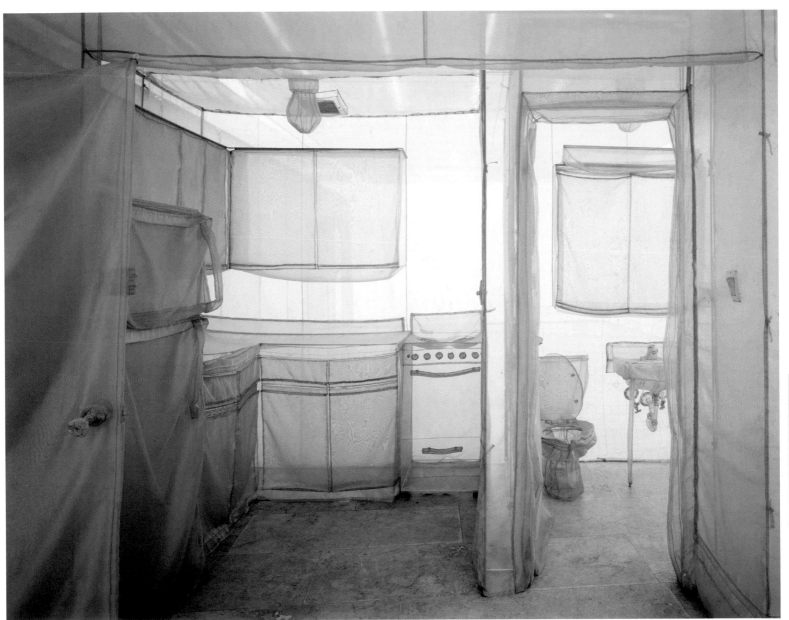

'I get involved in the craft aspect of the work but, rather than getting bogged down in making things, I prefer to look for new ideas and resolve new problems. So although I'm not a conceptualist, I like to teach other people to do the work for me; even my paintings are done with assistants.' Ghada Amer

Andy Holden, PYRAMID PIECE, 2008, knitted yarns, foam, steel support, 550 x 450 x 300 cm (installation view Tate Britain) Holden (b. 1982, UK) has made a series of works using the services of others, assisting them where possible or relying on them completely. In a work called *Cherry Grabber* (2006), he put up posters in his local shop asking for ladies to knit objects from paintings. From that project, he met a woman called Gillian, an experienced knitter, with whom he now works regularly. Gillian mocks up a model and then consults with other knitters to find the best way to make the piece. Holden worked in this way to create *Pyramid Piece*, a monumental replica of a stone he had stolen from the pyramid of Cheops in Giza as a child. Thirteen years later, he returned the rock to its original place, and had the knitted version made from paintings, photos and drawings.

RIGHT **Kara Walker**, <u>A WARM SUMMER EVENING IN 1863</u>, 2008, wool with hand-cut felt silhouette figure, 175 x 250 cm, edition of 5

BOTTOM RIGHT **Ghada Amer & Reza Farkhondeh**, <u>THE BUGS AND THE LOVERS</u>, 2008, wool with attached silk bugs, 154 x 232 cm, edition of 5

In 2008, Christopher and Suzanne Sharp, founders of the London-based The Rug Company, devised an exhibition of newly commissioned tapestries by fourteen artists from across the globe called 'Demons, Yarns & Tales: Tapestries by Contemporary Artists'. They chose to invite artists whose production did not normally involve craft processes. Walker (b. 1969, US), Amer (b. 1963, Egypt) and Farkhondeh (b. 1963, Iran) all created works for the show, alongside other artists from Britain, the US, Europe, Brazil and Pakistan. All of the designs were woven by Chinese workers in a factory near Shanghai that used traditional Flemish weaving methods. Tapestry was not a craft tradition of the area, and the work was carried out part time by women who otherwise laboured on local farms. Some of the pieces required very complex and detailed handiwork, and in some cases the weaving took over three years to complete. The expense and work involved precluded the possibility of the tapestries being manufactured in the West.

LEFT **Mara Castilho**, <u>HEART</u>, 2010, cotton
and blue thread, 50 x 50 cm; translation:
'As if a volcano cracked my soul and
I fall into the beginning of endless pain'
BOTTOM LEFT **Mara Castilho**, <u>FULL HEART</u>,
2010, cotton and blue thread, 50 x 50 cm
Mara Castilho (b. 1972, Portugal) works
across many media, especially video
and photography. In her native Portugal,
many mental patients and elderly are
housed in religious institutions, and
often help pay for their keep by doing
handiwork. Castilho commissioned
a group of elderly ladies belonging
to the association AURPIA (Assoçiacão
Unitária de Pensionistas e Idosos
de Azeitão) to make a series of
hand-embroidered handkerchiefs,
which are poignant reminders
of mortality.

OPPOSITE **Gary Hume**, <u>GEORGIE AND
ORCHIDS</u>, 2008, wool with raised silk
embroidery, 250 x 205 cm, edition of 5
Hume produced this tapestry of his wife,
the artist Georgie Hopton, and flowers
for the 'Demons, Yarns & Tales' show.
It is based on one of the 'Water Paintings'
he showed at the 1999 Venice Biennale.
'I've always loved tapestry,' he explains.
'It was really good for me because it has
very little pictorial depth – things float
in space, and nothing recedes; it's all
on the same plane – which is how I paint.
And it's interesting to see what happens
to your work when the materials change.'

RIGHT **Berend Strik**, <u>FARADIS, ARABIC CITY</u>, 2009, C-print with embroidery and fabric, 100 x 150 cm

BELOW **Berend Strik**, <u>MAMA LOVES YOU</u>, 2005, C-print with embroidery and fabric, 80 x 80 cm

Strik (b. 1960, Holland) starts with large-scale photographs (taken by him), which are then hand sewn and embroidered with many layers of fabric – often coloured gauzes or organza – to create hybrid images of great subtlety and complexity. The images sit between photography and painting, and between two- and three-dimensional work. Recent works such as these were completed using the sewing skills of Tatjana Panti, Ljiljana Lili Ravnjak, Junko Murakawa, Bojana Panevska, Andreja Leki, Janneke Laheij and Gina Ubels. It is Strik's vision and supervision of the craftwork that makes these objects so challenging.

THIS PAGE **Marya Kazoun**, SELF-PORTRAIT, 2003, installation and performance, fabric, thread, plastic bags, stuffing, mirrored glass, dimensions variable

Lebanese-Canadian artist Kazoun (b. 1976, Lebanon) investigates the intimate and personal memories of her childhood in war-torn Lebanon in works that are created in a wide variety of media, including fabric, glass, and performance. She mixes humble and semi-precious materials to give life to her interior world, inhabited by horrifying and shocking figures. Although she makes some of the pieces in her installations, Kazoun also works with a number of skilled craftspeople to fabricate many of the objects, including the Berengo Studio on Murano for the black and silver glass pieces seen in the foreground and bedside table of *Self-Portrait*. In some performances, the performers are sewn into the objects; here, she inhabited the installation herself, immersing herself in her work, dressed by the image of her surroundings.

Marya Kazoun, <u>IGNORANT SKIN</u>, 2005, installation and performance, thread, fabric, beads, wool, stuffing, glue on canvas, performers, 1125 x 280 x 200 cm

Kazoun weaves and embroiders her imaginary spaces using beads, string, plastic, bamboo, bones and glass. She creates mystical and disturbing shapes and structures, which, at the same time, are beautiful, feminine and fascinating. She sometimes inhabits her own installations, as she did in *Crumbling Desert Castles*, commissioned for the 8th Sharjah Biennial in 2007, but often cedes control of the finished product to others, by employing the technical skills of live performers who inhabit her clothing-sculptures and installations. Literally sewn into the pieces, as here in *Ignorant Skin*, at the 51st Venice Biennale, the performers appear as integral parts of the wall, as well as independent bodies crawling around the disquieting space.

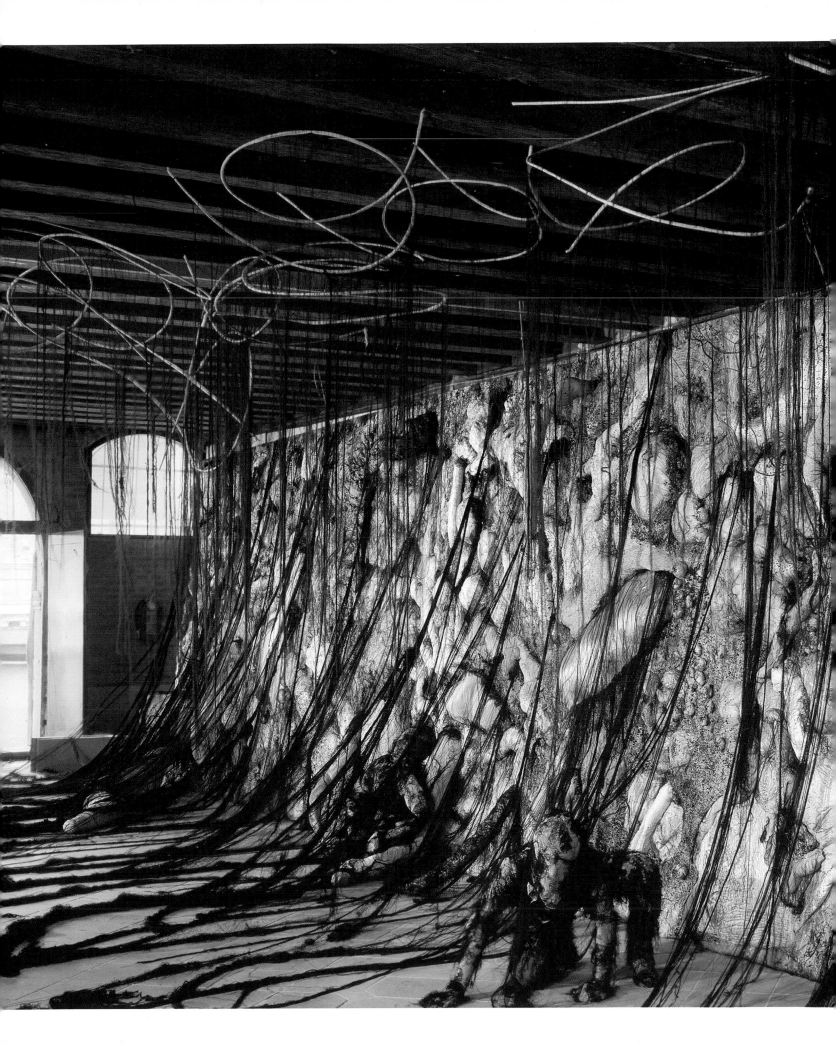

TOP **Fred Tomaselli**, <u>AFTER MIGRANT FRUIT THUGS</u>, 2008, wool background, silk birds with metallic thread detail, 250 x 160 cm, edition of 5
This tapestry was produced by Chinese workers for American artist Tomaselli's (b. 1956, US) contribution to the 'Demons, Yarns & Tales' show.

BOTTOM LEFT **Grayson Perry**, <u>VOTE ALAN MEASLES FOR GOD</u>, 2008, wool needlepoint, 250 x 200 cm, edition of 5
Best known for making his own pottery, Perry (b. 1960, UK) has created a series of tapestries after his participation in 'Demons, Yarns & Tales' with this piece.

ABOVE **Gavin Turk**, <u>MAPPA DEL MUNDO</u>, 2008, wool, silk tapestry and metallic thread tapestry, 313 x 200 cm, edition of 5

Turk's contribution to 'Demons, Yarns & Tales' pays homage to the earlier work of Italian conceptual artist Alighiero Boetti, who in the 1970s and 1980s had large embroidered tapestry maps produced for him by traditional Afghan weavers. Boetti's maps filled in each country with as much of its flag as could fit within its borders. Here, Turk acknowledges the spread of globalism (and its detritus) by covering all of the land with crumpled food, drink and tobacco packaging.

BELOW **Carlos Noronha Feio**, <u>THE END</u>
<u>(BIRTH AND FERTILITY – THE GOOD NEWS)</u>,
2008, wool Arraiolos, 173 x 202 cm
Carlos Noronha Feio (b. 1981, Portugal) has
created a number of rugs featuring scenes
of war and destruction. They are produced
by hand by women rugmakers in the town
of Arraiolos in Portugal, using a traditional
needlepoint stitching technique invented there.

OPPOSITE, TOP **Marc Camille Chaimowicz**,
<u>VERTIGINOUS PLEASURE</u>, 2009, mixed media,
dimensions variable
Chaimowicz (b. 1947, France) creates
installations that merge the domestic with the
museological space, arts and crafts with fine
art, and the banal with the literary. When he
was invited to create a new commission for the
Bloomberg SPACE in London, he was inspired

by the potential of contrasting the modern
office atrium with his own particular approach
to the decorative and chose to install a series
of moving 'magic' carpets. The installation
was originally planned for 2009 but was delayed
until the following year because the hand-tufted
rugs, made in France by Manufacture des Tapis
de Moroges to the artist's design, were held
up by UK customs officials.

OPPOSITE, BOTTOM **Pierre Bismuth**, <u>TAPIS</u>, 2006, wool, 320 x 220 cm, edition of 30
Bismuth (b. 1963, France) designed this carpet consisting of several differently
coloured parts, whose increasing size matches Fibonacci's number series,
for D&A Lab in Brussels. It is a modular system made up of separate carpet tiles,
which can be changed around, or even leave parts of the floor uncovered. With
the help of flooring specialists Limited Edition of Mouscron, Belgium, D&A Lab
specially developed a device for this purpose using Velcro. Except for the first two
black and white squares, each of identical size, the owner is at liberty to choose
the colours of the other parts. The carpet can be extended endlessly.

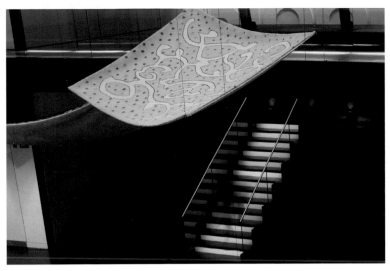

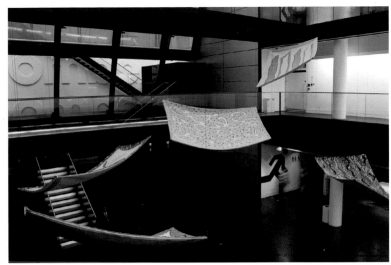

'I have never differentiated between the realms of art and craft. As an artist I am very hands on; everything done by me, by hand, with only one assistant, so jobbing out to a person whom I've never met and working in another country gave me some pause. But it's interesting to have the forms articulated by such great craftspeople.'

Fred Tomaselli

THIS PAGE **Rebecca Scott**, IMPERIAL SIZE BLANKET FOR THE DEVELOPING COUNTRIES, 1992, knitted acrylic wool, over three single beds, 276 x 200 cm

Scott's (b. 1960, UK) blanket was made for the 'Summer Lightning' show, an exhibition of eight women artists, at the Dreadnought Seamen's Hospital in Greenwich, London. The hospital had previously been used for treating sailors returning from overseas with venereal infections or tropical diseases. Scott had the individual squares of the blanket knitted by a group of Scottish women who normally made piecemeal woollens for a variety of stores and manufacturers. She referenced the building's past by providing them with a wide variety of male genitalia to knit in various bright colours.

BELOW **Peter Blake** <u>ALPHABET</u>, 2008, wool, silk, artificial silk, 180 x 180 cm

Leading pop artist Blake (b. 1932, UK) has produced alphabets of 'found' letters in a variety of mediums, including silkscreen, photographs and books. When invited to take part in 'Demons, Yarns & Tales', he took the chance to create a new alphabet in a material and art form he had recently started to work with. Four years before designing this tapestry, ARAM Design had commissioned him to design a rug for their 40th anniversary. It was hand-made by craftsmen in Uttar Pradesh, India.

'The tapestry project was an interesting way to work. Some of the letters are quite exotic, because I knew they could be translated well into fabric and thread.' **Peter Blake**

ABOVE **Joseph Havel**, <u>LUST</u>, 2001, fabric shirt labels and thread, 304.5 x 121.9 x 121.9 cm, dimensions variable (detail)

ABOVE AND OPPOSITE **Joseph Havel**, <u>DESIRE</u>, 2003–4, fabric shirt labels and thread, 195 x 56 x 56 cm

LEFT **Joseph Havel**, <u>NOTHING!</u>, 2008, woven silk shirt labels in plexi construction, 61 x 61 cm (detail)

Havel works with fabric in many states of flexibility. Some works like *Lust*, *Nothing!* and *Desire* use fabric shirt labels and thread. Some are boxed in clear acrylic to form minimalist paintings or sculptures, while others are sewn together in various shapes, nets, strings of labels. *Desire* (ABOVE AND OPPOSITE), for example, is a beautiful conical net, gracefully falling from a single point in the ceiling, reminiscent of army netting used to camouflage large objects. Havel's net catches – or more likely ensnares – desire. Each piece of this madly complex form is a simple tag, like those found in men's shirts. On each one, blue letters on a white field read simply the word 'DESIRE'. Havel orders ordinary shirt labels from a clothing wholesaler in Dallas to his design (colour and wording).

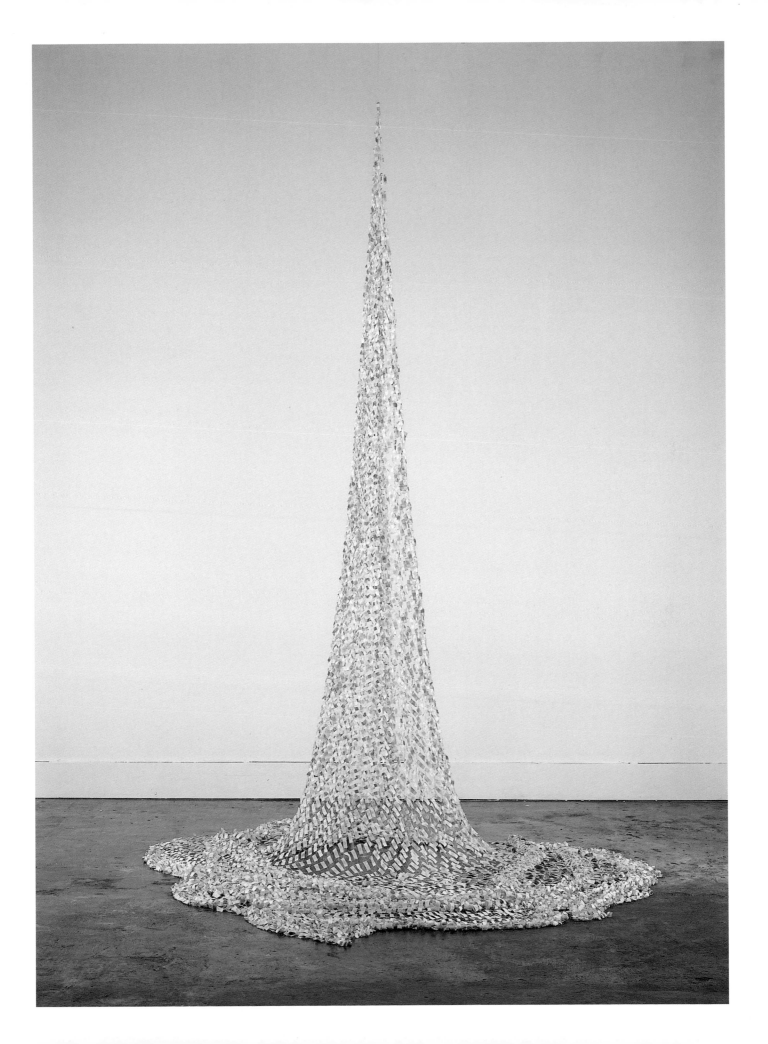

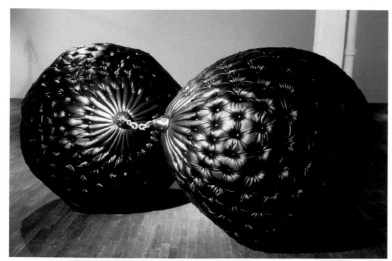

LEFT **Patrick Traer**, <u>BLACK TUFTEDS</u>, 2003, leather and metal fastenings, dimensions variable

Traer (b. 1964, Canada) has worked with a variety of craftspeople, including upholsterer Peter Sacher, who has fabricated a series of leather works that look like giant testicles. Also resembling punchbags, these oversized scrotums allude to both male aggression and fragility, while the soft, yielding quality of the leather suggest femininity.
'With Peter, over time, he taught me how to make the work myself, how to upholster. I would hire him to make a sculpture, and then he would use me as his apprentice to make that sculpture, giving me extensive instructions and demonstrations. It became an odd tangle of him working for me, me working for him.'

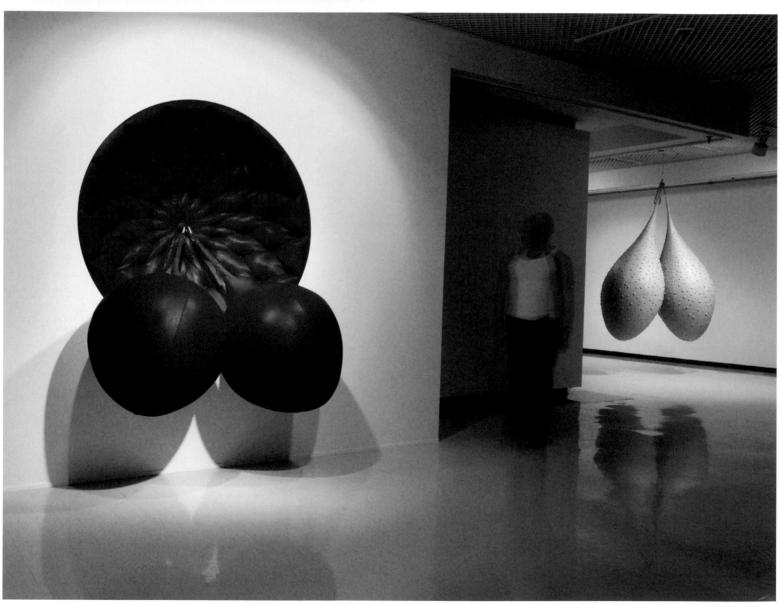

ABOVE **Patrick Traer**, <u>LIP RUDDY ROSE</u> and <u>BABY BLUE BALLS</u>, 2005 and 2003, leather and metal fastenings, dimensions variable

OPPOSITE **Patrick Traer**, <u>COLLAR, AFTER FRIDA</u>, 1991–2001, machine embroidery on shot taffeta, 112 x 77 cm

For his 'Embroidered Anatomies' series, the artist had local seamstress Anne Zbirun make embroider anatomical shapes on a variety of cloth materials. His works directly address the craft / fine art divide, challenging perceptions of what is traditionally seen to be women's work (craft) and men's (fine art).

ABOVE **Maria Roosen**, <u>BLOOD RELATIVES (SUNFLOWERS)</u>, 2006, hand-spun, dyed, knitted and crocheted sheep's wool, approx. 250 x 1200 cm
Roosen invited a whole team of women knitters to produce this giant red woollen sunflower, which was first installed in the attic of the monumental Stedelijk Museum in Schiedam, The Netherlands, for the museum's reopening exhibition in 2006. It seemed to be a reference to the famous sunflowers of Roosen's artistic 'blood relative', fellow Dutch artist Vincent van Gogh.

OPPOSITE **Andrea Zittel**, <u>SMOCKSHOP LONDON</u>, 2009, mixed-media installation
Zittel (b. 1965, US) is known for her ongoing A-Z project, described by the artist as 'an institute of investigative living. The A-Z enterprise encompasses all aspects of day-to-day living. Home furniture, clothing, food all become the sites of investigation in an ongoing endeavour to better understand human nature and the social construction of needs.' One of the elements of A-Z is the 'smockshop', an artist-run enterprise that generates income for artists whose work is either non-commercial or not yet self-sustaining. *Smockshop London*, held at the Sprüth Magers gallery during Fashion Week in September 2009, was the final stop of its world tour. The gallery/shop sold smocks (deemed to be a garment that suits most people in most life situations), made by a collective of makers. Each smock, while unique and interpreted by an individual artist, had to be made to Zittel's original design, an active testament to Zittel's principle that 'rules make us more creative'. The names of the makers were displayed at the entrance to the shop.

Ai Weiwei · Darren Almond · Fiona Banner · Per Barclay · Matthew Barney · Rachel Berwick · Nayland Blake · Christine Borland · Chris Burden · Scott Burton · James Lee Byars · Mara Castilho · Maurizio Cattelan · Angela de la Cruz · José Damasceno · Richard Deacon · Sam Durant · Lionel Esteve · Jan Fabre · Dan Flavin · Anya Gallaccio · Ryan Gander · Dan Graham · Denise Hawrysio · Jochem Hendricks · Carsten Holler · Mike Kelley · Glenn Ligon · Liliane Lijn · Kris Martin · Allan McCollum · Bryan Mulvihill · Peter Newman · Olaf Nicolai · Monika Oeschler ·

Other materials

Jacqui Poncelet · Charles Ray · Tobias Rehberger · Simon Starling · Haim Steinbach · Mark Wallinger · Pae White · Robert Wilson · Cerith Wyn Evans

As we have seen in previous chapters, many contemporary artists act like movie directors, drawing up elaborate schemes that are then fabricated by professionals. Whether the objects appear to be natural or futuristic, decorative or functional, these artists turn to others to create the work. Often, as with film, huge teams of specialists are employed, particularly when the objects are created from several materials, as many of them in this chapter are.

But we begin with ceramics. It is likely that our ancestors learned how to make rudimentary objects from heated clay soon after discovering how to master fire, and the oldest ceramic objects date to between 29,000 BC and 25,000 BC. Glazed tiles were made in Mesopotamia (modern-day Iraq) and India around 9000 BC, with actual pottery being developed soon after. Items for worship, trade and everyday functional use became established throughout most civilizations of the world. Classical Greek black and red vases were the height of sophistication and narration, while in the East, different traditions of making and decoration flourished and were traded extensively.

Ceramic tableware, particularly from China, Korea and Japan, has been an inspiration for artists working in Europe since at least the nineteenth century, when the vogue for *chinoiserie* was at its height. In the next century, Picasso was just one example of an artist who worked with ceramicists to produce a vast body of decorated plates, bottles and other ceramic objects. Canadian artist Bryan Mulvihill recently went to Jingdezhen in China to make a series of ceramic works based on the tea traditions of the country. 'Jingdezhen is the world capital of blue and white porcelain. The Lui potteries are famous for their large misty landscape paintings, as well as contemporary panels, sculpture and tea utensils. They have numerous technicians, preparing and rolling the porcelain, applying the white underglaze and the overglaze after the blue has been painted on, as well as teams of painters, calligraphers, and firers. I have worked with all of these specialists.'

Living artists have worked with famous porcelain factories in the West too. American artist Cindy Sherman has designed a complete tea service for the French porcelain manufacturer Sèvres. Over many centuries, the company has commissioned a vast array of artists to make work for them, including François Boucher in the eighteenth century, Auguste Rodin in the nineteenth, and Jean Arp, Alexander Calder, Jim Dine and Louise Bourgeois in the modern period.

Ceramics have also been used in industry for electrical insulation, as well as in the manufacture of radios and televisions. In the 1980s, high-temperature superconductors were developed along with other techniques that are now finding their way into the work of visual artists. Richard Deacon, for example, has worked with experts to explore performance clays, making a body of works that are possible to make only now.

Humankind has used wood to make objects and shapes since the beginning of time, and it has long been an artistic medium. From ancient tribal carvings in Africa to painted statues in medieval Europe and modern works by artists such as Barbara Hepworth, Carl Andre and Georg Baselitz, the sculpting of wood has been a staple of art practice for centuries. More recently, land artists such Richard Long and Andy Goldsworthy have used found pieces of wood to make their art. The American Martin Puryear has refined the use of wood to such a degree in his sculptures that they appear almost zenlike and rooted in Eastern tradition. All of these sculptors use wood themselves directly in a hands-on way. All of the artists in this chapter, however, have employed others to make their work with wood.

Many of the complex projects here have been made in large studios of professional fabricators who specialize in working for artists. Several have been made by the Mike Smith Studio in London. Smith has worked with many artists over more than twenty years to make large works and installations that require a huge degree of technical precision or knowhow. He is renowned for his ability to take artists' designs and ideas, however ambitious, and realize them. In contrast, others in this chapter have their work made in the developing world, where old skills are still in practice and the costs of production are lower. Often, the workers on these projects have no knowledge of the art world, which can lead to bewilderment or misunderstanding on their part. Ai Weiwei has most of his work made by traditional Chinese makers (in many media, including wood, stone, and porcelain). For instance, he has employed traditional craftsmen to reclaim wood from religious shrines destroyed by the Communist authorities, and to refashion it into other objects, including a bench in the shape of the map of China. He is conscious of some of the conceptual issues involved with working with traditional makers. He has said that they are 'liable to feel insulted by requests to direct their skills at such absurd tasks as freezing a flow of urine in fine porcelain, reconfiguring fine examples of classical furniture into dysfunctional forms, or to create perfect, lusciously glazed replicas of watermelons. This tension goes to the heart of the "culture" problem: who decides what is precious, of enduring value to society, and for what reasons?'

‘I have worked with the scientists, and the material with which they collected the dust, to create a metaphorical dialogue that relates to their "Stardust" mission.’ Liliane Lijn

TOP **Liliane Lijn**, <u>BURMA REQUIEM</u>, 2008, aerogel fragmented ring on bronze mirror in Perspex case, pearlescent metallic coated square column housing DVD player, projector, 295 x 50 x 50 cm
Lijn has produced several works using silicon-based aerogel, an ethereal material that is 99 per cent air and 1 per cent glass, heated to become solid. Aerogel is employed by Nasa to capture minute particles from space.

ABOVE **Liliane Lijn**, <u>RUINS OF KASCH</u>, 2008, aerogel and rosin on mirror in Perspex case, pearlescent metallic-coated square column housing DVD player, projector, 295 x 90 x 90 cm
The series was inspired by Lijn's residency at the Nasa-funded 'Stardust' mission at the Space Sciences Laboratory in California. She sent metal moulds to the labs for the scientists to create the aerogel pieces, and then projected images of Earth onto them.

BELOW **Rachel Berwick**, <u>HOVERING CLOSE TO ZERO – STILL #3</u>, 2000,
graphite, resin, painted wood, dimensions variable

Berwick's (b. 1962, US) *Hovering Close to Zero* project (2000–6) is based on
the extinction of the Tasmanian tiger in 1936. The artist 'recovered' the animal
using the few known still images of it and fewer than sixty seconds of footage,
remaking the tiger using digital modelling processes. The computer was
unable to distinguish flaws in the film from shadows, so both were modelled
in the resultant objects, which were shown with casts of the tiger's skull
in crystal. Berwick could never had had all the skills required to produce
such a complex work and so employed a number of technicians to realize
the piece. Art Andersen of Virtual Surfaces in Mt Prospect, Illinois, and Roger
Wilson of California translated the still images into three-dimensional prints
on the computer. These prints were fabricated by Kelly Hand at Satellite Models,
Belmont, California, and the sculpture was welded together by Warren Johnsen.
In Berwick's work, the computer has become the twenty-first-century craftsman,
as it is in that of Barry X Ball, Denise Hawrysio and Silvano Rubino.

BELOW **Olaf Nicolai**, <u>LA LOTTA</u>, 2006, mixed media, 153 x 215 cm
Nicolai's *La Lotta* features a black horse that has become a unicorn.
The initial shaping work (which took considerable effort) was carried
out by an Italian taxidermist without Nicolai's direct involvement. For the
finishing, he worked closely with a German taxidermist to oversee the details.
The title, which means 'the struggle', is in stark contrast to the relaxed pose
of the animal. Its calm demeanour may hide a more combustible interior, however.
The sculpture has an internal heating element so that it is warm to the touch
at 43 °C (or 109.4 °F), a temperature that would be lethal for a human.

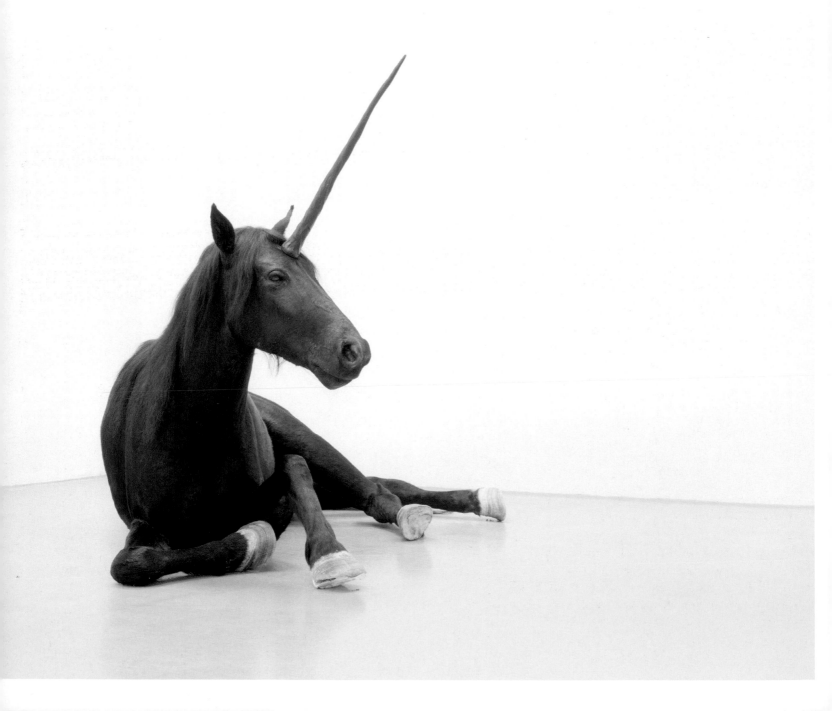

Jochem Hendricks, <u>SIBLINGS</u>, 2008, taxidermy dogs, each pair 85 x 120 x 60 cm

Hendricks's (b. 1959, Germany) art addresses the social codes and boundaries by which we live, including the moral and legal issues associated with labour. As a result, he frequently employs others to physically produce his works as part of the artistic concept. *Siblings* are among a series of pieces where he has worked with professional taxidermists. Hendricks collected a number of dead fighting dogs over several years and had them expertly stuffed and preserved with lapdogs in their mouths. He then arranged them into a menacing pack – a group that would never have existed in real life, as they would have killed each other.

RIGHT **Carsten Höller**, <u>RHINOCEROS</u>, 2005, yellow biresin, horn, blue glass eyes, 120 x 80 x 50 cm, edition of 4 plus 2 artist's proofs

Höller has worked with a French taxidermist to create a series of baby animals that seem surprisingly alive. A life-size cast is made from a living animal and then cast and formed to resemble the original as closely as possible, being soft and skinlike to the touch, but visually disturbing due to its vibrant colouring. The animals also have extremely lifelike eyes that add to the unsettling experience, as in *Rhinoceros*.

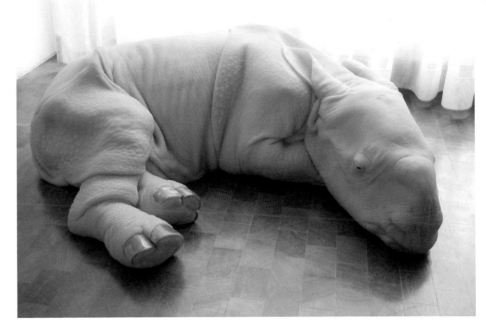

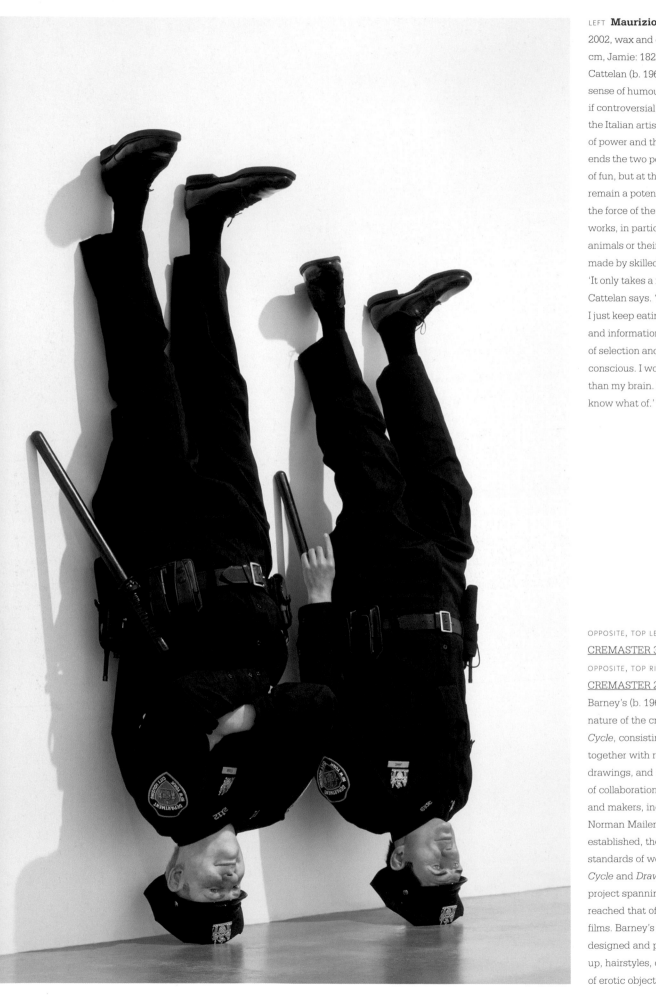

LEFT **Maurizio Cattelan**, FRANK & JAMIE, 2002, wax and clothes, Frank: 190.5 x 63.5 x 52.7 cm, Jamie: 182.2 x 62.9 x 45.7 cm

Cattelan (b. 1960, Italy) uses his Duchampian sense of humour to make a series of funny if controversial works. *Frank & Jamie* continues the Italian artist's investigation into the imagery of power and those who wield it. Cattelan up-ends the two policemen, making them figures of fun, but at the same time their weapons remain a potent symbol of their position with/in the force of the state. As with most of Cattelan's works, in particular those including stuffed animals or their skeletons, *Frank & Jamie* was made by skilled taxidermists and craftspeople. 'It only takes a minute to have the idea,' Cattelan says. 'After that, I don't do anything. I just keep eating things. In this case, images and information. And then there's a process of selection and separation that's not really conscious. I work more with my stomach than my brain. It's a digestive process. I don't know what of.'

OPPOSITE, TOP LEFT **Matthew Barney**, CREMASTER 3, 2002, production still
OPPOSITE, TOP RIGHT **Matthew Barney**, CREMASTER 2, 1999, production still

Barney's (b. 1967, US) epic exploration of the nature of the creative process, the *Cremaster Cycle*, consisting of five feature-length films, together with related sculptures, photographs, drawings, and artist's books, spans a decade of collaboration with a large number of artists and makers, including Richard Serra and Norman Mailer. As Barney became more established, the already high production standards of works such as the *Cremaster Cycle* and *Drawing Restraint*, another multi-part project spanning several years and art forms, reached that of the most expensive Hollywood films. Barney's teams of production assistants designed and produced costumes, sets, make-up, hairstyles, choreographies and all manner of erotic objects in a wide variety of media.

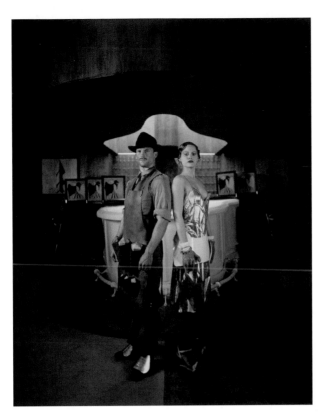

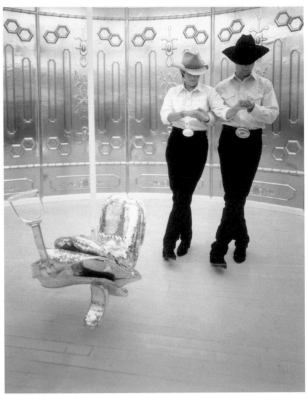

THIS PAGE **Matthew Barney**, <u>DRAWING RESTRAINT 9</u>, 2005, production still

With a soundtrack by Björk, *Drawing Restraint 9* is a love story set in Japan. It takes place primarily aboard the Japanese whaling ship, the *Nisshin Maru*, in the Sea of Japan, as it sails to Antarctica. The narrative is built upon themes such as the Shinto religion, the tea ceremony, the history of whaling, and the change from the use of blubber to refined petroleum for oil.

RIGHT **Dan Graham**, <u>IN GREEK MEANDER PAVILION, OPEN SHOJI</u>
<u>SCREEN VERSION</u>, 2001, two-way mirror glass, stainless steel, oak, PVC,
each part, 636 x 479 x 209 cm

Graham's (b. 1942, US) influential photographic project *Homes For America* (1965)
was a manifesto for his work as an artist whose projects are situated between art
and architecture. Since the 1980s he has collaborated with architects and
fabricators to create a large series of 'Pavilions' that focus on the act of viewing.
The immersive glass-and-steel objects allow viewers to explore the complex
spaces within, while directing visitors' view through and from the structures.

BELOW **Per Barclay**, <u>RUE VISCONTI</u>, 2010, oilroom, colour photograph,
dimensions of photograph 120 x 150 cm. Photograph: Paolo Pellion.

Barclay's works are staged and photographed by others (usually Fin Serck-
Hanssen or Paolo Pellion, as here). He leaves the craft of the photograph to the
professionals, who render his conceptual installations into images. He uses their
services to make works where pools of liquid are involved, be they motor oil, blood,
milk or water. He has worked with these men for several decades. Their ongoing
collaboration allows him to use their technical facility, but they do not attempt to
influence the content. Nor do they see these works as their own, but as Barclay's.

Peter Newman, <u>SKYSTATION</u>, 2009, Jesmonite, in a variety of colours, textures and finishes, 68 x 424 cm, edition of 100 Newman (b. 1969, UK) works in many media, including painting, photography, and sculpture. His *Skystation* is an outdoor sculpture that also can be used as a viewing platform. Its form draws from Le Corbusier's iconic LC4 chaise longue, using contours intended to fit the reclining human figure. Viewers can look at the object or use it to look at the sky, allowing them to collaborate with Newman as both observer and subject. He has said that '*Skystation* offers a rare opportunity in a city, to stop for a minute, lie back and enjoy the sense of space above. The seat makes conversations between strangers almost inevitable.' The project was commissioned by Futurecity, which oversees the fabrication. The first permanent installation of a *Skystation* was in Cambridge, following temporary sitings at the Hayward Gallery, Canary Wharf and Trafalgar Square in London.

Dan Flavin, <u>UNTITLED</u>, 1996, pink, yellow, green, blue and ultraviolet fluorescent tubes and metal fixtures, 246 x 7559 x 17.8 cm
Flavin (1933–96, US) started using commercially produced fluorescent lights in 1963, first as individual sculptures and then as large-scale installations. He created imaginative and haunting spaces with colour and light with the minimum of artifice, yet the works rely on the technical skills of manufacturers. In 1990, Dominique de Menil commissioned him to create a permanent site-specific piece for Richmond Hall in Houston, an annexe exhibition space of the Menil Collection. He finished the design for *Untitled* a mere two days before his death. The installation of the four-foot fixtures in two opposing banks for the east and west interior walls of the hall was installed by his studio assistants.

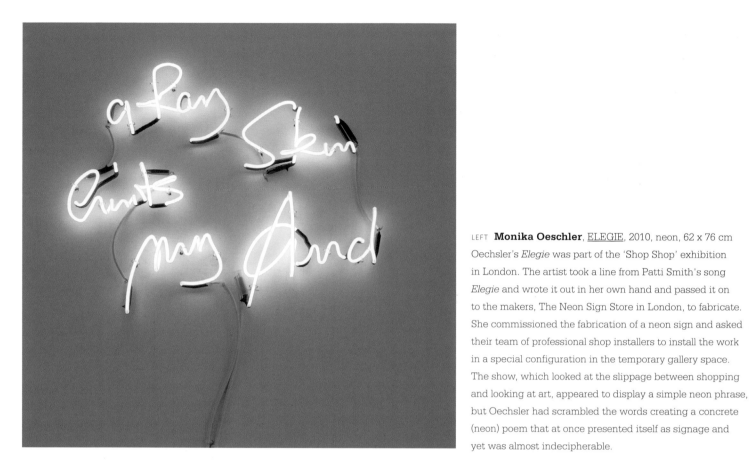

LEFT **Monika Oeschler**, <u>ELEGIE</u>, 2010, neon, 62 x 76 cm
Oechsler's *Elegie* was part of the 'Shop Shop' exhibition
in London. The artist took a line from Patti Smith's song
Elegie and wrote it out in her own hand and passed it on
to the makers, The Neon Sign Store in London, to fabricate.
She commissioned the fabrication of a neon sign and asked
their team of professional shop installers to install the work
in a special configuration in the temporary gallery space.
The show, which looked at the slippage between shopping
and looking at art, appeared to display a simple neon phrase,
but Oechsler had scrambled the words creating a concrete
(neon) poem that at once presented itself as signage and
yet was almost indecipherable.

BELOW LEFT **Glenn Ligon**, <u>THE PERIOD</u>, 2005, neon, 20 x 154 cm
BELOW RIGHT **Glenn Ligon**, <u>WARM BROAD GLOW</u>, 2005, neon, paint, 10.1 x 121.9 cm, edition of 7
Ligon (b. 1960, US) has used borrowed text (from James Baldwin poems to crude jokes) in
a variety of materials, from painting to bronze, questioning the relationship between words
and their meaning. He also highlights racial and sexual attitudes in America, incorporating
professionally fabricated neon tubes to form lines of contrasting black-and-white text or words.

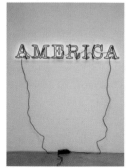
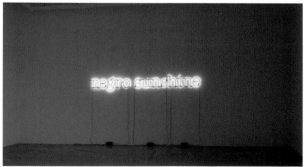

OPPOSITE BELOW **Mara Castilho**, <u>TURN ME ON</u>, 2009, neon light,
30 x 110 cm and <u>TURN ME OFF</u>, 2009, neon light, 30 x 110 cm
Industrial light and neon signmaker Anibal Henriques Ribeiro
made these two neon works for Castilho. He lives and works
in Lisbon, Portugal, where Castilho has many of her works
produced by local craftspeople.

...later on they are in a garden, he remembers there are gardens.
They walk in the park and come across a display showing a section cut through the trunk of a giant Sequoia tree.
They study its rings of growth marked with historical dates, she pronounces an English word he doesn't understand.
He indicates a point in space outside the circumference of the tree, and, – as if in a dream – hears himself say:
'This, is where I come from...'

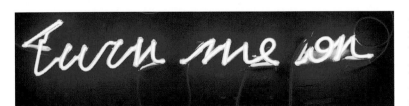

ABOVE **Cerith Wyn Evans**, ... LATER ON THEY ARE IN A GARDEN ..., 2007, neon, 230 x 490 cm, edition of 3

Wyn Evans has created many neon pieces throughout his career, using both text and images, such as flowers. The work pictured here presents an excerpt from the script of the 1962 film *La Jetée* by celebrated French film-maker Chris Marker, a sci-fi story based on a search for an authentic memory. Wyn Evans's neon text explores the potential of the future anterior tense of language. It describes a scene in which a man attempts to tell his girlfriend about his origins in a dream foretelling his death: an event that has already taken place. The piece was fabricated by Austrian company NEON-line Werbedesign, which has also produced work for Mario Merz, Joseph Kosuth, Bruce Nauman and James Turrell, among others.

THIS PAGE **Jochem Hendricks**, HORIZONTAL HAIRDO, 2007–9, hair, aluminium, ball-bearing, length of hair approx. 30 km, spool 20 x 5 cm

Horizontal Hairdo displays the entire hairdo of a Filipino woman, Annelie Ataccdor Alingasa, in one long line across the gallery wall. In order to create the work, Hendricks hired a group of Cameroonian women to glue together the thousands of hairs end to end. The hair is wound around small mounts attached to a central spool that was made in Germany, thereby physically and metaphorically linking the three continents of Europe, Asia and Africa around work.

OPPOSITE **Mark Wallinger**, TIME AND RELATIVE DIMENSIONS IN SPACE, 2001, stainless steel, MDF, electric light, 281.5 x 135 x 135 cm

Wallinger (b. 1959, UK) has long investigated the nature of Britishness, whether it be in his Union Jacks designed in the green, white and orange of the Irish flag, which he had manufactured by London flagmakers Turtle and Pearce, or in his paintings of racehorses. In this 2001 work, he re-created the time machine *TARDIS* from the long-running and highly popular BBC television series *Dr Who*, which disappeared into thin air as it carried the Doctor through time and space. The sculpture is in the shape of a police call box and was made life size and clad completely in mirror. It reflected not only the room in which it was installed, but also everyone in it. As a result, it almost became invisible in the space, similar to the original TARDIS in the series. The complex job of fabricating the work was completed by the Mike Smith Studio in London.

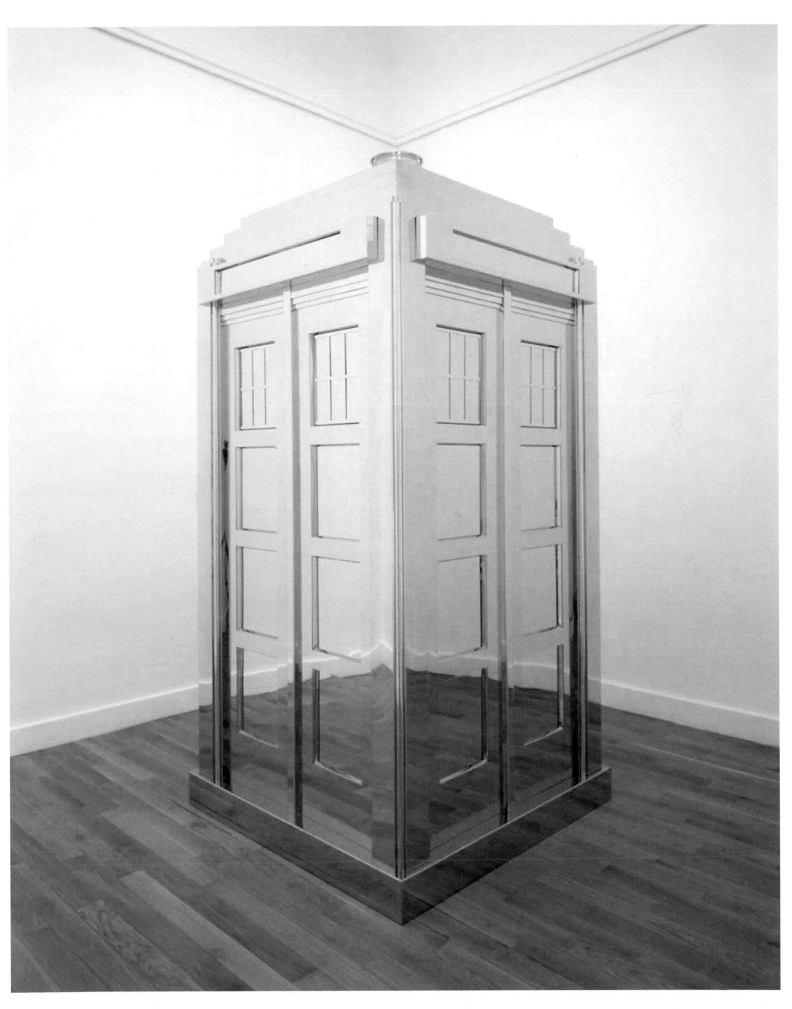

OPPOSITE **Chris Burden**, 14 MAGNOLIA DOUBLE LAMPS, 2006, cast iron, each 625 cm tall, approx. 1 ton
Known for his body art of the 1970s, Burden (b. 1946, US) has since created large sculptures and installations, often comprising industrially manufactured objects. For this work, shown at the South London Gallery, he had 1920s Los Angeles streetlamps renovated and brought to London. The installation was a great technical feat, owing to its weight and because the lamps were only a metre from the ceiling. The work investigated public power and its display, as the posts were made to show the wealth of a burgeoning new city. It also plays with the idea of exporting American 'antiques' based on European designs back to the UK.

TOP **Darren Almond**, MEANTIME, 2000, steel sea container, aluminium polycarbonate, computerized electronic control system and components, 290 x 1219 x 244 cm
ABOVE **Darren Almond**, TODAY, 2000, aluminium, steel, perspex, paint and motor, 70 x 70 x 248 cm
Almond (b. 1971, UK) has created a number of works about the passing of time, always fabricated for the artist, either by professional clockmakers or, as in the case of *Meantime*, by an art production company. The huge container-sized clock ticked loudly as the numbers flipped by, and was produced by the Mike Smith Studio, London. It is linked by satellite technology to Greenwich Mean Time, the world's official marker of time.

'The idea that the artist manipulates materials is not something that I agree with. I don't design. I don't paint. I don't sculpt. I absolutely never touch my works.' Maurizio Cattelan

OPPOSITE **Maurizio Cattelan**, <u>HOLLYWOOD</u>, 2001, aluminium, scaffolding, 2,300 x 17,000 cm

Cattelan was invited to make a special project for the 49th Venice Biennale. His Hollywood sign, the exact size and style of the original, was placed above Palermo in Sicily, overlooking the city. Cattelan's work, a parody as much as a homage to the Los Angeles monument, was sited above the city's rubbish dump. Flights from Venice were organized by the Fondazione Sandretto Re Rebaudengo for 150 special guests, including collectors and journalists. Cattelan has said of this piece: 'I tried to overlap two opposite realities, Sicily and Hollywood: after all, images are just projections of desire, and I wanted to shade their boundaries. It might be a parody, but it's also a tribute…. It's a sign that immediately speaks about obsessions, failures, and ambitions.'

ABOVE **Maurizio Cattelan**, <u>HOLLYWOOD</u>, 2001, colour print (framed perspex), 180 x 400 x 15 cm

ABOVE, LEFT TO RIGHT **Tobias Rehberger**, <u>KAO KA
MOO</u>, 2001, mixed media, 140 x 400 x 180 cm;
<u>PAD-SEE-EUW</u>, 2001, mixed media, 148 x 160 x 360
cm; <u>YAM KAI YEAO MAA</u>, 2001, mixed media,
140 x 400 x 180 cm; <u>YAM KOON CHIEN</u>, 2001,
mixed media, 112 x 430 x 180 cm (ALSO SEE RIGHT);
<u>LAP PED</u>, 2001, mixed media, 140 x 160 x 360 cm

Rehberger works in a truly collaborative way.
He invites friends to come up with suggestions
around a theme, which he then has realized by
makers. He commissioned African artisans to make
Bauhaus and Le Corbusier-style chairs; and he sent
sketches of cars drawn from memory to craftspeople
in Thailand and asked them make functional vehicles.

OPPOSITE **Charles Ray**, <u>FIRETRUCK</u>, 1993, painted
aluminium, fibreglass, plexiglas, 366 x 244 x 1417 cm
Ray (b. 1953, US) questions the status of the eye. Many
of his works appear to be one thing, but turn out to be
another, whether blocks of fluid ink, tables with tops
that rotate almost imperceptibly, or cast dummies
of himself in groups performing autoerotic fantasies.
This sculpture, fabricated for Ray in California, was
a large version of a child's toy scaled up to the size
of a real firetruck. The sculpture had much less detail
than an ordinary, working truck and highlighted the
nature of scale as an integral part of all art work. Ray
'parked' his firetruck on New York's Madison Avenue
outside the Whitney Museum. He has spoken about
working with fabricators: 'Just as artists work in
many different ways, they also work with fabricators
in many different ways. Some artists have an idea
or a vision and go to the fabricator to see that vision
realized. Perhaps they see this, in the best case, as a
one-to-one relationship between what they want to
have made and the finished product, but other noise
inevitably bubbles up in the process of making things.
Other artists might think of a fabrication company as
a very complicated hand tool. Collaboration is a word
that often comes up, but the initial vision is usually
not a collaboration. One can have a collaboration with
a fabricator as much as one can have a collaboration
with a hammer – though a hammer only tells you what
it can't do the hard way, and a fabricator usually tells
you this by talking about the budget.'

BELOW **Jacqui Poncelet**, <u>SHADOW SCREEN</u>, 2005, rubber, each panel 176 x 68 cm

Poncelet (b. 1947, UK) uses a wide variety of materials in her highly decorative works, which situate themselves between fine art, craft and architecture. She has created designs for many architectural and design firms, and her work appears in buildings and urban developments across the UK. She was commissioned in 2005 by Outgang, a British furniture manufacturer, to create *Shadowscreen*. Each panel is made from 2.5-mm recyclable rubber, and the work is scalable so that different sections (in many colours) can be placed together to make a screen, room divider or standalone tapestry.

OPPOSITE **James Lee Byars**, <u>THE ROSE TABLE OF PERFECT</u>, 1989, 3,333 red roses, diameter 100 cm

This work, which was first produced in 1989 and has been re-created several times since the artist's death in 1997, involves flower arrangers placing 3,333 red roses on a styrofoam ball to form a sphere. The flowers are then allowed to wilt over the course of the exhibition, eventually to take on the colour of coagulated blood. In this one piece, Byars not only continued his quest for perfection in art, but also expressed his awareness that perfect beauty is inseparable from death and decay.

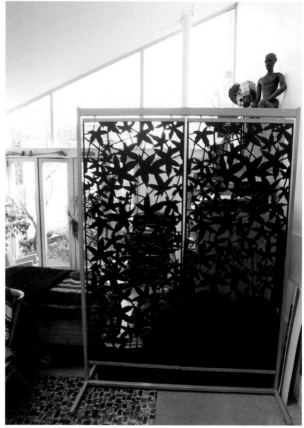

OVERLEAF **Mike Kelley**, <u>KANDORS</u>, 2007, mixed media, dimensions variable, installation view Jablonka Galerie, Berlin

Kelley's (b. 1954, US) installations have long incorporated found objects, such as stuffed toys purchased in thrift stores. His recent works have included sophisticated fabricated objects of his design. For his *Kandors* show, he had the finest Czech glass craftsmen produce a series of bell jars (which were hand tinted in the US) to cover tiny cityscapes. Kandor was the home of Superman, and the city and its inhabitants were shrunk by an evil villain, forcing the hero to take them in a capsule to his Fortress of Solitude. Kelley's installation was a dreamlike space of multi-coloured lights, video projection, models, airtight glass jars, room dividing screens and gas cylinders. He also wanted it to be a three-dimensional evocation of Matisse's colour qualities.

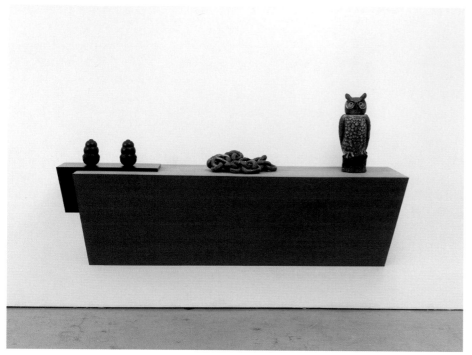

'It's not only about selecting and arranging objects of my own choice, but presenting the objects chosen by others. As such I work as a kind of arbitrator or interlocutor.' **Haim Steinbach**

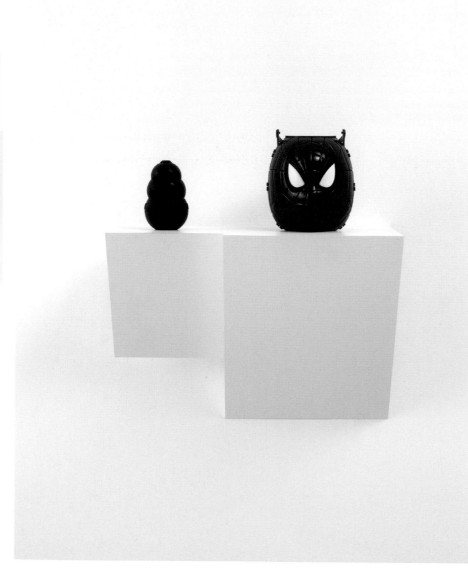

TOP LEFT **Haim Steinbach**, UNTITLED (DOG CHEWS, CHAIN, SCARECROW), 2008, plastic laminated wood shelf, two rubber dog chews, plastic chain, plastic owl, 109.2 x 185.4 x 53.3 cm
LEFT **Haim Steinbach**, SPIDER KONG 3A, 2008, plastic laminated wood shelf, rubber dog chew, plastic 'Spiderman' pail, 67.3 x 63.5 x 38.1 cm
Steinbach (b. 1944, Israel) has been an influential exponent of art based on already existing objects since the late 1970s. His art has been focused on the selection and arrangement of objects, above all everyday objects. His exhibition 'The Effect' in 2008, for example, featured a variety of tableaux of mass-produced artefacts on custom-designed plinths. Steinbach has been focusing the attention of the viewer for over thirty years in such a manner, often selecting items that reflect or contrast with the exhibition site. He hopes to generate psychological anxiety with these works, which question the nature and status of objects of consumption. He provides a detailed dossier for each work, directing gallery staff exactly where to place each object (within a millimetre).

OPPOSITE BELOW **Jochem Hendricks**, 6,128,374 GRAINS OF SAND, 2003–5, grains of sand, blown glass, 25.4 x 17 x 17 cm
Hendricks makes work that addresses the means of production directly, and with it the moral and legal issues associated with labour, beauty and value. He has made a series of *Grains of Sand* works, where he paid assistants (often illegal immigrants in Germany) to count individual grains of sand, which were then encased in hand-blown glass. The only way to verify the count would be to crack the egg, and destroy the work. The viewer is left with only Hendricks's (and the gallery's) word for the whole process.

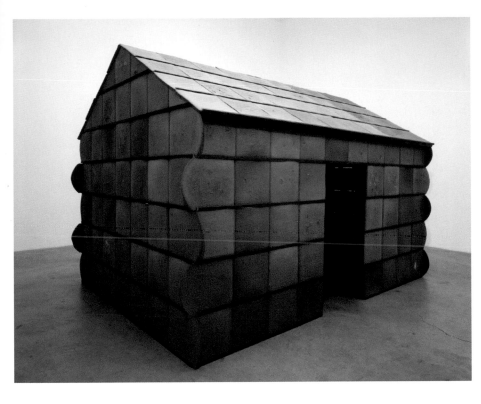

LEFT **Nayland Blake**, <u>FEEDER 2</u>, 1998, steel and gingerbread, 213 x 305 x 213 cm
Blake (b. 1960, US) was born of mixed-race parents and for many years his work investigated the differing social positioning this placed him in. His work is also often produced for him by others, such as *Feeder 2*, a giant gingerbread house so large viewers can enter it. Blake clearly likes to play with allowing others to make his art. His website provides step-by-step instructions for anyone who wants 'make their own Blake' to the artist's design, complete with certificate of authenticity.

'The basic system for making the shapes is now complete, but the project of constructing all of them is too large for me to finish by myself, or in my own lifetime. So I am organizing it in such a way that others may continue completing them in my absence. I am also making shapes available to others, with the hope that people will come up with many interesting ways to use them.' **Allan McCollum**

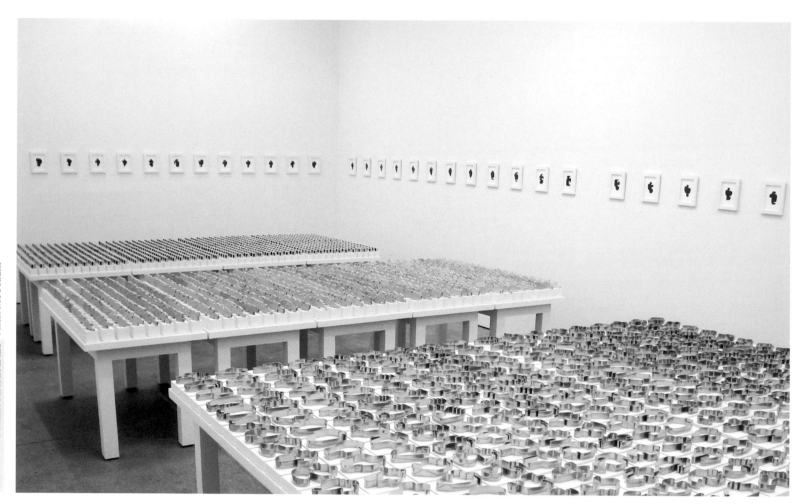

Allan McCollum, <u>THE SHAPES PROJECT: SHAPES FROM MAINE</u>, 2009, installation at the Friedrich Petzel Gallery, New York

Interested in how we ascribe value to an original and a copy, McCollum (b. 1944, US) has long utilized the methods of mass production to create objects that, while produced in large quantities, are each unique. Since 2005, he has been working on his most ambitious work to date, the 'Shapes Project'. Using his home computer, he devised a system to create 31 billion different graphic shapes, enough for one for each person living on the planet up to 2050, without ever repeating. Since then he has used the system in collaborations with different communities,

who have produced the shapes in a variety of forms, sizes and materials. For his 'Shapes From Maine' show in 2009, he invited craft makers from the US state of Maine to work with him. He was attracted by the pride Maine's inhabitants take in the traditions of homecraft, and researched artisans who ran small businesses out of their homes. After extensive email conversation, four home-based craftspeople expressed interest in working with him, without ever meeting in person. Eventually, he ordered a selection of custom-made 'Shapes' in the form of copper cookie cutters, wooden ornaments, rubber stamps, and black hand-cut silhouettes. In all, there were over 2,200 individual handmade shapes in the exhibition, each one made by a skilled artisan.

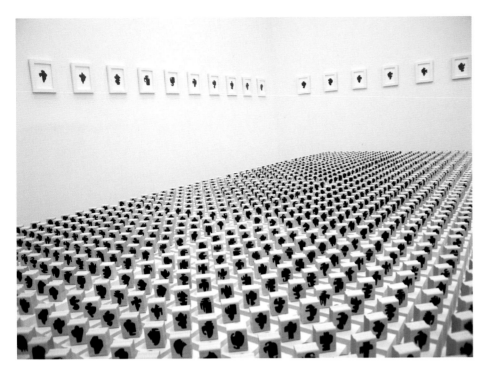

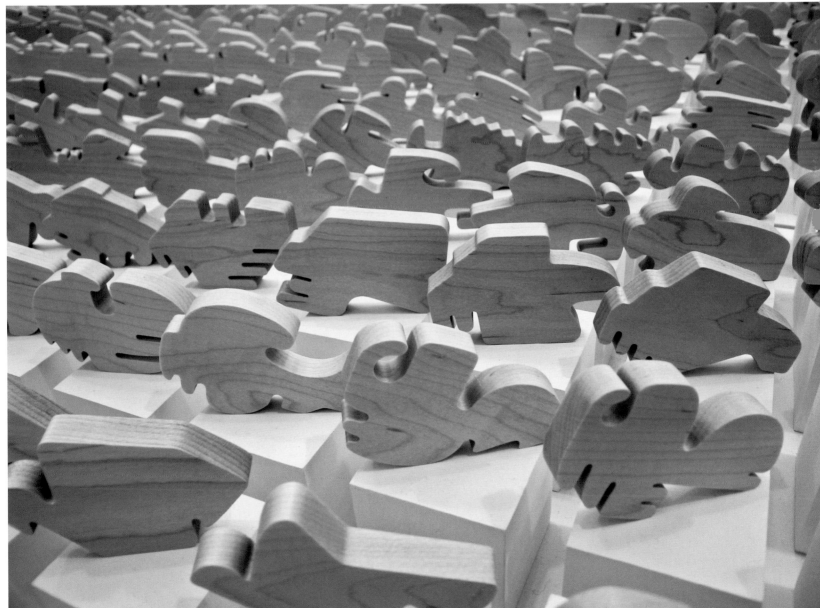

Nayland Blake, <u>ROOT</u>, 2003, briar wood, plastic, dye, 13.7 x 38.4 x 9.5 cm, edition of 2

Blake's work has often addressed his gay and mixed-race identity. He has stated that while he can 'pass' for white and 'pass' for straight, he cannot 'pass' for slim. His size and identification with gay 'bear culture' is at the heart of *Root*. He asked master carver J. M. Boswell of Chambersburg, Pennsylvania (see page 184), to make the pipe for two. Pipe smoking has long been a gay fetish and its popularity has grown as most cities ban public smoking, giving it additional outlaw status. That the pipe has two mouthpieces for sharing smoke adds to its erotic charge.

BELOW **Ryan Gander**, <u>BAUHAUS REVISITED</u>, 2003, zebrawood, each piece 5 x 5 cm

Gander's work is a life-size replica of a Bauhaus chess set designed by Josef Hartwig in 1924. He had the pieces reproduced in blacklisted zebrawood from the African rainforest, using the services of a technician at the Rijksakademie in Amsterdam. The Bauhaus ideal of bringing design to the masses is undermined, or at the very least questioned, by the use of such controversial banned material.

OPPOSITE **Denise Hawrysio**, <u>SPOTLIGHT SCULPTURE</u>, 2007, birch, 104 x 102 cm

The Spotlight Directory, founded in 1927, is film and television's main resource for casting actors. Hawrysio (b. 1957, Canada) has cut out the faces from the directory to create a series of objects, installations, artist's books and video, under the title 'The Spotlight Project'. For *Spotlight Sculpture*, she employed an AutoCAD (Automatic Computer Aided Drafting/Designing) program normally used in construction or design. Copying a sequence of the voided profiles from the altered *Spotlight Directory* created an AutoCAD drawing. Hawrysio then had the Architectural Association's workshop in London render the drawing in birch, allowing the computer to fabricate a complex work that would traditionally have been made by a skilled maker.

Anya Gallaccio, <u>AS LONG AS THERE WERE ANY ROADS
TO AMNESIA AND ANAETHESIA STILL TO BE EXPLORED</u>,
2002, 7 felled oaks, dimensions variable, installation at Tate
Britain, London

For her Duveen Galleries sculpture commission at Tate Britain
in 2002, Gallaccio worked with many technical and craftspeople
to create *As long as there were any roads to amnesia and
anaethesia still to be explored*. The trees mimic the classical
columns of the space but disrupt it and also reference the large
number of English landscape paintings held in the museum's
collection. The work was fabricated by technicians, art handlers
and the conservation department at Tate Britain. A fountain
(not seen in the image) was made from a tree root ball by
the Mike Smith Studio in London.

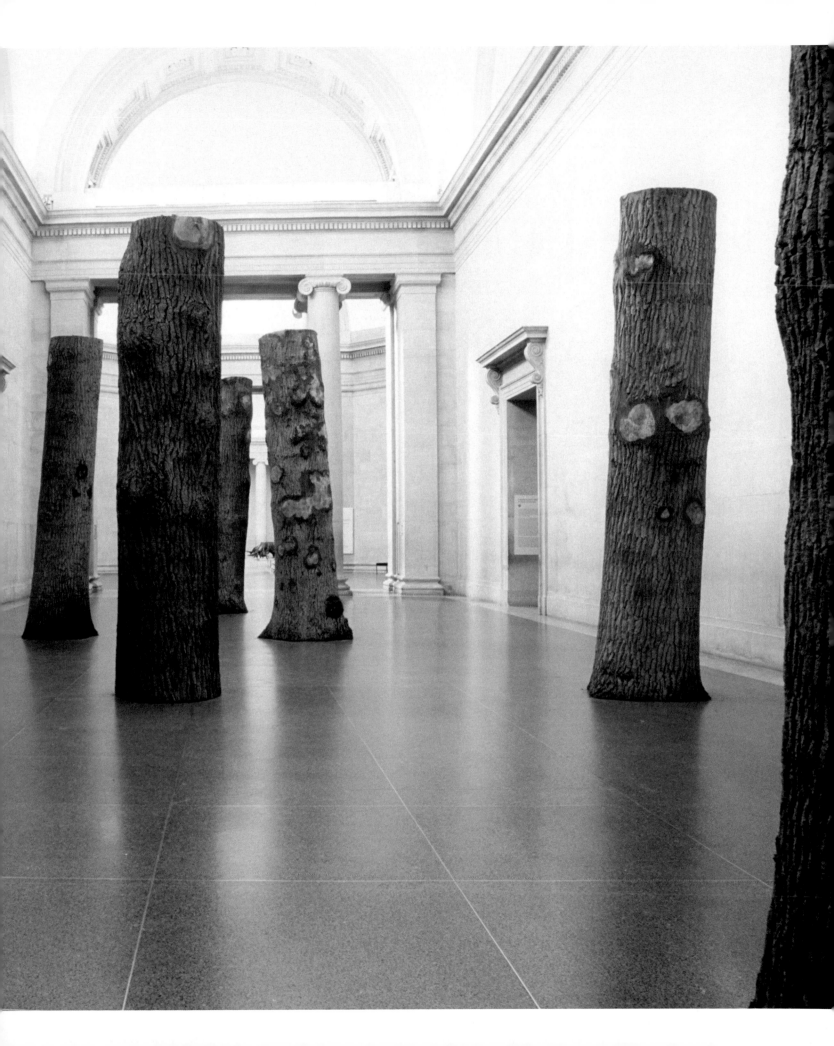

Scott Burton, <u>LAWN CHAIRS (A PAIR)</u>, 1976/9, wood, veneered
with pale yellow formica, each 111.2 x 78.7 x 129.5 cm
Burton's performative chair sculptures were made in many
materials and produced by a wide variety of fabricators.
His stone chairs and benches are his best-known works (pages
93 and 94), but he also made many such sculptures in metal
and wood. The works, in the forms of chairs, were meant to
be sat on, yet in the gallery setting they created a huge tension
between the viewer and the object, in that each person had
to decide if they would sit on the piece, and then themselves
become the focus of attention of others.

Pae White, <u>PLYWOOD BED</u> or <u>BED WITH ORNAMENTAL BRACKETS</u>, 2006, birch plywood, dimensions: California King

For *Plywood Bed*, White utilized the same tool paths as those used in the Corian® bed (see p. 104) to exploit the layered carving that occurred when working in this very different material, with its many layers and wood grain.

Robert Wilson, <u>CHILD'S HORSE CHAIR</u>, 1994, red oak, 53.3 x 81.3 x 11.4 cm
Wilson involves himself in every step of the design process for his stage props, from conception to production, although he does not physically produce the pieces himself, leaving master craftspeople to complete the work. Nonetheless, while their original function may have been to enhance stage productions, the finished objects are often treated as works of art, being sold to public and private collections. The year before he produced this chair, he won the Golden Lion award at the Venice Biennale in 1993 for one of his sculptural works.

OPPOSITE TOP **Ai Weiwei**, <u>BENCH</u>, 2004, ironwood from dismantled temples of the Qing Dynasty (1644–1911), 56 x 400 x 43 cm
OPPOSITE BOTTOM **Ai Weiwei**, <u>TWO JOINED SQUARE TABLES</u>, 2005, Qing Dynasty (1644–1911) tables, 136 x 167.5 x 91.5 cm
Ai has often used his art to express his ambivalence towards Chinese cultural traditions. With these two works, he literally takes the material of China's history and subverts it to create new objects that question the value and legacy of the country's past. For *Bench*, he employed Chinese makers to use traditional furniture craft techniques to cut ironwood timber retrieved from a dismantled Qing Dynasty temple into long slivers and reconstitute them into a bench, the end profile of which is in the shape of China.

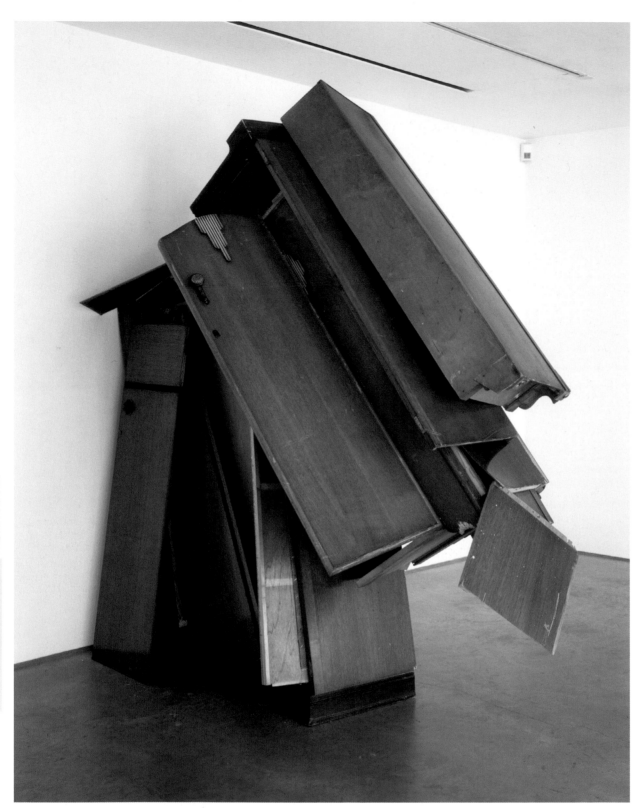

ABOVE **Angela de la Cruz**, <u>CLUTTER
WARDROBES</u>, 2004, wood, dimensions variable
Cruz (b. 1965, Spain) has created a series of
sculptures that are assembled for her by
a series of assistants, as well as fabricator
Mike Smith. In *Clutter wardrobes*, she had
her assistants disassemble traditional British
wardrobes and then had them reassembled
in a huge cluster that looks as if it might topple
over at any moment.

OPPOSITE **Angela de la Cruz**, <u>UPRIGHT (PIANO)</u>,
1999, mixed media and piano, 170 x 60 x 14 cm
She had Smith cut two pianos in half to create
Upright (piano). The top of one piano and the
bottom of another were joined together so that
it was still possible to play the instrument. It
remains a piano (a highly crafted object in itself)
but also a sculpture. The inherent tension in her
works forces the viewer to reassess the original
object and what she has had done to them.

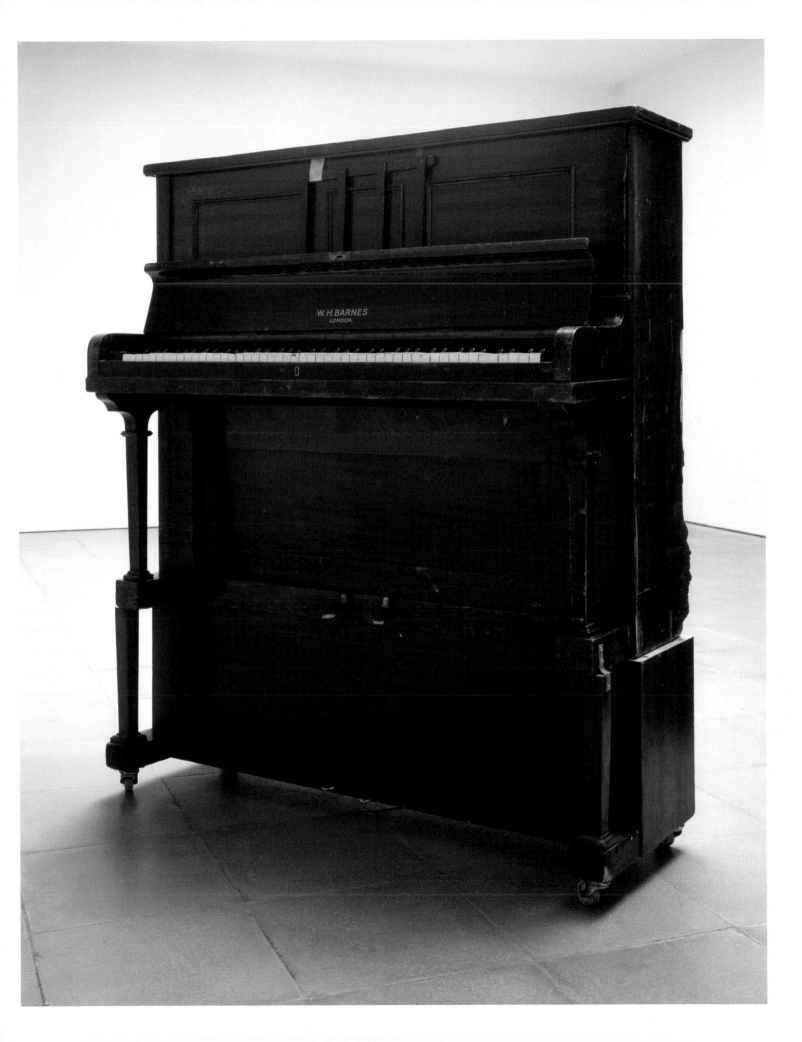

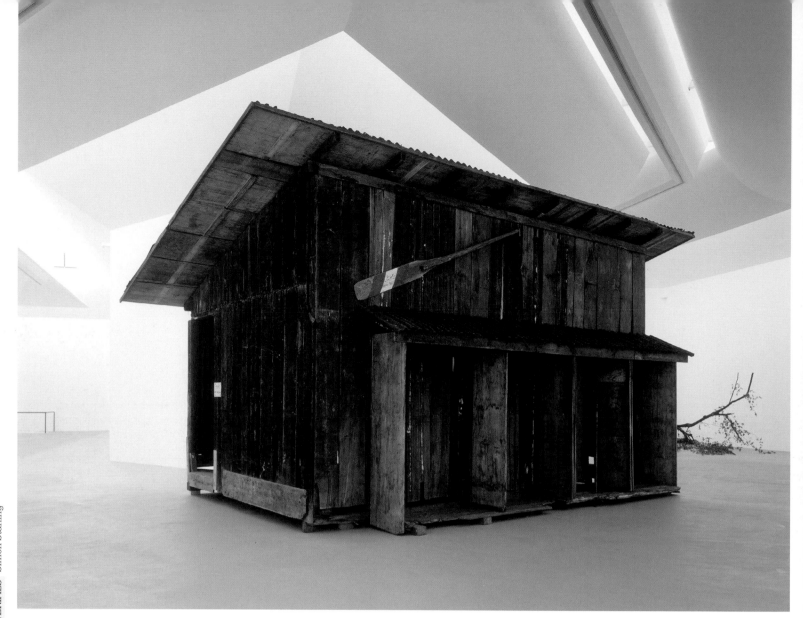

ABOVE AND OPPOSITE **Simon Starling**, <u>SHEDBOATSHED</u>
<u>(MOBILE ARCHITECTURE NO. 2)</u>, 2005, wood,
400 x 600 x 400 cm

Starling is fascinated by the processes involved in transforming
one object or substance into another. He describes his work
as 'the physical manifestation of a thought process', revealing
hidden histories and relationships. His most famous work is
Shedboatshed (Mobile Architecture No. 2), for which he won
the 2005 Turner Prize. The artist found a wooden shed upriver
from the Kunstmuseum Basel, where he was preparing for a solo
show, which was then taken apart by workmen and transformed
into a *weidling*, a type of boat found locally. Starling then loaded
the vessel with the remains of the shed and floated it the eight
kilometres down the Rhine to the gallery, where it was returned
to its original form as a shed. The work was a comment on the
museum itself, which had recently been refurbished. Starling's
show was the first in the newly reconfigured space.

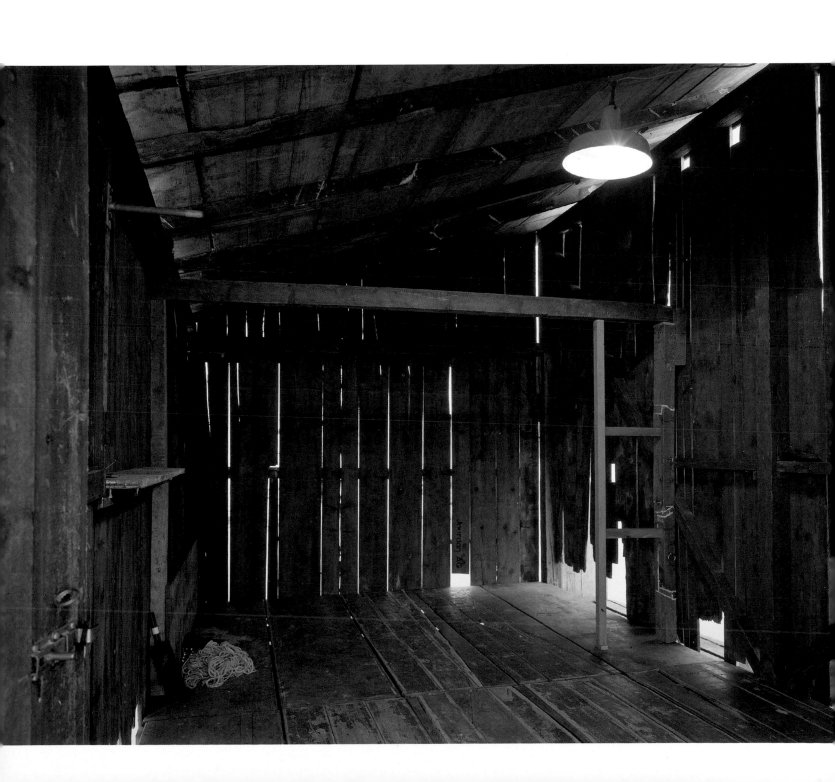

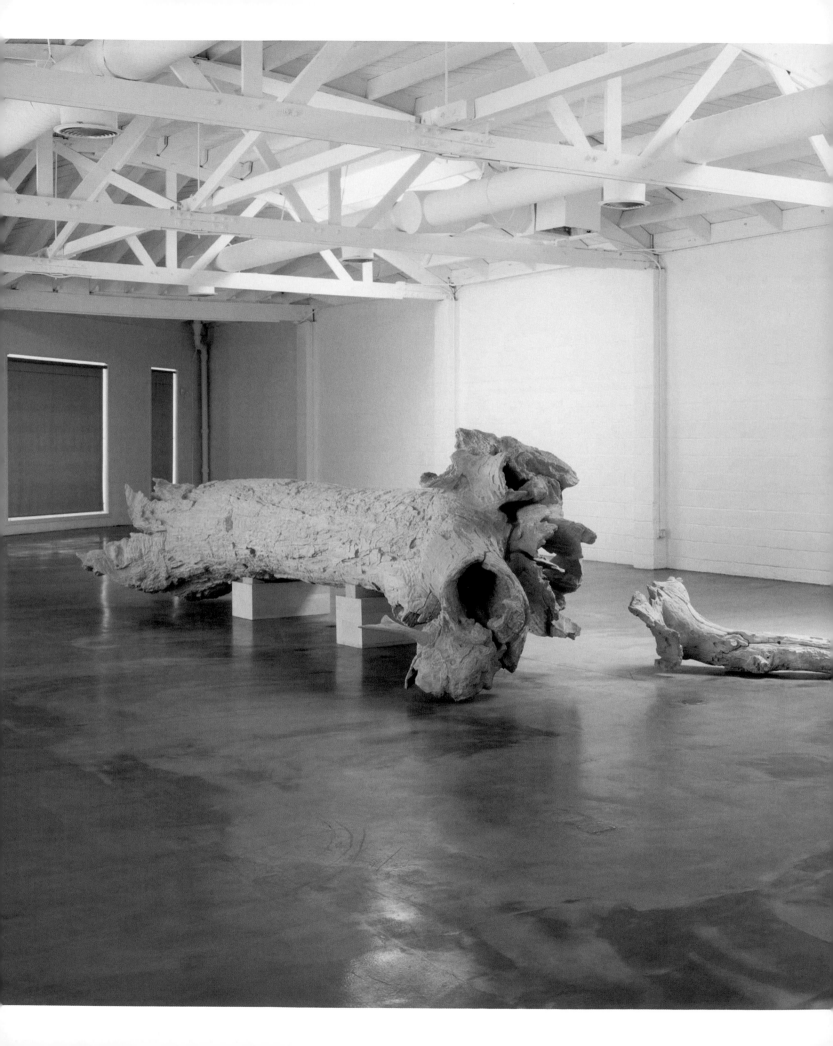

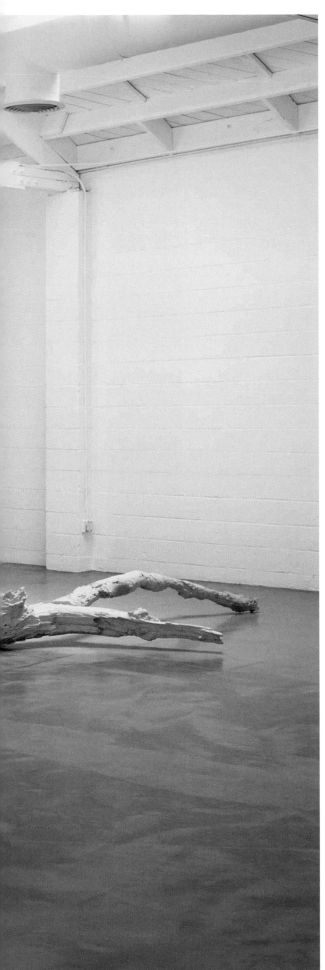

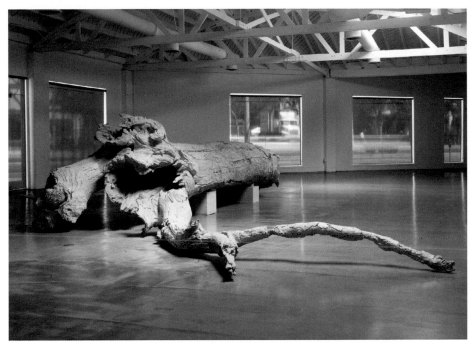

Charles Ray, <u>HINOKI</u>, 2007, cypress, three parts: 172.7 x 762
x 233.7 cm; 63.5 x 426.7 x 208.3 cm; approx. 60.5 x 400 x 200 cm
Ray's *Hinoki* appears to be a life-size tree placed in the gallery.
It is in fact made up of pieces of wood carved by the Japanese
master carver Yuboku Mukoyoshi and his team, and resembles
a fallen tree that Ray found in California and from which
he made a mould. It took the team four years to carve the work
from cypress wood (*hinoki*), a different wood than the original,
which further distanced the work from its origin, calling into
question the veracity of originality.

LEFT AND ABOVE **José Damasceno**, <u>CRASH OF A PROP</u>, 2008, ceramic, polypropylene and steel cable, 3000 x 120 cm

Damasceno's show 'Coordenadas y Apariciones' at the Reina Sofía museum in Madrid saw the artist install nine works throughout the museum's public areas, including its stairwells, bookstore and patio, exploring the idea of maximizing space. *Crash of a Prop* is made up of eight polypropylene elements fixed to a steel cable suspended over an oversized cup and saucer. The artist sought to open up the museum, expand the way work is exhibited and ask visitors to question traditional museological practices. The polypropylene pieces were fabricated by the Tornotec company in Rio de Janeiro, while the large cup and saucer were made from Sargadelos porcelain in cooperation with a 200-year-old Spanish firm in Galicia.

ABOVE **Bryan Mulvihill**, <u>ZEN AND TEA ARE THE SAME TASTE</u>, 2010, tea set, calligraphy on porcelain, dimensions variable Mulvihill (b. 1950, Canada) is known for his series of performances called the World Art Tea Party, in which he works with a museum to explore social history by using various tea-related objects in the collection). Mulvihill recently worked with the Lui potteries in Jingdezhen, China, to make a series of tea-related ceramics. The specialist makers produced all the objects for him, and Mulvihill painted the calligraphy on them.

ABOVE **Ai Weiwei**, <u>THE WAVE</u>, 2005, porcelain, 25 x 40 x 40 cm
BELOW **Ai Weiwei**, <u>PILLAR</u>, 2006, sixteen porcelain pillars, dimensions variable, heights between 178 and 238 cm
Ai is another artist to have worked with traditional Chinese ceramicists, here creating both a small-scale porcelain piece and a large room-sized installation. *The Wave* was part of Ai's presentation at Documenta in Kassel, Germany, in 2007. Like much of his work, it considers the relationship between China's antiquity and past traditions and its growing modernity.

RIGHT **Kris Martin**, <u>VASE</u>, 2005, Chinese porcelain, glue, height 225 cm

Martin uses the passage of time and the knowledge of the ever-present nature of death and decay as the starting-point for many of his works. For *Vase*, he purchased a large readymade vase, smashed it, and then reassembled it. He shows it in this semi-broken state. Over time, it gradually loses pieces and its integrity. Each time the work is shown in a new exhibition, the process begins again: it is toppled over, broken and reassembled once more.

OPPOSITE, TOP LEFT **Christine Borland**, <u>ENGLISH FAMILY CHINA</u>, 1998, bone china, dimensions variable

Borland (b. 1965, UK) uses intensive investigative processes for her sculptural installations. For this piece, she had Alison Borthwick of the Buchlyvie Pottery Shop in Scotland remake in bone china a series of plastic replica human skulls (a child's, a man's, a woman's and a foetal skull) of the type supplied to medical schools. The bone-china skulls were then painted by Borthwick and Borland with designs made by the artist. The traditional blue iconography was similar to that seen on eighteenth-century tableware manufactured in Liverpool, the major UK slave trade entry point). The skulls required many stages in production, casting, firing, glazing and painting, all to Borland's specifications.

OPPOSITE, TOP RIGHT **Lionel Estève**, <u>DENDRIER</u>, 2007, porcelain, 16 cm diameter, edition of 30

Estève (b. 1967, France) designed this ashtray for D&A Lab based on a cast of his own dentures. There is room for a cigar to rest on the gum where two teeth are missing. The title is a play on the French words for ashtray (*cendrier*) and teeth (*dents*). Celebrated Belgian ceramicist Piet Stockmans developed the prototype and produced the whole series for Estève.

OPPOSITE, BOTTOM **Fiona Banner**, <u>TABLE STOPS</u>, 2000, glazed ceramic, boxed, 30 x 30 x 16 cm, edition of 100

In Banner's hands, full stops become abstract sculptures, each containing their own highly individual characteristics. Commissioned by the Multiple Store in London, her *Table Stops* are a series of ceramic full stops in a range of different fonts (Klang, Slipstream, Avant Garde, Nuptial, Formata, Optical and Courier), all scaled to the same size. Banner has said of these works that '"TABLE STOPS" are abstract points of focus. Like tableware, or executive toys, they are to be handled and moved around. The act of arranging and rearranging them enacts a silent conversation.'

LEFT **Richard Deacon**, SIAMESE YELLOW, 2005, glazed ceramic, 57 x 84 x 40 cm

Deacon has made a series of large works in ceramic that have required the input of ceramic specialists. He worked with Anna Zimmerman on *Siamese Yellow*: 'Basically I had made some shapes which she then reproduced as something like wire diagrams (in clay). We then explored which of these could be put together (made to share a facet) and together cut out and fitted them. Anna tidied them up and I did the glazing.' The piece was made in Niels Dietrich's workshop in Cologne, and Dietrich controlled the complex firing process.

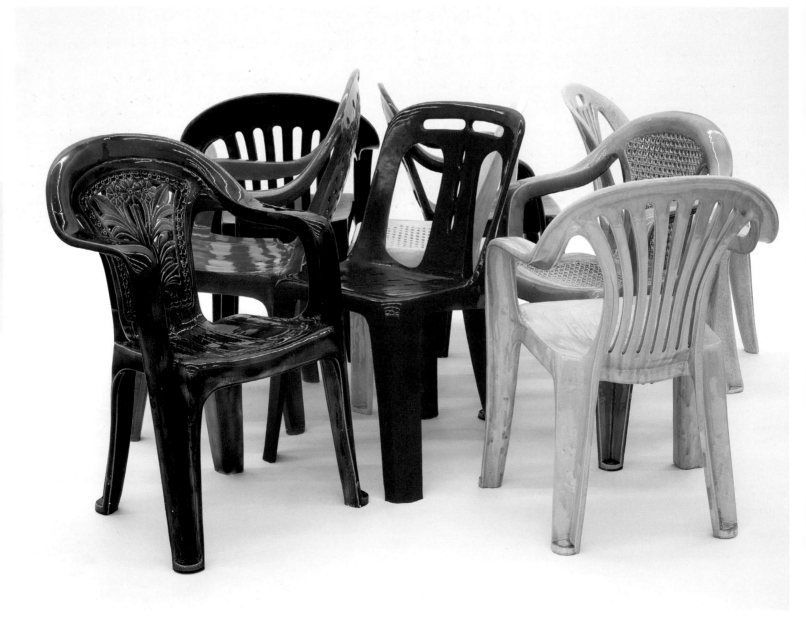

'You should never make anything somebody else can make. I only make things that nobody but me can make. In the 1960s that got me into trouble because I was a woman. No one complained about Judd or Serra getting things fabricated did they?' Liliane Lijn

Liliane Lijn, STRIPED KOANS, 2009, ceramic, six sizes, edition of 30

Lijn started her signature series of 'koans' in various materials in 1968. The name is a reference not only to their conical shape, but also to a Zen Buddhist concept meaning 'a question without an answer'. 'The central concept is of energy within matter', she has written about her koans. 'It is as if beneath the skin of a stone there is a luminous interior.' Her ceramic series was manufactured to her design by the Rometti factory in Umbertide, Italy, a company that has worked with many artists since the 1920s. Lijn tried to paint the pieces herself, but found that the company's professional painters, given their extensive experience, realized her ideas far better.

OPPOSITE **Sam Durant**, UNIQUE MONO-BLOCK RESIN CHAIRS. BUILT AT JIAO ZHI STUDIO, XIAMEN, CHINA. PRODUCED BY YE XING YOU WITH CRAFTSPEOPLE XU FU FA AND CHEN ZHONG LIANG. KANG YOUTENG, PROJECT MANAGER AND LIAISON, 2008, glazed porcelain, dimensions variable

At first glance, Durant's (b. 1961, US) chairs look like nothing more than average plastic lawn furniture. In fact, they are unique *trompe l'oeil* works hand made in China from porcelain. In a series exploring ideas of production, value and implied hierarchies endemic in art, craft and 'craftiness', objects that are normally mass-produced (often in China) are instead highly crafted works of art made with ancient Chinese ceramics techniques. The titles of the works are expansive, as Durant includes the names of all those who worked on the pieces.

LEFT AND BELOW **Anya Gallaccio**, <u>BECAUSE NOTHING HAS CHANGED</u>, 2000, cast bronze, 250 live apples, twine, approx. 280 x 200 x 150 cm

Many of Gallaccio's recent large-scale and more permanent works have required the services of additional craftspeople beyond her normal assistants. As well as working with metal foundries, glassmakers and other technicians, she has required the skills of expert ceramicists to make, for example, porcelain apples to hang on bronze trees such as this.

OPPOSITE **Jan Fabre**, <u>NEN ASSEBAK</u>, 2008, porcelain, 28 x 16 x 14 cm

Fabre's devilish ashtray was produced for Belgium's D&A Lab. Although the result is executed in traditional porcelain, it was realized using high-end technology. It started with the artist's head being scanned, then the 3D image was transformed slightly on the computer to enlarge the mouth area. Then the head was printed in nylon, using stereolithography, which then was used to make mutiple moulds for the porcelain process.

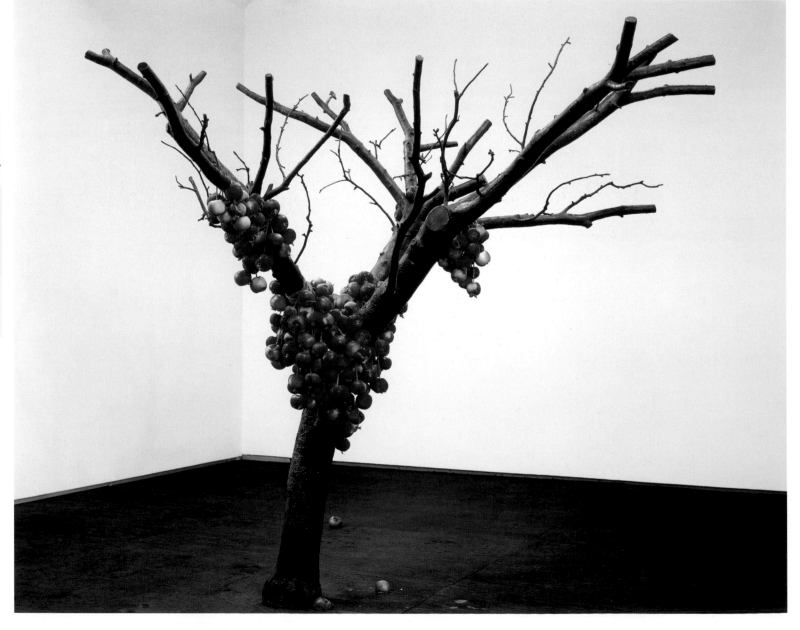

interviews

OPPOSITE **Roni Horn**, PINK TONS, 2008, solid cast glass, 121.9 x 121.9 x 121.9 cm

BELOW LEFT **Sam Adams**, LOVE CHAIR, 2009, wood, plastic, electronics, each chair approx. 120 x 60 x 90 cm

BELOW RIGHT **Sam Adams**, DAY TRIP TO PICCADILLY, 2007, wood plastic, electronics, 1100 x 300 x 30 cm

SAM ADAMS
London, UK
Works with a range of artists

As a practising artist, how do you feel about making work for other artists?

As a student, I thought it was a negative thing to do — you want to make your own work — and after you leave college you tend to work on your own and that can be hard. Oddly, when you are working with another artist there is a benefit to your own practice. When I am solving problems for others, it often teaches me things I use in my own work and it is a real positive.

How many artists have you worked for?

About a dozen in the two years since we set up. We have a small company, Big Soda, which works with artists and their studios. Jeff Koons and Glenn Brown are the main ones. The Jeff Koons studio is a really big enterprise. They employ a lot of people. Arnold is their specialist metalwork fabricator and Carlson in California is the other.

Do you ever discuss the concept of the work with the artists?

No, not really. We don't work on that basis. Maybe with younger artists we work with — people who are friends — but not with professional artists.

What do you do if an artist wants you to make something that you feel won't work?

It hasn't happened yet. People come to you for solutions — they can start with an outline or a sketch for an idea and we try to put flesh on it. That's our role in their practice — to make solutions.

What is the most difficult problem you have faced?

Some projects have taken longer than expected, but so far, we haven't had any really difficult problems — touch wood.

As an artist, do you make your own work?

Yes, I do. I use a similar approach to when I work with others and solve problems for them. I just do that for myself when I make my own work.

If you couldn't make something, would you go to someone else to fabricate it?

Maybe. Quite often I want something done immediately, so I have to think around the idea and find another way to make something. But in theory I would get something fabricated for me. That said, there is a strong link between the thinking and making processes in my work. What happens when I make something is I think about it and maybe I just chop something off here or change something there. You can't do that if you have someone making it for you.

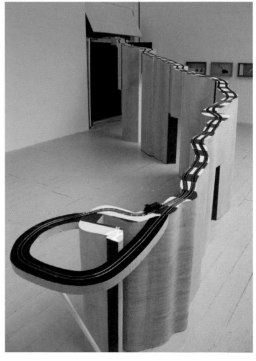

Sam Adams INTERVIEWS

183

Nayland Blake, pencil drawing on paper sent to master carver J. M. Boswell with instructions for making <u>ROOT</u>, 2003

J. M. BOSWELL
Chambersburg, Pennsylvania
Worked with artist
Nayland Blake

What did you think of Nayland Blake's request for a two-stemmed pipe?

I have been making pipes for thirty years and everybody has something different. The technical difficulties were how to get two shanks on the pipe before it would work. It was my chore to make it work. It had to work or it wouldn't be a pipe. It was fun to make, it was different and challenging. When you get a request like that it is a chore but fun to make at the same time.

What were the technical difficulties?

Obviously it has to work, you have to be able to put tobacco in it and get two people to smoke it at the same time. I wouldn't make it if you couldn't use it. One person can smoke it, they can hold one stem closed. What makes it nice is if two people smoke it at the same time. There are two ways you can do that. One person can draw in the smoke while the other covers up their side. Both can also smoke it at the same time.

How long did it to make Nayland's pipe?

Not that long in the making; it was long in the thinking of it and the preparations to make it. Once I got started it was very fast. The difficult thing was to think about how to attach the shanks to each side – how to fuse the pieces together. One piece is solid and then I added the other piece, and I had to think about it because at first, if it got too hot when smoking the shank might have fallen off. It was the first time I made a pipe with two shanks. I had to join them at the same internal level.

Why did you not carve the pipe from one piece of wood?

Because you can never get a piece of wood big enough for that. The wood grows underground and it's hard to get big enough pieces.

How much variation from Nayland's drawing to the actual pipe was there.

Sometimes with commissions, the drawings are not functional. Any time you get a drawing in, there are things that you have to do to make it functional. Nayland is an artist, but he is also a pipe smoker so he knows about pipes. His drawing was pretty good. It was about 90% correct, not exact but real close.

In making his pipe did you find any new techniques or things that you could apply to other pipes?

Probably not. The principles of engineering a pipe are all pretty much the same. In the end, it went together exactly as I planned it. But getting it to smoke was the key. It's not a pipe if you can't smoke it.

Do you have a favourite pipe of all the ones you have made?

I like 'em all. I've made over half a million pipes in my life. I make about four or five thousand a year and have been making pipes for thirty-five years. There was a time when I had to turn out twelve to fourteen thousand pipes a year. I needed the money. You add it up – that's a lot of pipes.

How long does it take to carve a pipe?

A regular pipe takes about ten minutes or so. We sell those for $59.95. Essentially what you are selling is time. It's all about time. Commissions obviously take more time. If you only did customs, you'd starve to death because of the time and effort. But I enjoy the challenge. Nayland's pipe was a challenge. Yes it sure was, but it was fun to do.

Has anyone ever asked you to carve something too difficult or impossible?

It's very rare that we have to say no.

Saint Clair Cemin, VORTEX, 2008,
stainless steel, 700 x 310 x 310 cm:
(LEFT) under construction; (BELOW) installation view

SAINT CLAIR CEMIN
**Born Brazil, lives and works
New York, US
Works with craftspeople
and industrial makers**

When or why would you use a maker to produce a work for you?

My work relies on an integration of the entire organism of the artist, on his mind and body as well as the environment where this body/mind resides. The making of the work is part of the work. I prefer, therefore, to make the work myself. All small- and medium-size marbles have been carved by me, all wood carving as well. I make all my models. When the work is of such a nature that I cannot make it myself, then I use specialized craftsmen. This is always the case when I cast bronze or when I carve large marbles or ones that are too delicate for my level of skill, or when I use material that requires a technical expertise that I do not possess. An example of it is in my production of hammered steel and copper, which is difficult and time consuming, and so needs the help of many specialist workers.

When you work with makers, what production issues are raised?

All sorts of issues are discussed. But I do not leave anything for them to decide in terms of the results, materials, and final look. We even discuss transport and installation before the piece is made.

Do you speak about issues of authorship with the makers?

There is no question of authorship (which is mine, naturally), since the model is given by me, the choice of material and finish is mine as well. That is one issue that has never occurred, and I believe it would not occur in the worker's mind either.

What happens when a maker raises concerns about realizing your wishes?

I make complex work – problems of all types are a constant. So I listen and I'm open to suggestions at all times during the conception and creation of a piece. When I make something altogether new, there is quite a lot of consultation with workers, sometimes with engineers as well.

Have you ever had any difficulties with a maker and how were they resolved?

Difficulties are common and to resolve them demands diplomacy but also clarity of purpose. From my side it is the case of being explicit and didactic; from the craftsman's side, his role is to be skilled and flexible. When this cannot be achieved, then there is the possibility that another craftsman will be able to satisfy the demands of the work.

What would happen if you were not satisfied with the finished object?

When the work is not to my liking there are the following possibilities: the work must be corrected (supposing that can be done); the work has to be redone partially; or the work must be redone entirely. All three have happened to me. Once I had a piece worked on by someone who was not skilled enough. I left him, paid for his work and gave the badly finished piece to someone else to finish.

Could I be in touch with any of the makers you have worked with so I can ask them about their side of the process?

That would be useless. The only thing a Chinese craftsman will say is that we have a wonderful relationship, which is true, and that we never had any problems, which is false, since we spend all our time together solving problems, mostly technical, of all types.

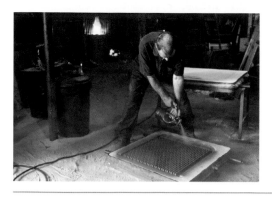 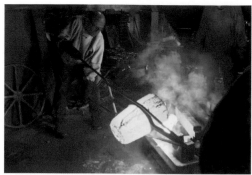

CORNFORD & CROSS
London, UK
Matthew Cornford
and David Cross
Work with craftspeople
and industrial makers

When or why would you use a maker
to produce a work for you?

We have worked with people that
we consider skilled in the crafts
on three occasions. In 1999, we made
Jerusalem, a life-size figure of a toy
soldier to go in the grounds of a
school in Norwich. We employed
a local artisan to make the figure
out of lead taken from spent bullets
gathered from the firing range
of the National Rifle Association.
The figure was mounted on a plinth
of stone quarried and brought over
from Normandy. In the same year,
we produced *Utopia*, which was
based on the restoration of an
ornamental pond in Bournville,
Birmingham. And in 2004 we
created *Where is the Work?*, in
which we had one of the cast-iron
floor grilles in the South London
Gallery remade.

When you work with makers, what
production issues are raised?

Because we use a wide range
of materials and techniques and work
in a wide variety of situations, we
anticipate that issues will arise
in terms of our works' production.
Over time we have grown to accept
these unknown issues and rather than
dismiss or be irritated by them, we
try to embrace them as important

moments on the journey to the works
conclusion. For *Where is the Work?*,
the materials and processes of
production were contemporary,
because the original grille was no
longer in production, and a
readymade was not possible. Instead,
we commissioned an industrial
design consultancy to 'reverse
engineer' the original grille, and used
a computer to prepare a 'third angle
projection' drawing. A pattern maker
worked from the drawing to
handmake a three-dimensional
pattern, using power tools to cut,
shape and finish MDF and epoxy
resin filler. The foundry used electric
pumps to inject carbon dioxide into
the mould to harden the sand, and
smelted the iron with propane gas.

Do you speak about issues of authorship
with the makers?

We always explain that we are artists
and the work will be shown within
an art context. We discuss the project
and why we wish to work with
a particular person or company,
process and material. This is usually
very straightforward and everyone
is clear on what needs to be done
and their role.

What happens when a maker raises
concerns about realizing your wishes?

We work with a particular
craftsperson or maker because
of their skills and experience, so we
would not normally ask them to
work outside their area of expertise.
If problems do arise, we listen and
try and resolve them. For instance,

in making *Jerusalem*, the artisan
expressed concern about fumes from
melting lead bullets, a problem we
resolved with the help of an army
surplus gas mask.

Have you ever had any difficulties with a
maker and how were they resolved?

When working on the statue for
Jerusalem, lack of communication
was a problem. Rather than allow
us to witness or document the craft
process, the artisan carried out the
work as he interpreted it, only
announcing it once completed.
The stonemason who carved the
lettering for *Jerusalem* didn't speak,
other than to refuse payment for his
work. No resolution was possible in
either case. For *Where is the Work?*
the pattern maker mistakenly made
a positive copy that resulted in the
cast-iron version being a 'mirror
image' of the original. The
difference was only discernible
when the original and copy were
placed side by side, which was never
likely to happen. But he agreed to
make a new pattern.

Do you find that makers from different
disciplines work with you in different ways,
and if so how?

The pattern maker, and foundry
workers, the craftspeople who
undertook the modelling and
casting of the lead figure, and the
carving of the lettering on its
stone plinth had far more room for
artistic interpretation than people
simply tasked with delivering
industrial goods.

186

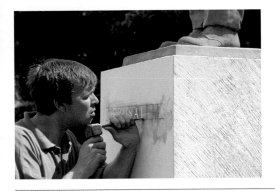

OPPOSITE FAR LEFT Making the cast-iron floor grille for
WHERE IS THE WORK?, 2004, cast iron, 62 x 61 cm,
at Whitton Castings in south-east London
OPPOSITE CENTRE Preparing the mould for WHERE IS
THE WORK?
OPPOSITE RIGHT Spent lead bullet casings for
JERUSALEM, 1999
LEFT Master stonemason carving the plinth for
JERUSALEM
BELOW Toy soldier used as the model for JERUSALEM

What would happen if you were not satisfied with the finished object?

If we weren't satisfied with the object, we would arrange for it to be adjusted or made again. As mentioned, we had the pattern remade and the grille recast for *Where is the Work?* But more importantly, for us the finishing of the object or installation is one stage in a process rather than the completion of the work. The interpretation of the work, including all the material difficulties in realizing it, brings the work's completion closer. The response of participants, audiences and commentators keeps deferring the moment of finish.

ANGELA DE LA CRUZ
London, UK
Works with assistants
and fabricators

When or why would you use a maker to produce a work for you?

I have had to ask another person to do a work because basically I couldn't do it in my studio. When I find it impossible to do something, I ask other people.

When you work with makers, what production issues are raised?

You become like a film director. The artist knows what is going on all the time, has the last say. The issue of trust is very important.

Do you speak about issues of authorship with the makers?

No, the boundaries are very clear from the beginning. The artist has the original idea and the maker executes it.

What happens when a maker raises concerns about realizing your wishes?

We try to find solutions together. I tend to think if something is going to work because the maker has more experience than me, then I go with it. It's part of the process and the deal. In this way it is very organic.

Have you ever had any difficulties with a maker and how were they resolved?

If the difficulties get too much, I go to another one.

Do you find that makers from different disciplines work with you in different ways, and if so how?

I prefer working with photographers and sculptors because of their skills and different ways of looking.

What would happen if you were not satisfied with the finished object?

The whole process would have to start again, providing I had the money and the time. I am a perfectionist.

Jan Fabre, <u>SHITTING DOVES OF PEACE AND FLYING RATS</u>, 2008, Murano glass, Bic ink, 25 x 25 x 260 cm, glass seen during production at the Berengo Studio, Murano

RICHARD DEACON
London, UK
Works with craftspeople and industrial makers

When or why would you use a maker to produce a work for you?

Obviously, from time to time I need help – that's one reason. Another would be that I'm interested in a particular process, material or technique – and I don't really make a distinction between industrial and craft processes in this regard – and it could be that it's the individual that interests me. A third, connected to the last, would be the availability of a particular material or process that I can't use in the studio. A fourth would be that I like working with other people.

When you work with makers, what production issues are raised?

Mostly the process is discursive and I rarely come with a definite design, so there are issues about deadlines, but more often it's a case of finding a way to produce a worthwhile result. You don't need to finish everything you begin.

Do you speak about issues of authorship with the makers?

Yes. In particular I have an ongoing discussion with Matthew Perry and we have agreed on a phrase 'In association with Matthew Perry Studio' as testament to his input, together with an agreed percentage (additional to payments) of any sale.

With Niels Dietrich, I have worked since the beginning with him as an equal partner in sales one-third, one-third, one-third – this resolves many issues. I remain clear all the time that it is my sculpture. The situation gets reversed when I am working with a graphic designer or typographer.

What happens when a maker raises concerns about realizing your wishes?

We discuss it.

Have you ever had any difficulties with a maker and how were they resolved?

There are always difficulties! We are not making simple things. But that's part of what is interesting, and mostly there is a solution.

Do you find that makers from different disciplines work with you in different ways, and if so how?

Different materials have different imperatives and working practices. Glassmakers, for example, learn how to make a particular thing by repeatedly doing it; steel fabricators can work to very tight tolerances.

What would happen if you were not satisfied with the finished object?

Like I said before, you don't have to finish everything you begin.

JAN FABRE
Antwerp, Belgium
Works with craftspeople and makers

When or why would you use a maker to produce a work for you?

I only use craftsmen on work I cannot produce myself, or that needs specific techniques, materials or knowhow I do not possess. I'm very keen on making things with my own hands. But sometimes you really need professionals. A good example is my trip to Murano. It was 1987, and I had tried blowing glass in the shape of an owl without getting the result I was looking for. I realized I was never going to be a master glassblower. So I called on the Berengo Studio for help, and I still work with them now. The most recent work I created with them is *Shitting doves of peace and flying rats*. I gave them sketches and drawings of different types of doves – 'dove in love', 'horny dove', 'skeleton dove', 'a sick dove', etc. – and they developed some prototypes. They then adjusted each one step by step until they achieved in glass the image I had in mind. After all the doves were made, I went to Venice with an assistant, and coloured them by hand using ballpoint ink.

When you work with makers, what production issues are raised?

I like this meeting with specialists of another field. I'm curious how they react to problems I give them. I like the exchange of knowledge

and energy. I believe in the idea of 'consilience' – literally, a 'jumping together' of knowledge across disciplines. *Totem* is a good example. It is a piece commissioned by Leuven in Belgium: a 23-metre needle with a 2.7-metre beetle impaled on it. The size already suggested it would be a technical challenge. I worked on the design with the Structural Mechanics Division in the Civil Engineering Department of the University of Leuven, as well as the Metallurgy and Materials Engineering Department. And during the production, I worked with engineers and researchers. The beetle was 'sculpted' by Remie Bakker of Manimal Works from a rigid modelling foam. Based on his experience and advice of experts in composite materials, he built it from a mixture of polyesters. He also developed an iridescent paint to protect it from the weather.

Do you speak about issues of authorship with the makers?

Absolutely! I always make it clear that their technical knowledge, support and/or execution will be credited, but that the idea is mine, and that it will be known as such: 'a work of art by Jan Fabre'.

What happens when a maker raises concerns about realizing your wishes?

Each work of art is a process. When I depend on craftsmen or professionals to create a piece and it looks like we are not getting along, or if I think that they will not be able to carry out my ideas, I will end our collaboration. I will never go through with something if I am not satisfied with the interim results. I sometimes even set to work on it myself, or else I go out and look for people who are capable of giving shape to my ideas.

Do you find that makers from different disciplines work with you in different ways, and if so how?

Each material has its own set of laws and rules. Almost like a scientist, I very much enjoy examining and at the same time bending and breaking those rules. I always try to discover new directions and to see whether we can think outside the box or colour outside the lines. My collaboration with Art Casting is a good example of this. I have been challenging them to explore the possibilities of the casting process. Under my impulse, they have been developing new techniques in editing and finishing castings.

What would happen if you were not satisfied with the finished object?

For that reason I've destroyed already a lot of works.

CARLOS NORONHA FEIO
Born Portugal, lives and works London, UK
Works with craftspeople and industrial makers

When or why would you use a maker to produce a work for you?

When the work would gain strength from being produced by others than me. When I have no technical capacity to compete with a traditional maker or specialist. When the issue of production itself forms part of the conceptual idea behind the work.

When you work with makers, what production issues are raised?

I don't always work with makers. I worked with makers for some neons, some rugs and a few other things that I do not have enough knowledge to make on my own. With some works, like the rugs, my use of makers goes beyond the technical side. I wanted the rugs to be made in a traditional house, in a traditional way, in a specific town with an old tradition. I wanted them to be traditional products, as well as works of art. They needed to be sincere products that could represent the cultural identity of the country where I grew up.

Do you speak about issues of authorship with the makers?

In the case of the rugs, the copyright of the drawings is mine. No one can reproduce them without my

THIS PAGE **John Frankland**, <u>BOULDER</u>, 2008: (RIGHT) the boulders in Carnsew Quarry near Falmouth in Cornwall; (FAR RIGHT) the boulders in transit; (BELOW) one of the boulders being installed

permission, and that is implied when I produce the image to be put on the rugs. They are commissions by me, and as such are of my own making. That is as far as I can claim authorship. The technique of the rugs itself has no author. It has a maker, a craftsman or woman (traditionally a woman). It is a very old tradition.

What happens when a maker raises concerns about realizing your wishes?

We try to figure out a different way to sort the problem. Usually, the problem has to do with the scale of the drawing and what is possible or not to do with the stitches – like complicated details in the drawing.

Have you ever had any difficulties with a maker and how were they resolved?

I had a problem with one of the rugs – there was a slight alteration of the drawing. My design had wheels of destiny, but they ended up as swastikas. I contacted them as soon as I realized what happened, which was already during the first show with the rugs. They said they would correct the mistake at zero cost, and were very apologetic.

Do you find that makers from different disciplines work with you in different ways, and if so how?

As long as they are professional and we both understand the process that's needed, they are all equally great people to work with.

JOHN FRANKLAND
London, UK
Works with technical experts and assistants

When or why would you use a maker to produce a work for you?

I would ask for help with something if I couldn't do it myself, such as lifting and transporting an 85-tonne boulder.

When you work with makers, what production issues are raised?

Purely practical ones.

Do you speak about issues of authorship with the makers?

Not in the case of the *Boulder* project.

What happens when a maker raises concerns about realizing your wishes?

I talk it through and solve the problem.

Have you ever had any difficulties with a maker and how were they resolved?

The word 'maker' is not really appropriate: I am the maker; the people helping have access to equipment and technical information that I do not have. Any difficulties may be technical but they could equally be financial – both are important but different from authorship.

Do you find that makers from different disciplines work with you in different ways, and if so how?

I haven't worked with many 'makers' from different craft disciplines so can't really make the comparison. My guess would be that it would come down to personality. I think social skills are important …

What would happen if you were not satisfied with the finished object?

It would be a failure and I wouldn't use it.

Could I be in touch with any of the makers you have worked with so I can ask them about their side of the process?

I am the maker … feel free to contact me.

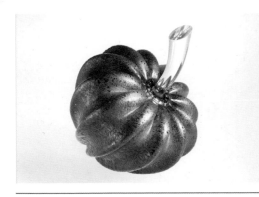

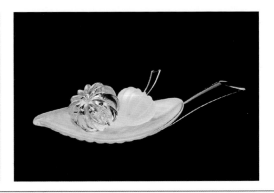

IAN HANKEY
Bovey Tracey, UK
Works with visual artists, makers and art students

When or why do artists ask you to produce a work for them?

I used to make pieces for students at the Royal College of Art. These days I make my own work, do the occasional commission and design for the likes of Caithness Glass, Dartington Crystal and Teign Valley Glass. I would make the first pieces and then hand over the making of the work to the production makers. I also undertake some production work for artists who have their own glass workshops.

When you work with artists, what production issues are raised?

The main thing is communication. I have to take on board the artists' expectations and balance this with what is practical with the glassmaking process and materials. I have learnt never to say no, as trying the artists' ideas is a perfect way to communicate the limitations. I've also found that often trying ideas conceived outside of a craft often results in unique and extremely successful outcomes. Glassmakers can tend to get 'bogged down' in technique, and it does us good to break a few rules and push the boundries of what is possible.

Do you speak about issues of authorship with them?

No. Whatever is made is theirs. It's a bit like classical music. The greatest works are recognized as the creation of the composer rather than that of the musician. Although musicians are of course highly regarded, they can't claim to be the author. This of course is completely different with pop music, where the musician/singer is credited with most of the acclaim for a song. However it would be difficult to imagine the craftsperson achieving the same adulation as a pop singer.

What happens when you raise concerns about realizing the work?

Normally the artist is present during these difficulties and we work out strategies for dealing with them together. The great thing about molten glass is that it has a life of its own and when things don't go according to plan, it has a way of suggesting what it 'wants' to do. This can produce the kind of development that would never take place on paper or computer, and can result in truly unique work.

Have you ever had any difficulties with an artist and how were they resolved?

I don't recall ever having any difficulties with an artist, perhaps due to my experience at the RCA. When your role is to facilitate the needs of artists, you tend to be able to overcome any problems amicably.

Do you find that makers from different disciplines work with you in different ways, and if so how?

Definitely. But just as skills are transferable, so are processes. I'm interested in applying elements from ceramics into my glassware, developing Raku glazes that are compatible with glass.

What would happen if you were not satisfied with the finished object?

If it were mine, it would go in the bin. If it was a piece for an artist, I have learnt to let them make judgments about quality. I think quality is a set of ideals where the elements of skills and aesthetics are constantly changing to suit the piece of work. As I am not the author and am not deciding on what elements to use to achieve quality, it's not for me to say.

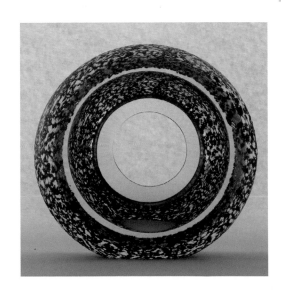

ANTHONY HARRIS
London, UK
**Works with visual artists
and art students**

When or why do artists ask you to produce a work for them?

Artists approach me all year round with requests. Because I work in an art college, most are often ex-students, who have little or no budget. They usually approach me for a service rather than realizing actual objects. Cold working mainly.

When you work with artists, what production issues are raised?

Deadlines, unrealistic deadlines. Also artists tend to believe that if something 'hasn't been tried before' that legitimizes the work, not considering that it probably has been tried before and maybe there is a reason why it doesn't exist.

Do you speak about issues of authorship with them?

There is no issue of authorship. Work that is made to an artist's brief is not mine. People accuse us here of making students' work, as if it undermines their abilities as artists. When does an architect build a building? When does a composer play the orchestra? The ability to make doesn't define what is and isn't an artist. Many technicians think they don't get the credit they deserve. But they wouldn't be a technician if they were making their own work – they would be the artist. I have no time for anyone who questions the artist because 'they don't make their own work'. It doesn't matter who made it. Do you like it, will you buy it, how much do you want to pay for it? That's it. The creative process is complete: idea, object, sale!

What happens when you raise concerns about realizing the work?

Eduardo Paolozzi used to have moulds made here. If there was a problem, his response was 'Ok, what shall we do?' then after being given an alternative, 'Ok, let's do that.' If only the world were so simple. The artist has to be trusting of the technician's opinions and skill. Discussion is important.

Have you ever had any difficulties with an artist and how were they resolved?

The problem with people and artists is the need for immediacy. I no longer take on work when someone says 'The deadline is tight' or 'My budget is limited.' Another problem is non-payment. One colleague, after repeatedly being let down by an artist who owed him about three jobs' worth of money, refused to let a piece leave the department. He was met with a very abusive response. The payment arrived the next day.

Do you find that makers from different disciplines work with you in different ways, and if so how?

If a designer has an engineering background, they will work through ideas, while being open to other options and adjust their needs accordingly. Product designers tend to be dismissive of alternatives. Good fine artists are fun and open; bad ones are lost at sea.

What would happen if you were not satisfied with the finished object?

It is not my business to be satisfied with the finished object. If the artist is not satisfied with it, and it's my error, then I'd do it again. If it's something more fundamental, we've probably talked it through in the first place, but really the artist decides on the quality. If they are happy with it, then so am I. I have done work that I know could have been done better, and I have redone it willingly, but I don't recall ever being in a situation where something is so bad it can't be fixed. I am a professional after all!

Micah Lexier, production and installation views of the 20,000 custom-minted nickle-plated coins used in <u>I AM THE COIN</u>, 2009

MICAH LEXIER
Toronto, Canada
Works with assistants, craftspeople and makers

When or why would you use a maker to produce a work for you?

I use fabricators for making all of my work. I always have. Even when I was a student, I had works fabricated by others. It is just the way I bring things into the world.

When you work with makers, what production issues are raised?

Most of the fabricators have worked with me for decades, so the conversations that we had about the nuances of fabrication happened a long time ago. We understand each other very well at this point. Whenever I add a new process or fabricator, I spend a lot of time talking with them about issues that may come up, and ask them to communicate with me when an issue arises, rather than assume that I want it one way or another.

Do you speak about issues of authorship with the makers?

Never. I work with industrial processes, and my job is just one of many that they are working on that day or week. It is very clear to all of us that it is their machines and labour, but that the final product is mine. The imagery and ideas are mine. I supply them with files that they then use to produce the work.

What happens when a maker raises concerns about realizing your wishes?

Again, that doesn't happen too much, as I have been using the same processes for a while and know what the machines are capable of. But every so often something does come up and we work it through. I have a motto I use often: 'Problems are good.' If I come up against a technical issue, we adjust and often this solution is better than my original idea.

Have you ever had any difficulties with a maker and how were they resolved?

The only problems I have had are ones of personality, and if that is the case I move on to a different fabricator. It is important that the people I work with are able to communicate with me, and if we are not able to do that effectively, then I find someone else who can. Many of the processes I use are industrial ones, and there is always another company that can make the work. Getting work fabricated is a major component of what I do, so it is important to me to find fabricators that I like to work with and who like to work with me.

Do you find that makers from different disciplines work with you in different ways, and if so how?

Yes, but only because they are each different people. Each person relates to you in a different way, independent of the industry they are working in.

What would happen if you were not satisfied with the finished object?

Again, we just talk it through. If something has to be remade because of some error in the fabrication process, then they pay to remake it. If it is made properly, but I don't like it for some reason, then I pay to have it remade with whatever changes I want. I like working with reasonable people and seek those people and companies out.

Bryan Mulvihill's ZEN AND TEA ARE THE SAME TASTE, 2010, tea set, calligraphy on porcelain, dimensions variable, being manufactured in China: (FAR LEFT) an artisan rolling the porcelain clay; (LEFT) unglazed leaves ready for Mulvihill to paint

BRYAN MULVIHILL
Vancouver, Canada
Works with craftspeople
and makers

When or why would you use a maker to produce a work for you?

I work with craft artisans who are carrying on a cultural tradition that I explore in a contemporary context. Having developed a live-art practice of recontextualizing traditional tea cultures of the world, I think it's only right to work with producers of culturally explicit utensils to create specific wares for particular related events. Having the opportunity to work with traditional craftspeople is a great inspiration and opportunity to explore new ways of seeing. In the case of the ceramic makers of Jingdezhen, China, they have been making porcelain ceramics for hundreds of generations. There are masters of throwing, moulders, glaze makers, clay preparers, painters, kiln firers, finishers, packagers. All the work in these mass-production potteries has been done in piecework processes for over a millennium. The concept of an individual artist does not really exist. There is equally a long tradition among tea masters to work with traditional crafts people to produce particular tea utensils, pieces of furniture, architectural structures, metal kettles, calligraphy, and even the style of tea cultivating and curing tea to suite specific occasions or events.

When you work with makers, what production issues are raised?

I generally have a basic idea of the type or specific use for an object I want to commission, but work with the producer to select the best materials, techniques employed, and the traditional decorative or stylistic finishing to be applied. I consider the process a collaboration of the maker's tradition and skillset and my vision of intended use.

Do you speak about issues of authorship with the makers?

In the tea ceremony, the identity and lineage of the maker is part of the appreciation of the objects chosen for each tea occasion. Each object has a box or container with the name of the maker, where and when it was made, and often a poetic name given to the object itself. This object container also acts as an archival record for all future uses of the object, thus giving each work a living history, both of its making and subsequent uses.

What happens when a maker raises concerns about realizing your wishes?

These become important considerations to myself and the makers to work out together, to find creative ways to solve and develop ways to address these problems. There are specific physical requirements for utensils to be used in tea practice. After these have been fulfilled, both the maker and commissioner can agree on the aesthetics and process of realizing them. It tends to be an ongoing and very enriching process for both.

Have you ever had any difficulties with a maker and how were they resolved?

On occasion, what I was asking a maker to produce was not physically possible for the material or technical ability of the maker, but that has been rare and new solutions can usually be found. When not possible, one either has to find someone else or rethink what one is trying to achieve.

Do you find that makers from different disciplines work with you in different ways, and if so how?

I often work with people of different cultural traditions, for example asking an Indian stonecarver to make something for a contemporary new media installation-based tea event, or a Chinese traditional potter to make something for a Japanese tea ceremony. In these cases, culturally specific skills are often more of a consideration than the actual materials used. There are aesthetic attitudes about the degree of finishing to consider, and attention to details particular to each cultural mode of production, as well as the basic understanding of the intended use of the object being made. In these cross-cultural engagements, the process often needs more detailed direction and involvement from my side.

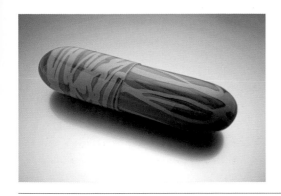

LEFT **Liam Reeves**, <u>PANACEA</u>, 2009, 16 x 60 x 16 cm, free-blown glass, colour trails, cut and glued

BELOW **Liam Reeves**, <u>VECTOR BOTTLE</u>, 2010, 55 x 15 x 15 cm, free-blown glass, 'reticello' technique

LIAM REEVES
London, UK
Works with visual artists and art students

What is the worst thing about working with visual artists?

When they want something impossible and won't listen to reason. I have fourteen years' experience as a glassblower and sometimes they won't take no for an answer.

Do you ever just try what they want?

Only if it is a small thing, so I can demonstrate why it won't work. If it is big and painful to make, I say so. Large work can be physically painful (I hurt my arm last year). It's very hot, very uncomfortable, in a way that is specific to glass.

What is the best thing?

As a maker, you can be restricted by your own ideas of the limits of the process, and quite often artists will push you to do something you didn't think was possible. It can be a fine line between yes and no. When I came to the Royal College of Art, I said yes to everything. Working here has given me a greater view of what that line is. So when someone asks me to make a half-scale full-sized car roof out of glass I say NO! The problems arise when people come to the material completely blind – as glass is the most awkward material.

What makes a piece be on the line between yes and no?

How difficult the material is to work with. With my experience, if I can't say if it will work, but it is on the line, I'll give it a shot.

Does a working relationship impact on what you will try to do?

It must do. The relationship is built up over time. Working for someone inevitably has some effect, but the limits can be quite clear. No matter how good the working relationship, if something is not possible, I'll say no, so as not to waste everyone's time.

Does working with artists feed back into your own work?

Definitely, in a practical sense – in terms of technical possibilities. Sometimes it closes avenues and sometimes it opens them up – for the same reasons. They will push you to see something is possible and that has an impact on my work. On another level, working with artists broadens your understanding of creativity and art. Sometimes with students it is about art not craft.

Is your own work art or craft?

It's strongly rooted in the traditions of making glass. But I'd like to think it has a conceptual edge. If pushed, I'd have to say that craft plays a big part. In ceramics and glass that's a big question and has been for a while (if something is art or craft).

What do you think of this divide?

There is a lot of work out there that blurs the boundaries.

How objective or distant are you from what you make for artists?

There is always a fingerprint of the maker. Even in a factory, if two guys are blowing the exact same things, a trained eye can pick out the differences and who made what.

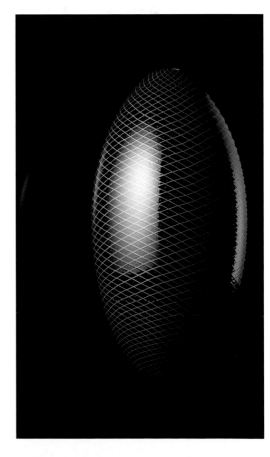

Silvano Rubino, ADDIZIONE SOTTRATTIVA, 2009: (LEFT) the production of the work; (BELOW) Rubino inspecting the computer-controlled cutting of the sheet of glass

SILVANO RUBINO
Venice, Italy
Works with craftspeople, makers and industrial workers

When or why would you use a maker to produce a work for you?

I will use a maker in a project when I think they can produce a better piece than I could. Every time I project something, I think about which craftsman would be best to produce my pieces.

When you work with makers, what production issues are raised?

I talk with them very quietly and explain what I want. If we need more time to explain, I will go over it again and again. I will ask them to make everything 'perfect', and it is also very important to make it on time.

Do you speak about issues of authorship with the makers?

No, I don't speak about that. Only for my Murano glass design works, when someone realizes a glass-blowing project, will I credit the glass master by name.

What happens when a maker raises concerns about realizing your wishes?

Many times, makers raise some problems about the difficulty in realizing a work, but by speaking, we jointly find some good solutions.

Have you ever had any difficulties with a maker and how were they resolved?

I think is very important to listen to the reasons that makers flag up, and to discuss it until we find an answer.

Do you find that makers from different disciplines work with you in different ways, and if so how?

For every material there is always someone who is the best person working in that medium, often in the same town where the artist lives, and I would always want to use them.

What would happen if you were not satisfied with the finished object?

In this case it is ever so difficult, but in my experience, I prefer not to have such unpleasant surprises,

so I only work with makers of well-known ability, who I know will produce work that I find acceptable.

FAR LEFT Upholsterer Peter Sacher working on the leather and metal fastenings for Patrick Traer's sculpture BABY BLUE BALLS in his upholstery shop in 2002

LEFT Seamstress Anne Zbirun at work in her home embroidery business, making an embroidered anatomical shape for a series of works by Traer

PATRICK TRAER
Montreal, Canada
Works with an upholsterer
and an embroiderer

When or why would you use a maker to produce a work for you?

It is usually a technical need, a need for expertise, with a type of equipment, or a type of process or skill with materials. Or all of the above. I like to work with many different types of materials and processes. I could not possibly achieve mastery working with all these materials in one lifetime.

When you work with makers, what production issues are raised?

Usually I have a deadline that cannot be moved. The craftspeople I work with are used to setting their own deadlines. It is on their terms. So I have learned that I must act well ahead of my own deadline before I approach them. I cannot expect them to stay up all night the night before the work is due. This has had an impact on procrastinating – I can't – and on my process. Sometimes I need to use every possible minute to do the best I possibly can for an exhibition, but when working with a business, this is not how things go.

Do you speak about issues of authorship with the makers?

Yes, I have, but this hasn't really been an issue. I always acknowledge everyone who works on the pieces, whether it is Anne Zbirun (embroiderer) or Peter Sacher (upholsterer), or Peter's apprentices, or my own student assistants from the university where I teach. Neither Anne nor Peter have aspirations to be artists. They see themselves as providing a service to me as a client.

What happens when a maker raises concerns about realizing your wishes?

This is something I have been lucky with. They continue to surprise me with what they are able to do. I also just happened to hit upon two people who, like me, think anything is possible. And when sometimes the amount of labour seems excessive, I do as much as I can to help. I offer to do errands for both Anne and Peter so that they can concentrate on applying their skill to the pieces. With Peter, over time, he taught me how to make the work myself, how to upholster. I would hire him to make a sculpture, and then he would use me as his apprentice, giving me extensive instructions and demonstrations. It became an odd tangle of him working for me, me working for him.

Have you ever had any difficulties with a maker and how were they resolved?

No, all of them were excited to try something new, outside of their routine and which tested their abilities.

Do you find that makers from different disciplines work with you in different ways, and if so how?

I don't think it makes a great deal of difference. I think it has to do with how large a business they are. The larger the business, the less I am inclined to work with them. It is far less personal. The larger businesses just want to take the work and hand it back finished. The smaller businesses let you inside. The making is visible. There is a much stronger sense of pride. They are not making the work with complete indifference.

What would happen if you were not satisfied with the finished object?

This happens. If it is a matter of how it is crafted, I say, 'This has to be more even, or these threads cannot show.' This is the type of thing that craftspeople completely understand. It is never an issue when improving on something technical. But there is also the idea itself. I accept that all my proposals may not turn out to be as exciting as I had hoped. If there is a possibility of remaking, then I tell the makers we have to start again. But I take full responsibility for the failures, just like anything I make entirely on my own, not everything works. I have a garage full of sculptures that I couldn't quite convince myself were successful enough to show. But I have just as many that I love.

Further reading

GENERAL

Glenn Adamson, *The Craft Reader*, Berg, 2009

Glenn Adamson, *Thinking Through Craft*, Berg, 2007

Sandra Alfondy (ed.), *Neo Craft: Modernity and the Crafts*, Press of the Nova Scotia College of Art & Design, 2008

Roland Barthes, *Image, Music, Text*, Hill & Wang, 1977

Adriano Berengo, *Glasstress*, exh. cat., Venice, 2009

Nayland Blake, Lawrence Rinder, Amy Scholder (eds), *In a Different Light: Visual Culture, Sexual Identity, Queer Practice*, City Lights Books, 1995

Ecke Bonk, *Duchamp:The Box in a Valise*, Rizzoli, 1989

Nicolas Bourriaud, *Relational Aesthetics*, Les Presses du réel, 2002

Michael Brenson, *David Smith: Medals for Dishonor*, Independent Curators International, 1997

Laurie Britton Newell (ed.), *Out of the Ordinary: Spectacular Craft*, V&A Publications, 2007

Séan Burke, *The Death and Return of the Author: Criticism and Subjectivity in Barthes, Foucault, and Derrida*, Edinburgh University Press, 1998

Whitney Chadwick, *Women, Art, and Society*, Thames & Hudson, 1990

R. G. Collingwood, *The Principles of Art*, Oxford University Press, 1938

Egidio Costantini, *Vetro, un amore*, La Fucina degli Angeli, 1992

Blanche Craig, *Contemporary Glass*, Black Dog, 2008

Douglas Crimp, *On the Museum's Ruins*, MIT Press, 1993

Hugh M. Davies, *Blurring the Boundaries Installation Art 1969–1996*, Museum of Contemporary Art San Diego, 1997

Nicolas de Oliveira, Nicola Oxley, Michael Petry, *Installation Art*, Thames & Hudson, 1994

Jacques Derrida, *Given Time: I. Counterfeit Money*, University of Chicago Press, 1992

Peter Dormer (ed.), *The Culture of Craft: Status and Future*, Manchester University Press, 1997

Briony Fer, *Eva Hesse: Studiowork*, Yale University Press, 2009

Cynthia Freeland, *But Is It Art?: An Introduction to Art Theory*, Oxford University Press, 2002

Boris Groys, *Art Power*, MIT Press, 2008

Lisa Iwamoto, *Digital Fabrications: Architectural and Material Techniques*, Princeton Architectural Press, 2009

Karin Knorr Cetina, 'Objectual Practice' in Theodore R. Schatzki, Karin Knorr Cetina, Eike von Savigny (eds), *The Practice Turn in Contemporary Theory*, Routledge, 2001

Rudolf Kuenzli, *Dada*, Phaidon, 2006

Faith Levine, *Handmade Nation: The Rise of DIY, Art, Craft, and Design*, Princeton Architectural Press, 2008

Malcolm M. McCullough, *Abstracting Craft: The Practiced Digital Hand*, MIT Press, 1997

David Revere McFadden, Jennifer Scanlam, Jennifer Steifle Edwards, *Radical Lace and Subversive Knitting*, ACC Editions, 2008

Pam Meecham, Julie Sheldon, *Modern Art: A Critical Introduction*, Routledge, 2004

Egidio Costantini, il maestro dei maestri, sculture d'arte in vetro, Andrea Moro, 1999

Ursula Ilse Neuman, *GlassWear*, Arnoldsche in collaboration with the Museum of Arts & Design New York and the Schmuckmuseum Pforzheim, 2007

Valerie Cassel Oliver (ed.), *Hand+Made: The Performative Impulse in Arts and Craft*, Contemporary Arts Museum Houston, 2010

Juhani Pallasmaa, *The Eyes of the Skin: Architecture and the Senses*, John Wiley & Sons, 2005

Juhani Pallasmaa, *The Thinking Hand* (Architectural Design Primer), John Wiley & Sons, 2009

Michael Petry, *Hidden Histories: 20th Century Male Same Sex Lovers in the Visual Arts*, Artmedia Press, London, 2004

David Pye, *The Nature and Art of Workmanship*, Herbert, 2007

Sculpture in Glass of the Fucina degli Angeli, Fucina degli Angeli, 1968

Howard Risatti, *A Theory of Craft: Function and Aesthetic Expression*, University of North Carolina Press, 2007

Jac Scott, *Textile Perspectives in Mixed-Media Scultpure*, Crowood Press, 2003

C. Sharp, S. Kent, *Demons, Yarns and Tales: Tapestries by Contemporary Artists*, Damiani, 2008

Joost Smiers, *Arts Under Pressure: Promoting Cultural Diversity in the Age of Globalisation*, Zed Books, 2003

Pamela H. Smith, *The Body of the Artisan: Art and Experience in the Scientific Revolution*, University of Chicago Press, 2004

Terry Smith, *What is Contemporary Art?*, University of Chicago Press, 2009

Joanne Turney, *The Culture of Knitting*, Berg, 2009

Mark Wallinger, Mary Warnock, *Art for All?: Their Policies and Our Culture*, Peer, 2000

ARTISTS' MONOGRAPHS

Darren Almond, *Index*, Koenig Books, 2008

Darren Almond, text by Brian Dillon, *Moons of the Iapetus Ocean*, White Cube, 2008

Ghada Amer, essay by A. M. Homes, Gagosian Gallery, 2004

Ghada Amer, *Color Misbehaviour*, Cheim & Read, 2010

Fiona Banner, *All the World's Fighter Planes*, Vanity, 2004

Fiona Banner, *THE NAM*, Frith Street Books, 1997

Barry X Ball, SITE Santa Fe, 2007

Per Barclay, Reina Sofia Museum, 2004

Giulietta Speranza, Mariano Navarro, Frederick Bonnet, *Per Barclay*, Hopefulmonster Editore, 2003

Nancy Spector, *Matthew Barney: The Cremaster Cycle*, Guggenheim Museum, 2002

Alberto Barbera, Guido Curto, Richard Flood, *Matthew Barney*, Hopefulmonster Editore, 2008

Massimiliano Gioni, Francesco Bonami, *Matthew Barney (Supercontemporanea)*, Mondadori Electa, 2007

Brenda Richardson, *Jennifer Bartlett: Early Plate Work*, Yale University Press, 2006

Raimar Stange, Thierry Davila, *Pierre Bismuth*, Flammarion, 2006

Alexander Alberro, *Pierre Bismuth*, Art Gallery of York University, Canada, 2005

Nayland Blake, *Some Kind of Love: Performance Video 1989–2002*, Matthew Marks Gallery, 2003

Gavin Turk, Mel Gooding, *An Alphabet by Peter Blake*, Paul Stolper, 2008

Christoph Grunenberg, Laurence Sillars (eds), *Peter Blake: A Retrospective*, Tate Publishing, 2007

The Collections of Barbara Bloom, International Center of Photography, 2008

Alighiero e Boetti, essay by Norman Rosenthal, Gagosian Gallery, 2001

Luca Cerizza, *Alighiero e Boetti: Mappa*, MIT Press, 2008

Christine Borland, *Preserves*, Fruitmarket Gallery, 2006

Christine Borland, *Progressive Disorder*, Dundee Contemporary Arts, 2000

Louise Bourgeois, Frankfurter Kunstverein, 1995

Paulo Herkenhoff et al., *Louise Bourgeois*, Phaidon, 2003

Mignon Nixon, *Fantastic Reality: Louise Bourgeois and a Story of Modern Art*, MIT Press, 2008

Fred Hoffman et al., *Chris Burden*, Thames & Hudson, 2007
Peter Noever et al., *Chris Burden: Beyond the Limits*, Cantz, 1996

Daniel Buren et al., *Daniel Buren: Modulation: Arbeiten (Works) in Situ: Arbeiten in situ*, Verlag für moderne Kunst Nürnberg, 2010
Daniel Buren, *New Situated Works*, Lisson Gallery and Hatje Cantz, 2007
Daniel Buren, Cornerhouse, 2008

Ana-Maria Torres, Cosme de Baranano, *Scott Burton*, IVAM Centre Julio Gonzalez, 2000
Scott Burton, Tate Gallery, 1985

James Elliot, *The Perfect Thought: Works by James Lee Byars*, University of California Press, 1990
Klaus Ottmann (ed.), *Life, Love and Death: The Work of James Lee Byars – A Critical Retrospective*, Hatje Cantz, 2004

Maurizio Cattelan, *Hollywood*, Fondazione Sandretto Re Rebaudengo, 2001
Maurizio Cattelan, Charta, 2000
Maurizio Cattelan, Phaidon, 2003

Saint Clair Cemin: Sculptor from Cruz Alta, Sikkema Jenkins & Co., 2005

Tom Holert, *Marc Camille Chaimowicz: Celebration? Realife*, MIT Press, 2007
Anette Freudenberger et al., *Marc Camille Chaimowicz*, Cornerhouse, 2006

Kenneth Lum, Maite Vissault, Wang Min'An, *Chen Zhen: The Body as Landscape*, Verlag Moderne Kunst, 2007

Dale Chihuly: 365 Days, HNA Books, 2008
Timothy Anglin Burgard, *Art of Dale Chihuly*, Chronicle Books, 2009

William Cobbing, *Gradiva Project*, Freud Museum, 2007

Cornford & Cross, Black Dog, 2009

Keith Coventry, *Vanishing Certainties*, Haunch of Venison, 2009

Germano Celant, *Tony Cragg*, Thames & Hudson, 1996
Tony Cragg, *Signs of Life*, Richter Verlag, 2003

Dorothy Cross, Irish Museum of Modern Art, 2005
Gone: Site-Specific work by Dorothy Cross, University of Chicago Press, 2005

Angela de la Cruz, *Trabalho/Work*, Edificio-Sede da Caixa Geral de Depósitos, Lisboa Galleries, 2006

Jon Thompson et al., *Richard Deacon*, Phaidon, 2000
Sacha Craddock, Graham Gussin, *On the Rocks, Richard Deacon & Bill Woodrow*, Bloomberg Space, 2008

Sam Durant, *Proposal for White and Indian Dead Monument Transpositions, Washington, D.C.*, Paula Cooper Gallery, 2005
Jeremy Strick, Georg Kulenkampff, *Sam Durant*, Hatje Cantz, 2002

Lionel Estève, *Night Rainbow*, Galerie Emmanuel Perrotin, 2006

Jan Fabre, *The Lime Twig Man*, Hatje Cantz, 1995

Sacha Craddock, James Cahill, *Angus Fairhurst*, Philip Wilson, 2009

Christoph Keller (ed.), *Matias Faldbakken: Not Made Visible*, JRP Ringier, 2007

A A and Away: Carlos Noronha Feio, Transition Editions, 2009

Corinna Thierolf and Johannes Vogt, *Dan Flavin: Icons*, Thames & Hudson, 2009
Dan Flavin: The Complete Lights 1961–1996, Yale University Press, 2004

Lucio Fontana, Infinite Space, Sperone Westwater, 2005

Ralph Rugoff, *Anya Gallaccio – Chasing Rainbows*, Locus+, 1999
Simon Schama, *Anya Gallaccio: Beat*, Tate Publishing, 2002

Ryan Gander, *In a Language You Don't Understand*, Ikon Gallery, 2002
Jonathan Watkins et al., *Ryan Gander: Heralded as the New Black*, Ikon Gallery, 2008

Liam Gillick, *All Books*, Book Works, 2009
Lionel Bovier (ed.), *Liam Gillick: Proxemics: Selected Writings, 1988–2004*, JRP Editions, 2005
Monika Szewczyk, *Meaning Liam Gillick*, MIT Press, 2009

David Deitcher, *Felix Gonzalez-Torres*, Magasin 3, 1992

Dan Graham, *Beyond*, MIT Press, 2009
Dan Graham Pavilions: A Guide, Art Metropole, 2009

Subodh Gupta, *Gandhi's Three Monkeys*, Jack Shainman Gallery, 2010
Subodh Gupta, *Common Man*, JRP Ringier, 2010
Nicolas Bourriaud, *Subodh Gupta*, Galleria Continua, 2009

Mona Hatoum, White Cube, 2006
Chiara Bertola (ed.), *Mona Hatoum. Interior Landscape*, Charta, 2009
Mona Hatoum, Phaidon, 1997

Peter Doroshenko, *Joseph Havel: A Decade of Sculpture 1996–2006*, Scala, 2006

Sally O'Reilly, *Jochem Hendricks*, Haunch of Venison, 2007

Damien Hirst, Rudi Fuchs, *For the Love of God: The Making of the Diamond Skull*, Other Criteria, 2007

Carsten Höller, Hatje Cantz, 2010
Carsten Höller Register, Fondazione Prada, 2002
Carl Roitmeister, Eckhard Schneider, *Carsten Höller: Carrousel*, Koenig Books, 2008

Urs Stahel, Elisabeth Lebovici, *Roni Horn: If on a Winter's Night …*, Steidl, 2003
Roni Horn, Phaidon, 2000

Shirazeh Houshiary, *A Suite for Shirazeh Houshiary*, Lisson Gallery, 2008
Isthmus: Shirazeh Houshiary, British Council, 1995

Gary Hume, *American Tan*, White Cube, 2007
Gary Hume, *Karneval/Carnival*, Matthew Marks Gallery, 2005

Nathalie Ergino et al., *Ann Veronica Janssens 8'26"*, ENSBA, 2004

Michel François, *Ann Veronica Janssens: Are You Experienced?*, Basepublishing, 2009

Achille Bonito Oliva, *Personal Living Space: Marya Kazoun*, Berengo Fine Arts, 2005

Mike Kelley, *Mike Kelley's Day Is Done*, Yale University Press, 2007
Isabelle Graw et al., *Mike Kelley*, Phaidon,1999

Rob Kesseler, *Up Close*, Papadakis, 2010
Rob Kesseler et al., *Seeds: Time Capsules of Life*, Papadakis, 2009

Jeff Koons, *Popeye Series*, Serpentine Gallery, 2009

David Freedberg, *Play of the Unmentionable: An Installation by Joseph Kosuth at the Brooklyn Museum*, The New Press, 1994
Joseph Kosuth, *Art After Philosophy and After: Collected Writings, 1966–90*, MIT Press, 1993

Michael Landy, *Everything Must Go*, Ridinghouse, 2008

Johannes Meinhardt, *Louise Lawler: An Arrangement of Pictures*, Assouline, 2000

Sherrie Levine, Simon Lee Gallery, 2007

Micah Lexier, *I'm Thinking of a Number*, Press of the Nova Scotia College of Art & Design, 2010

Glenn Ligon, *Some Changes*, The Power Plant, Toronto, 2005
Richard Meyer, Thelma Golden, Patrick T. Murphy, *Glenn Ligon, Unbecoming*, University of Pennsylvania, 1998

Alessandro Vestrelli, Enrico Mascelloni, *Liliane Lijn: Light and Memory*, Thames & Hudson, 2002
David Mellor, *Liliane Lijn: Works 1959–1980*, Mead Gallery, Warwick Arts Centre, 2005
Liliane Lijn, *Stardust*, Riflemaker Gallery, 2008

Matthew Thompson, *Kris Martin: Idiot*, Aspen Art Museum, 2009

'Allan McCollum', in Judith Olch Richards (ed.), *Inside the Studio:*

Two Decades of Talks with Artists in New York, Independent Curators International, 2004

Sheena Wagstaff, *Dhruva Mistry: Sculptures and Drawings*, Kettle's Yard, 1985
David Cohen, *Dhruva Mistry: Work 1990–1995*, Anthony Wilkinson Fine Art, 1995

Erik Verhagen, *François Morellet: 45 années lumière*, Flammarion, 2008
Marie-Laure Bernadac et al., *François Morellet: L'esprit d'escalier*, Editions du Regard, 2010

Joel Morrison, *CIRCUS*, Gagosian Gallery, 2008

Jorg Heiser, Rachael Thomas, *Paul Morrison: Haematoxylon*, Irish Museum of Modern Art, 2004

Bryan Mulvihill, *World Tea Party, Victoria*, Art Gallery of Greater Victoria, CURA, University of Victoria, Canada, 2004

Takashi Murakami, *©MURAKAMI*, MOCA Los Angeles, 2007
Margrit Brehm (ed.), *The Inevitable Japanese Experience: Takashi Murakami*, Hatje Cantz, 2002

Marc Newson, Gagosian Gallery, 2007
Alice Rawsthorn, Richard Allan, *Marc Newson*, Booth-Clibborn Editions, 2002

Olaf Nicolai 2003–2006, Eigen + Art, 2006

Jean-Michael Othoniel, *Un Coeur abstrait*, Actes Sud, 2009
Jean-Michael Othoniel, *Othoniel Crystal Palace*, Fondation Cartier pour l'art contemporain, 2003

Monika Oechsler, *Parallel Worlds*, Site Gallery Sheffield, 2005
Monika Oechsler, *At The Far and Farthest Point*, Revolver, 2004

Cornelia Parker, *Perpetual Canon*, Württembergischer Kunstverein Stuttgart, 2004

Jorge Pardo, Hatje Cantz, 2000
Jorge Pardo, Phaidon, 2008

Michael Bracewell, *Simon Periton*, Koenig Books, 2008

Jacky Klein, *Grayson Perry*, Thames & Hudson, 2010

Michael Petry, *The Trouble with Michael*, Artmedia Press, 2001
Michael Petry, *Golden Rain*, Hå Gamle Prestegard and MOCA London, 2008

Jacqui Poncelet, *Carpet*, Southbank Centre, 1992

Christoph Grunenberg, Victoria Pomery (eds), *Marc Quinn*, Tate Publishing, 2002

Walter Hopps, Susan Davidson, *Robert Rauschenberg: A Retrospective*, Guggenheim Museum, 1997

Charles Ray, *Log*, Matthew Marks Gallery, New York, 2009
Charles Ray, MOCA Los Angeles, 1998

David Thorp, *Ugo Rondinone: Zero built a nest in my navel*, Whitechapel Gallery, 2006
Klaus Biesenbach et al., *Ugo Rondinone: The Night of Lead*, JRP Ringier, 2010

Ulrike Lorenz, *Public, Tobias Rehberger 1997–2009*, Art Stock Books, 2010
Iwona Blazwick, Anthony Spira, Rirkrit Tiravanija, *Tobias Rehberger: Private Matters*, Whitechapel Gallery, 2004

Hanne Hagenaars, Wim Van Mulders, *Maria Roosen: Monster*, Valiz, 2009
Bianca Stigter, *Maria Roosen: Ziezo*, Art Data, 1998

Silvano Rubino, *In equilibrio tra due punti sospesi*, Damiani, 2010

Joan Cohen, *Art of Shan Shan Sheng*, East West Art, 1995

Haelaine Poner, *Kiki Smith*, Monacelli Press, 2005
Siri Engberg, *Kiki Smith*, Walker Art Center, 2005

Nathalie Zonnenberg, *Drop Sculpture Atlas Simon Starling*, Yale University Press, 2010
Susan Cross, *Simon Starling: The Nanjing Particles*, MASS MoCA, 2009

Richard Wentworth, *The Effect: Haim Steinbach*, Waddington Galleries, 2008
Bruce Ferguson, *Haim Steinbach: North East South West*, Hatje Cantz, 2001

Berend Strik, *Body Electric*, Valiz, 2004

Miwon Kwon, Lisa G. Corrin, *Do Ho Suh*, Serpentine Gallery, 2002

Michael Rush et al., *Fred Tomaselli Ten Year Survey*, Palm Beach ICA, 2001

Helen Marzolf, *Matchless, Patrick Traer*, Kenderdine Art Gallery, 2003
Patrick Traer, *Falling from Afar*, Dunlop Art Gallery, 1998
Patrick Traer, Southern Alberta Art Gallery, 1995

Gavin Turk, *Me as Him*, Riflemaker Gallery, 2007
David Barrett, *Gavin Turk*, Royal Jelly Factory, 2004
Alex Farquharson, *Gavin Turk: Collected Works 1994–1998*, Art Data, 1998

Koen Vanmechelen, *Cosmopolitan Chicken Project – Virtual Mechelse Fighters*, Deweer Gallery, 2005

Not Vital, Sperone Westwater, 2007
Not Vital, Sperone Westwater, 1999

Mark Wallinger, *The Russian Linesman*, Hayward Publishing, 2009
Richard Grayson, Janneke de Vries, Madeleine Schuppli, *Mark Wallinger*, JRP Ringier, 2008

Gwendolyn DuBois Shaw, *Seeing the Unspeakable: The Art of Kara Walker*, Duke University Press, 2005
Kara Walker, *After the Deluge*, Rizzoli, 2007

Bruce Hainley, *Andy Warhol: Piss & Sex Paintings And Drawings*, Gagosian Gallery, 2002
Heiner Bastian, *Andy Warhol, Retrospective*, Tate Publishing, 2001

Karen Smith, *Ai Weiwei*, Phaidon, 2009
Ai Weiwei, *So Sorry: So Sorry*, Haus der Kunst, München and Prestel, 2009

Charles Merewether et al., *Ai Weiwei: Works 2004–2007*, JRP Ringier, 2008

Franz West, *PAßSTÜCK*, Gagosian Gallery, 2008
Franz West, *To Build a House You Start with the Roof, Work 1972–2008*, MIT Press, 2008

Pae White, *Lisa, Bright & Dark*, Scottsdale Museum of Contemporary Art, 2008
Pae White, *WPEP: Pae White-Victor Estrada*, Finesilver Gallery, 1999

Richard Klein, *Fred Wilson: Black Like Me*, Aldrich Museum of Contemporary Art, 2005
Fred Wilson, *A Conversation with K. Anthony Appiah*, PaceWildenstein, 2006

Simon Morrissey, *Richard Wilson*, Tate Publishing, 2005
Michael Archer, Smon Morrissey, Harry Stocks, *Richard Wilson*, Merrell, 2001

Carmen Pardo, Miguel Morey, Miquel Morev, *Robert Wilson*, Ediciones Poligrafa, 2002
Maria Shevtsova, *Robert Wilson*, Routledge, 2007

Hermione Wiltshire, *Lost at Sea Found on the Ground*, Galerie Eugen Lendl, 1994

Bill Woodrow, *Sculptures*, Waddington Galleries, 2005
Jon Wood, *Oscillator: Bill Woodrow New Sculpture and Painting*, Waddington Galleries, 2008

Hans Ulrich Obrist, *Hans Ulrich Obrist and Cerith Wyn Evans: The Conversation Series*, Koenig Books, 2010
Susanne Gaensheimer, Molly Nesbitt, Helmut Friedl, *Cerith Wyn Evans: In Which Something Happens All Over Again for the Very First Time*, Koenig Books, 2007
Cerith Wyn Evans, *Look at that picture …*, White Cube, 2003

Aaron Young, *ARC LIGHT*, Gagosian Gallery, 2008

Paola Morsiani and Trevor Smith (eds), *Andrea Zittel: Critical Space*, Prestel, 2005
Jan Avgikos, *Andrea Zittel: Personal Programs*, Hatje Cantz, 2000

FURTHER READING

Artists' websites

Ai Weiwei www.aiweiwei.com
Almond, Darren www.whitecube.com/artists/almond/
Amer, Ghada www.cheimread.com/artists/ghada-amer
Ball, Barry X www.barryxball.com
Banner, Fiona www.fionabanner.com
Barclay, Per www.perbarclay.com
Barney, Matthew www.gladstonegallery.com/barney.asp
Bartlett, Jennifer http://www.paulacoopergallery.com/artists/3
Benónýsdóttir, Guðrún gbenonys.blogspot.com
Berwick, Rachel www.rachelberwick.com
Bismuth, Pierre www.teamgal.com/artists/pierre_bismuth
Blake, Nayland www.naylandblake.net
Blake, Peter www.artnet.com/artist/2582/peter-blake.html
Bloom, Barbara www.tracywilliamsltd.com
Borland, Christine www.lissongallery.com/artists/christine-borland/
Bourgeois, Louise www.hauserwirth.com/artists/1/louise-bourgeois
Burden, Chris www.gagosian.com/artists/chris-burden/
Buren, Daniel www.danielburen.com
Byars, James Lee www.michaelwerner.com/artist_5_main_1.htm
Castilho, Mara www.maracastilho.co.uk
Cattelan, Maurizio www.mariangoodman.com/artists/maurizio-cattelan
Cemin, Saint Clair www.saintclaircemin.com
Chen Zhen www.chenzhen.org
Cobbing, William www.theagencygallery.co.uk/William Cobbing.html
Cornford & Cross www.cornfordandcross.com
Coventry, Keith
www.haunchofvenison.com/en/index.php#page=home.artists.keith_coventry
Cragg, Tony www.tony-cragg.com
Cross, Dorothy www.frithstreetgallery.com/artists/bio/dorothy_cross
Cruz, Angela de la www.lissongallery.com/#/artists/angela-de-la-cruz
Damasceno, José www.thomasdane.com/artist.php?artist_id=4
Deacon, Richard www.richarddeacon.net
Durant, Sam www.samdurant.com
Estève, Lionel www.galerieperrotin.com/artiste-Lionel_Esteve-35.html
Fabre, Jan www.troubleyn.be
Fairhurst, Angus www.sadiecoles.com/angus_fairhurst
Faldbakken, Matias
www.simonleegallery.com/Artists/Martias_Faldbakken
Farkhondeh, Reza
www.tinakimgallery.com/artists/ghada-amer-and-reza-farkhondeh
Feio, Carlos Noronha www.carlosnoronhafeio.co.uk
Flavin, Dan www.davidzwirner.com/danflavin
Gallaccio, Anya www.lehmannmaupin.com/#/artists/anya-gallaccio
Gander, Ryan www.lissongallery.com/artists/ryan-gander/
Gillick, Liam www.airdeparis.com/liam.htm
Graham, Dan www.hauserwirth.com/artists/9/dan-graham
Gupta, Subodh www.hauserwirth.com/artists/11/subodh-gupta
Hatoum, Mona www.whitecube.com/artists/hatoum
Havel, Joseph www.artnet.com/artist/7957/joseph-havel.html
Hawrysio, Denise www.hawrysio.com
Hendricks, Jochem www.jochem-hendricks.de
Hillerova, Hana www.hillerova.info
Holden, Andy www.andyholdenartist.com
Höller, Carsten www.airdeparis.com/holler.htm#
Horn, Roni www.hauserwirth.com/artists/14/roni-horn
Houshiary, Shirazeh www.shirazehhoushiary.com
Hume, Gary www.whitecube.com/artists/hume
Ivie, David www.eharrisgallery.com/dibio.html
Jamieson-Cook, Anika www.helloanika.com
Janssens, Ann Veronica
www.gms.be/index.php?content=artist_detail&id_artist=29
Kazoun, Marya www.galleriamichelarizzo.net/artists/kazoun/index.shtm
Kelley, Mike www.mikekelley.com
Kesseler, Rob www.robkesseler.co.uk
Landy, Michael www.thomasdane.com/artist.php?artist_id=7
Lexier, Micah www.micahlexier.com
Ligon, Glenn www.regenprojects.com/artists/glenn-ligon
Lijn, Liliane www.lilianelijn.com
McCollum, Allan www.allanmccollum.net

Martin, Kris www.sieshoeke.com/artists/kris-martin
Mistry, Dhruva www.dhruvamistry.com
Morellet, François www.francois-morellet.com
Morrison, Joel www.joelmorrison.com
Morrison, Paul www.alisonjacquesgallery.com/paul-morrison-ab-13.html
Not Vital
www.speronewestwater.com/cgi-bin/iowa/artists/record.html?record=24
Othoniel, Jean-Michel
www.sikkemajenkinsco.com/jean-michelothoniel.html
Pardo, Jorge www.jorgepardosculpture.com
Parker, Cornelia www.frithstreetgallery.com/artists/bio/cornelia_parker
Periton, Simon www.sadiecoles.com/simon_periton/index.html
Perry, Grayson www.victoria-miro.com/artists/_12/
Petry, Michael www.myspace.com/michaelpetrylondon
Poncelet, Jacqui www.poncelet.me.uk
Rauschenberg, Robert
www.artnet.com/artist/14005/robert-rauschenberg.html
Ray, Charles www.matthewmarks.com/artists/charles-ray/
Rehberger, Tobias www.petzel.com/artists/tobias-rehberger
Rondinone, Ugo www.sadiecoles.com/ugo_rondinone/biog.html
Roosen, Maria www.mariaroosen.com
Schönbächler, Daniela www.danielaschonbachler.com
Shan Shan Sheng www.shanshansheng.com
Smith, Kiki www.timothytaylorgallery.com/artists/home/kiki-smith
Starling, Simon
www.themoderninstitute.com/artists/27/selected-solo-exhibitions
Steinbach, Haim www.haimsteinbach.net
Strik, Berend www.berendstrik.nl
Suh, Do-Ho www.lehmannmaupin.com/#/artists/do-ho-suh
Tomaselli, Fred www.jamescohan.com/artists/fred-tomaselli
Turk, Gavin www.gavinturk.com
Vanmechelen, Koen www.koenvanmechelen.be
Walker, Kara www.sikkemajenkinsco.com/karawalker.html
Wallinger, Mark www.markwallinger.com
White, Pae www.suecrockford.com/artists/images.asp?aid=46
Woodrow, Bill www.billwoodrow.com

List of illustrations

Numbers refer to page numbers. Measurements represent height before width before depth.

1 Aaron Young, UNDERDOG, 2009, polyester resin with fibreglass and chrome finish, 25.4 x 91.4 cm. Photo: Philippe D. Photography. Courtesy: Almine Rech Gallery, Brussels.

2 Do Ho Suh, STAIRCASE-V, 2008, polyester and stainless-steel tubes dimensions variable. Installation at the Hayward Gallery, London, England. Collection Thyssen-Bornemisza Art Contemporary. Courtesy: the artist and Lehmann Maupin Gallery, New York.

4 Takashi Murakami, FLOWER MATANGO (B), 2001–6, mixed media, dimensions variable (installation view), at '© MURAKAMI' at the Brooklyn Museum, 2008. Photograph by GION. Artwork © Takashi Murakami/Kaikai Kiki Co., All Rights Reserved.

7 Marcel Duchamp, FOUNTAIN, 1917, porcelain, 36 x 48 x 61 cm. © Succession Marcel Duchamp/ADAGP, Paris and DACS, London 2011.

7 Sherrie Levine, FOUNTAIN (AFTER MARCEL DUCHAMP), 1991, bronze, 36.8 x 35.6 x 66 cm, edition of 6. Courtesy: Simon Lee Gallery, London. Courtesy: Paula Cooper Gallery, New York. © the artist.

8 Marcel Duchamp, AIR DE PARIS, 1919, glass, 14.5 x 8.5 cm. © Succession Marcel Duchamp/ADAGP, Paris and DACS, London 2011.

8 Jean Arp, COLLAGE NO. 2 (GLASS OBJECT), 1964, blue glass form on an opaque glass sheet, 50 x 34.7 x 3 cm, edition 2 of 3. Photo: Francesco Allegretto. Courtesy: Berengo Private Collection, Venice. © DACS 2011.

9 Joseph Kosuth, ANY TWO METER SQUARE SHEET OF GLASS TO LEAN AGAINST ANY WALL, 1965, metal plaque and glass, glass: 200 x 200 cm, metal plaque: 5.8 x 20 cm. Photo: Francesco Allegretto. Courtesy: Joseph Kosuth studio, Sean Kelly New York and Studio Berengo. © ARS, NY and DACS, London 2011.

10 Lucio Fontana, PANNELLO, 1965, 15 Murano glass bubbles and a glass bowl on copper panel with holes, 124.5 cm diameter x 6 cm. Courtesy: Private collection, Bassano and Studio Berengo, Fontana archive 2733/1. © Lucio Fontana/SIAE/DACS, London 2011.

10 César, COMPRESSION, 1992, glass bottles, 37 x 23 x 24 cm. Photo: Francesco Allegretto. Courtesy: Berengo Private Collection, Venice. © ADAGP, Paris and DACS, London 2011.

11 Olaf Nicolai, CELIO, 2004, aluminium, acrylic glass, 130 x 90 cm. Courtesy: Galerie EIGEN + ART, Leipzig/Berlin.

11 James Lee Byars, IS, 1989, gilded marble, 60 x 60 x 60 cm. Courtesy: Galerie Michael Werner, Berlin, Cologne and New York. © Estate of James Lee Byers.

11 Subodh Gupta, ET TU, DUCHAMP?, 2009, black bronze, 114 x 88 x 59 cm. Installation view 'Subodh Gupta: Common Man', Hauser & Wirth, London, 2009. Photo: Mike Bruce. Courtesy: the artist and Hauser & Wirth

Glass

14 Jorge Pardo, UNTITLED, 2005, glass, mdf, metal screws, light bulbs, dimensions variable. Photograph by Damian Gillie. Courtesy: Haunch of Venison. © Jorge Pardo 2010.

14 Robert Rauschenberg, UNTITLED [GLASS TIRES], 1997, blown glass and silver-plated brass, 76.2 x 71.1 x 61 cm. © The Estate of Robert Rauschenberg.

15 Jorge Pardo, UNTITLED (detail), 2005, glass, mdf, metal screws, light bulbs, dimensions variable. Photograph by Damian Gillie. Courtesy: Haunch of Venison. © Jorge Pardo 2010.

15 Ann Veronica Janssens, OBJECT, 2008, uranium glass, 100 x 100 x 20 cm, edition of 7. Courtesy: the artist and D&A, www.dna-lab.net.

16 Ai Weiwei, CUBE LIGHT, 2008, glass crystals, lights and metal, 414 x 400 x 400 cm. Courtesy: the artist and Galerie Urs Meile, Beijing-Lucerne.

17 Tobias Rehberger, OUTSIDERIN, 2002, GELÄUT BIS ICH'S HÖR…., 2002, light installation at the Museum of Contemporary Art, Karlsruhe. Courtesy: Neugerriemschneider, Berlin. © Tobias Rehberger, 2002.

18–19 Shan Shan Sheng, OPEN WALL, 2009, Murano glass bricks, approx 2000 x 200 x 80 cm. Courtesy: the artist and Studio Berengo

20 Pae White, SHIP TO SHORE, 2003, blown glass bricks, dimensions variable. Courtesy: the artist and 1301PE, Los Angeles.

20 Pae White, BLUE HAWAIIAN, 2003, blown glass bricks, dimensions variable. Courtesy: the artist and 1301PE, Los Angeles.

20 Tony Cragg, VISIBLE MEN, 2009, Murano glass, 67 x 16 cm. Photo: Francesco Allegretto. Courtesy: Buchmann Galerie Lugano/Berlin. © DACS 2011.

21 Mona Hatoum, WEB, 2006, crystal balls and metal wire, dimensions variable. Installation at Galleria Conitinua, 515 x 2100 x 1325 cm. Photo: Ela Bialkowska. Courtesy: Galleria Continua, San Gimignano and White Cube, London. © the artist.

22, 23 James Lee Byars, THE ANGEL, 1989, 125 glass globes, each 20 cm diameter. Courtesy: Galerie Michael Werner, Berlin, Cologne and New York. © Estate of James Lee Byars.

24 Not Vital, 50 SNOWBALLS, 2001, Murano glass, variable sizes. Courtesy: Sperone Westwater, New York. © Not Vital 2009, New York.

24 Ryan Gander, A SHEET OF PAPER ON WHICH I WAS ABOUT TO DRAW, AS IT SLIPPED FROM MY TABLE AND FELL TO THE FLOOR, 2008, 100 crystal balls, each 15 cm diameter, edition of 3. Photo: Andy Keate. Courtesy: the artist and Lisson Gallery.

24 Guðrún Benónýsdóttir, LAVA DIAMOND, 2000, cast Icelandic lava, each unique, approximately 9 x 9 x 9 cm. Courtesy: the artist.

25 Barbara Bloom, FLAUBERT LETTERS II, 1987–2008, six engraved glass objects, dimensions variable, edition of 3. Etching: Robert DuGrenier Assoc. Inc, Townshend Vermont, USA. Courtesy: the artist and Galleria Raffaella Cortese.

25 Chen Zhen, CRYSTAL LANDSCAPE OF INNER BODY, 2000, crystal, iron, glass, 95 x 70 x 190 cm (detail). Photo: Attilio Maranzano. Courtesy: Galleria Continua, San Gimignano / Beijing / Le Moulin.

26 Jean-Michel Othoniel, BLACK HEARTS – RED TEARS, 2007, black, red and mirrored glass, metal cable, 391.2 x 431.8 x 12.7 cm. Courtesy: the artist and Sikkema Jenkins & Co.

27 Fred Wilson, IAGO'S MIRROR, 2009, Murano glass, 203.2 x 123.8 x 26.7 cm. Edition of 6 + 2 APs + 1 bon à tirer. Courtesy: The Pace Gallery. © Fred Wilson.

28 Fred Wilson, DARK DAWN, 2005, blown glass and plate glass, installation dimensions variable. Photograph by Ellen Labenski. Courtesy: The Pace Gallery. © Fred Wilson.

29 Kiki Smith, TEARS, 1994, glass, 50 units, each approx. 11.4 to 36.8 cm in length, installation dimensions variable. Photo: Ellen Wilson. Courtesy: The Pace Gallery. © Kiki Smith.

30 Kiki Smith, RED SPILL, 1996, glass, 75 units, each approx. 19.1 x 17.8 x 5.1 cm, installation dimensions variable. Courtesy: The Pace Gallery. © Kiki Smith.

31 Kiki Smith, SHED, 1996, glass, 43 units, each approx. 26.7 x 9.5 x 10.2 cm, installation dimensions variable. Courtesy: The Pace Gallery. © Kiki Smith.

32 Bill Woodrow & Richard Deacon, BOUTEILLE DE SORCIÈRE 9, 2008, glass, mirroring, sealing wax, 31 x 38 x 28 cm. Courtesy: the artists

33 Michael Petry, THE TREASURE OF MEMORY, 2000, glass, yachting rope, dimensions variable.

34 Shirazeh Houshiary, COMMISSION FOR ST MARTIN-IN-THE-FIELDS, 2008, etched mouth-blown clear glass and shot opened stainless-steel frame. Collaboration with Pip Horne. Photo: Dave Morgan. Courtesy: the artist and Lisson Gallery.

35 François Morellet, L'ESPIRIT D'ESCALIER at the Louvre, 2009, glass, lead. Courtesy: Zane Bennett Gallery, Santa Fe, NM and Musée du Louvre, Paris.

36 Jennifer Bartlett, COMMISSION, ST STEPHENS EPISCOPAL CHURCH, HOUSTON TX (detail, inside view and outside view), 1998, coloured glass, 244 x 168 cm. Executed by Architectural Glass Art, Kentucky. Photo: Joshua Pazda. Courtesy: the artist and St Stephens Episcopal Church.

37 Daniel Buren, PHOTO-SOUVENIR: TRANSPARENCE VÉNITIENNE AVEC REFLETS, 1972–2009, mirrored glass, 611 x 270 cm, work in situ, in 'Glasstress', Istituto Veneto di Scienze Lettere ed Arti–Palazzo Cavalli Franchetti, Venice. Photo: Francesco Allegretto. Courtesy: Buchmann Galerie, Berlin/ Lugano. © ADAGP, Paris and DACS, London 2011.

38 Koen Vanmechelen, THE ACCIDENT, 2005, Murano glass, Mechelse Bresse stuffed, iron, rope, wood, 60 x 35 x 45 cm. Photo: Francesco Allegretto and Alex Deyaert. Courtesy: Moss Private Collection, Miami.

38 Koen Vanmechelen, THE CATHEDRAL, 2007, Inox, clear glass, globe: the cosmopolitan chicken ten different generations, medusa totem: clear Murano glass, 120 x 120 x 270 cm. Photo: Francesco Allegretto and Alex Deyaert. Courtesy: Berengo Studio.

39 Christine Borland, BULLET PROOF BREATH, 2001, glass, spider's silk, steel, 34 x 22 x 22 cm. Courtesy: the artist and Lisson Gallery.

40 Jan Fabre, TABLE FOR THE KNIGHTS OF DESPAIR (RESISTANCE), 2006, fused glass with blue glass enamelled surface, 400 x 100 x 74 cm, edition of 7. Courtesy: the artist and D&A Lab, www.dna-lab.net. © Angelos.

40 Jan Fabre, TABLE FOR THE KNIGHTS OF DESPAIR (RESISTANCE), 2006, fused glass with blue glass enamelled surface, 400 x 100 x 74 cm, edition of 7 (detail). Courtesy: the artist and D&A Lab, www.dna-lab.net. © Angelos.

41 Jan Fabre, SHITTING DOVES OF PEACE AND FLYING RATS, 2008, Murano glass, BIC ink, 25 x 25 x 260 cm. Installation view 'Jan Fabre au Louvre: L'ange de la métamorphose'. Musée du Louvre, Salles du département des Peintures, Ecoles du Nord, Aile Richelieu. Photographer: Attilio Maranzano. Collection: Venice Projects. Courtesy: the artist. © Angelos.

42 Daniela Schönbächler, BLUE MOON, 2007, ink between glass, 30 x 30 x 16.5 cm. Photo: Urs Kaiser. Courtesy: the artist.

42 Simon Periton, BARBITURATE, 1998, coloured glass (white, black or lilac), 69.5 x 9 x 4.7 cm, boxed, edition of 100. Commissioned by the Multiple Store.

42 Roni Horn, UNTITLED (YES) 2, 2001, solid cast glass, 122.2 x 73.7 x 43.2 cm. Installation view at Dia Center for the Arts, New York. Private collection, Basel.

43 Silvano Rubino, ADDIZIONE SOTTRATTIVA, 2009, steel, fretworked industrial glass, 400 x 100 x 80 cm, edition of 3. Photo: Francesco Allegretto. Courtesy: the artist.

44 Per Barclay, UNTITLED (detail), 2003, mixed materials, dimensions variable. Courtesy: Galleria Giorgio Persano, Turin.

x 366 cm base diameter. Photo: Stephen Weiss. Courtesy: the artist and Riflemaker Gallery. © Liliane Lijn.

88 Marcel Duchamp, BOUCHE-ÉVIER, 1964, lead, 7.5 cm diameter. © Succession Marcel Duchamp/ADAGP, Paris and DACS, London 2011.

88 Dhruva Mistry, MAYA, MEDALLION – THE DARK ONE, 1988, cast bronze, 13.3 cm, edition of 56, front and back view. Courtesy: the artist and the British Art Medal Society.

88 Rob Kesseler, BOOK OF LEAVES, 1991, cast bronze, 7 x 7.8 cm, front and back view. Courtesy: the artist and the British Art Medal Society.

88 Dhruva Mistry, HUMANITY MEDAL, 1994–7, cast bronze, 9.5 cm diameter, front and back view. Courtesy: the artist and the British Art Medal Society.

88 Cornelia Parker, WE KNOW WHO YOU ARE. WE KNOW WHAT YOU HAVE DONE, 2008, struck silver (one medal designed on both sides), 3.8 cm diameter, 0.4 cm thick, front and back view. Courtesy: the artist and Frith Street Gallery.

89 Michael Landy, ASBO MEDAL, 2009, photo-etched brass, 89 cm diameter, edition of 3, front and back view. Courtesy: the artist and Thomas Dane Gallery, London. © Michael Landy.

89 Bill Woodrow, OUR WORLD, 1997, bronze, 5 x 3.5 cm, cast by Niagara Falls Casting for the British Art Medal Society, top, side and internal view. Courtesy: the artist and the British Art Medal Society.

Stone

92 Gary Hume, MILK FULL, 2006, marble, lead, 246 x 185 cm. Photo: Stephen White. Courtesy White Cube. © the artist.

93 Scott Burton, THREE-QUARTER CUBE BENCH (ENLARGED VERSION, GROUP OF FOUR BENCHES), 1985–9/2003, radiant red granite, four pieces each 83.8 x 83.8 x 83.8 cm. Installation view at the Art Institute of Chicago. Courtesy: Max Protetch Gallery.

93 Scott Burton, THREE-QUARTER CUBE BENCH, 1985, radiant red granite 76.2 x 76.2 x 76.2 cm. Courtesy: Max Protetch Gallery.

94 Scott Burton, ROCK CHAIR V1, 1981, sierra granite, 76.2 x 122 x 81 cm. Courtesy: Max Protetch Gallery.

95 John Frankland, BOULDER, 2008, granite, two pieces, each

approx. 400 cm tall. Top image: John Frankland, BOULDER (MABLEY GREEN). 2008, Photo: Chris Dorley Brown. Courtesy: the artist, Peer and Matt's Gallery. Bottom image: BOULDER (SHOREDITCH PARK), 2008. Photo: Chris Dorley Brown. Courtesy: the artist, Peer and Matt's Gallery.

96 Louise Bourgeois, DÉCONTRACTÉE, 1990, pink marble and steel, 72.3 x 91.4 x 58.4 cm. Photo: Peter Bellamy. Collection Brooklyn Museum, Brooklyn, NY. © Louise Bourgeois Trust/DACS, London/VAGA, New York 2011.

97 Louise Bourgeois, UNTITLED (WITH GROWTH), 1989, pink marble, 80 x 53.3 x 144.7 cm. Photo: Peter Bellamy. Collection Ginny Williams Family Foundation, Denver. © Louise Bourgeois Trust/DACS, London/VAGA, New York 2011.

98 Barry X Ball, PURITY, 2008–9, sculpture: golden honeycomb calcite, stainless steel, 61 x 41.9 x 28.6 cm; pedestal: Macedonian marble, stainless steel, wood, acrylic lacquer, steel, nylon, plastic, 114.3 x 35.6 x 30.5 cm, after Antonio Corradini, *La Purità*, 1720–5, Ca' Rezzonico, Venice. Photo: Barry X Ball. Private Collection, United Kingdom.

98 Barry X Ball, DUAL-DUAL PORTRAIT (MATTHEW BARNEY / BARRY X BALL), *paired, mirrored, flayed, javelin-impaled, cable-delineated-pendentive-funnel-suspended, squid-like, priapic / labio-vulval, Janusian meta-portrait lozenges of the artist, screaming, and Matthew Barney, in two guises: determined combatant and recently-deceased, resigned stoic, with the first composite figure richly embossed, in a manner reminiscent of late-Renaissance Milanese parade armor, with a cornucopia of silhouetted motifs: Abrahamic ecclesiastical symbols, animals, decorative flourishes, and protuberant, warty, half-spheres; and the second devoid of embellishment, in book-split, medially-bifurcated onyx from Baja California: half an exuberantly-variegated, intensely-colored, fractal-patterned, striped-and-spotted white-yellow-red; half a comparatively-uniform semi-translucent, nacreous, pale yellow-white with differing surface treatments keyed to the corresponding swag-draped corporeal flay strata: a glistening mucosal sheen for the splayed entrails, either miniature horizontal flutes or a micro-*

stippled matte finish for the mid-level viscera, and either gnarled, ridged, sfumato-esque soft-focus ornamental relief or, again, diminutive horizontal flutes for the epidermis, with eyes and oral features gleaming, respectively, with a moist, lachrymal / salivary polish, with mannered, attenuated, crown-like cranium-top shatter-burst exit-wounds, 2000–7, Mexican onyx, stainless steel, 24-carat gold, various other metals; head/shaft assembly: each 139.7 x 13.3 x 20.3 cm; stone figures: each 55.9 x 13.3 x 20.3 cm, three quarter view. Photo: Barry X Ball. Private collection, Italy.

99 Barry X Ball, DUAL-DUAL PORTRAIT (MATTHEW BARNEY / BARRY X BALL), 2000–7, Mexican onyx, stainless steel, 24-carat gold, various other metals; head/shaft assembly: each 139.7 x 13.3 x 20.3 cm; stone figures: each 55.9 x 13.3 x 20.3 cm, three quarter view. Photo: Barry X Ball. Private collection, Italy.

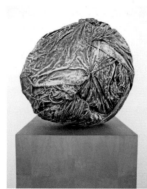

100 Barry X Ball, PURITY, 2008–9, sculpture: Iranian onyx, stainless steel, 61 x 41.9 x 28.6 cm; pedestal: Macedonian marble, stainless steel, wood, acrylic lacquer, steel, nylon, plastic, 114.3 x 35.6 x 30.5 cm, (detail), after Antonio Corradini, *La Purità*, 1720–5, Ca' Rezzonico, Venice. Photo: Barry X Ball. Private collection, Germany.

101 Kris Martin, MANDI VIII, 2006, plaster, 220 x 150 x 100 cm, edition of 3 plus 1 artist's proof. Photo: Achim Kukulies, Düsseldorf. Producer: Staatliche Gipsformerei and Bernhard Gutmann. The Rachofsky Collection. Courtesy Sies + Höke, Düsseldorf.

102–3 José Damasceno, DANCEFLOOR (STEP BY STEP), 2006, marble, variable dimensions. Courtesy: Galeria Fortes Vilaça, São Paulo. © José Damasceno.

104 Marc Newson, VORONOI SHELF (WHITE), 2006, Carrara marble, 180.1 x 279.9 x 39.9 cm, edition of 8. Photo: Larry Lamay. Courtesy: Marc Newson Ltd. and

Gagosian Gallery. © Marc Newson www.marc-newson.com.

104 Pae White, CORIAN® BED, 2006, Solid Corian®, 800 pounds weight, dimensions: Italian king size. Courtesy: the artist and Kaufmann Repetto, Milan.

105 Not Vital, SLED (A), 2004, white marble, 100 x 100 x 25 cm. Courtesy: Sperone Westwater. © Not Vital 2009, New York.

Textiles

108 Do-Ho Suh, REFLECTION, 2004, nylon and stainless-steel tube, dimensions variable, edition of 2. Installation at Lehmann Maupin Gallery, New York. Inhotim Collection, Minas Gerais, Brazil. Courtesy: the artist and Lehmann Maupin Gallery, New York.

109 Do-Ho Suh, THE PERFECT HOME II, 2003, translucent nylon, 279.4 x 609.6 x 1310.6 cm. Private collection, New York. Courtesy: the artist and Lehmann Maupin Gallery, New York.

110 Andy Holden, PYRAMID PIECE, 2008, knitted yarns, foam, steel support, 550 x 450 x 300 cm. Installation view Tate Britain. Courtesy: the artist.

111 Kara Walker, A WARM SUMMER EVENING IN 1863, 2008, wool tapestry with hand-cut felt silhouette figure, 175 x 250 cm, edition of 5. Courtesy: Banners of Persuasion, www.bannersofpersuasion.com.

111 Ghada Amer & Reza Farkhondeh, THE BUGS AND THE LOVERS, 2008, wool with attached silk bugs, 154 x 232 cm, edition of 5. Courtesy: Banners of Persuasion, www.bannersofpersuasion.com.

112 Mara Castilho, HEART, 2010, cotton and dark blue thread (points: po de flor, knot, screen and full), 50 x 50 cm. Artist's collection. Courtesy: the artist. © the artist.

112 Mara Castilho, FULL HEART, 2010, cotton and dark blue thread (points: po de flor, knot, screen and full), 50 x 50 cm. Artist's collection. Courtesy: the artist. © the artist.

113 Gary Hume, GEORGIE AND ORCHIDS, 2008, wool with raised silk embroidery, 250 x 205 cm, edition of 5. Courtesy: Banners of Persuasion, www.bannersofpersuasion.com.

114 Berend Strik, FARADIS, ARABIC CITY, 2009, C-print with embroidery and fabric, 100 x 150 cm. Courtesy: the artist and Galerie Fons Welters, Amsterdam.

114 Berend Strik, MAMA LOVES YOU, 2005, C-print with

embroidery and fabric, 80 x 80 cm. Courtesy the artist and Galerie Fons Welters, Amsterdam.

115 Marya Kazoun, SELF-PORTRAIT, 2003, installation and performance, fabric, thread, plastic bags, stuffing, mirrored glass, dimensions variable. Photo: Luca Casonato. Courtesy: the artist.

116–7 Marya Kazoun, IGNORANT SKIN, 2005, installation and performance, thread, fabric, beads, wool, stuffing, glue on canvas, performers, 1125 x 280 x 200 cm. Photo: Francesco Fenuzzi. Courtesy: the artist.

118 Fred Tomaselli, AFTER MIGRANT FRUIT THUGS, 2008, wool background, silk birds with metallic thread detail, 250 x 160 cm, edition of 5. Courtesy: Banners of Persuasion, www.bannersofpersuasion.com.

118 Grayson Perry, VOTE ALAN MEASLES FOR GOD, 2008, wool needlepoint, 250 x 200 cm, edition of 5. Courtesy: Banners of Persuasion, www.bannersofpersuasion.com.

118–19 Gavin Turk, MAPPA DEL MUNDO, 2008, wool, silk tapestry and metallic thread tapestry, 313 x 200 cm, edition of 5. Courtesy: Banners of Persuasion, www.bannersofpersuasion.com.

120 Carlos Noronha Feio, THE END (BIRTH AND FERTILITY – THE GOOD NEWS), 2008, wool Arraiolos, 173 x 202 cm. © Carlos Noronha Feio.

121 Marc Camille Chaimowicz, VERTIGINOUS PLEASURE, 2009, mixed media, dimensions variable (detail). Commissioned for COMMA at Bloomberg SPACE by Bloomberg, 2010. Photography © Peter Abrahams.

121 Marc Camille Chaimowicz, VERTIGINOUS PLEASURE, 2009, mixed media, dimensions variable. Commissioned for COMMA at Bloomberg SPACE by Bloomberg, 2010. Photography © Peter Abrahams.

121 Pierre Bismuth, TAPIS, 2006, wool, 320 x 220 cm, edition of 30. Courtesy: the artist and D&A. www.dna-lab.net.

122 Rebecca Scott, IMPERIAL SIZE BLANKET FOR THE DEVELOPING COUNTRIES, 1992, knitted acrylic wool, over three single beds, 276 x 200 cm. Photo: Claire Paxton. © Rebecca Scott.

122 Rebecca Scott, IMPERIAL SIZE BLANKET FOR THE DEVELOPING COUNTRIES, 1992, knitted acrylic wool, over three single beds, 276 x 200 cm (detail). Photo: Claire Paxton. © Rebecca Scott.

Interviews

Pages 198–208

Index

Page numbers in *italic* refer to illustrations

PRECEDING PAGES:

PAGE 198 **Franz West**, <u>FAUXPAS</u>, 2006, Epox resin, 545 x 205 x 205 cm.

PAGE 204 **Joseph Havel**, <u>30 SHEETS</u>, 2006, bronze, 35.6 x 38.1 x 34.3 cm.

PAGE 208 **Liliane Lijn**, <u>DIVIDED SELF</u>, 2001, 28 x 38 x 38 cm, patinated bronze, cast glass, argon, stainless-steel box.

The author would like to thank all the participating artists, their gallery representatives and their staff, along with the Thames & Hudson production team. Particular thanks for all their help and diligence in the making of the book go to Roberto Ekholm, Niki Medlik and especially to Andrew Brown, whose editorial contribution was invaluable. He would also like to thank the following for their support: Travis Barker, Devin Borden, Hiram Butler, Mark Davy, Dr James Mooney, Dr Katharine Meynall, Professor Susan Melrose, Professor Francis Mulhern, Terry New, Norman Rosenthal, Sundaram Tagore, Chris Westbrook, and especially Ursula Neuman of the Museum of Arts & Design, New York. The author would also like to thank Constance Kaine for her continuing belief in and support of this project from the outset.

Picture research: Roberto Ekholm
Administrative assistant: Charlotte King

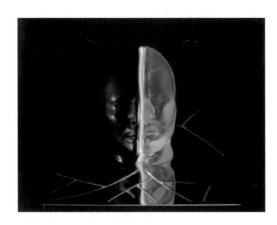

First published in the United Kingdom in 2011 by Thames & Hudson Ltd, 181A High Holborn, London WC1V 7QX

First paperback edition 2012
Copyright © 2011 Michael Petry

British Library Cataloguing-in-Publication Data
A catalogue record for this book is available from the British Library
ISBN 978-0-500-29026-2

Printed and bound in China by C&C Offset Printing Co. Ltd

To find out about all our publications, please visit **www.thamesandhudson.com**.
There you can subscribe to our e-newsletter, browse or download our current catalogue, and buy any titles that are in print.